Digital
Photo
Magic

Digital Photo Magic

Easy Image Retouching and Restoration for Librarians, Archivists, and Teachers

Ernest Perez

 Information Today, Inc.
Medford, New Jersey

First printing

Digital Photo Magic: Easy Image Retouching and Restoration for Librarians, Archivists, and Teachers

Copyright © 2016 by Ernest Perez

Library of Congress Cataloging-in-Publication Data

Perez, Ernest Raoul, author.
 Digital photo magic : easy image retouching and restoration for librarians, archivists, and teachers / by Ernest Perez.
 pages cm
 Includes bibliographical references and index.
 ISBN 978-1-57387-513-4
1. Photography—Retouching. 2. Photography—Digital techniques. 3. Photography in education. I. Title.
 TR310.P47 2016
 770—dc23

2015031259

Printed and bound in the United States of America

President and CEO: Thomas H. Hogan, Sr.
Editor-in-Chief and Publisher: John B. Bryans
Production Manager: Tiffany Chamenko
Indexer: Nan Badgett, dba Wordability

Interior Design by Amnet Systems
Cover Design by Dana Stevenson

infotoday.com

Contents

Figures and Tables

Preface

The book you are holding describes and teaches what I call "Digital Photo Magic," or DPM—an inexpensive and simple, yet productive and powerful approach to retouching, repairing, and restoring digitized photographs and other images. I wrote the book specifically for the benefit of information professionals and other knowledge workers in libraries, archives, museums, and schools, but it should be useful to anyone who works frequently with digital images or who may be preparing to undertake an image restoration project.

There's no formidable learning curve for DPM retouching technology. It's an easy-to-understand, easy-to-use, intuitive approach to photo editing. The time required to learn how to use the recommended software tools is measured in single-digit hours and days. There's no intensive study, no tutorials, no poring over manuals, and no need to sit through lengthy seminars or training programs.

I should mention here that my coverage is limited to Windows-compatible environments. While there are many terrific tools available for the Macintosh, Mac users will need to look elsewhere for guidance.

You'll find my tone informal and, I hope, helpful throughout. I begin by explaining the DPM concept and approach in the book's Introduction, followed by Chapter 1, where you'll read about many of the effective, productive, and rewarding aspects of DPM for professionals in the target fields. I then progress through clear explanations of digital photo technology, retouching, and digital scanning operations, along with coverage of basic work planning techniques and the importance of designing an effective workflow.

In Chapter 5, I list and describe a number of recommended software products, calling attention to their particular capabilities and strengths. I describe commonly used photo-editing processes in Chapter 6, along with illustrated step-by-step examples of photo-editing tasks and procedures. I also provide extensive and easy-to-follow coverage of cost and equipment issues.

The DPM concept hinges on the use of readily available free and low-cost photo-editing software, apps, and utilities. The emphasis is on products that are easy to learn and use, and on an organized, common-sense approach to processing and workflow. DPM avoids complicated, hard-to-learn, and, in some cases, expensive post-processing software applications such as Adobe Photoshop and the free GIMP package. Learning to use these complex applications skillfully can present a serious challenge for the average non-techie user.

The DPM software tools I recommend are remarkably robust. The developers of these programs have successfully combined high-horsepower editing functions with clear, simple controls and intuitive user interfaces. You'll be surprised how easy it is to do high-quality photo retouching and restoration—even if you *aren't* an advanced computer user. If you can master the basics of word processing and spreadsheet software, you have what it takes to effectively retouch, repair, and restore digital images.

Digital Photo Magic will show you how to do it cheaply, quickly, and easily.

About the DPM Website

www.update4dpm.com

The *Digital Photo Magic* (DPM) companion website augments and updates information provided in the book and offers a conveniently organized and hyperlinked list of recommended DPM resources. Designed as a bonus for *Digital Photo Magic* readers, it emphasizes software and hardware products for library, archives, museum, and teaching professionals who need a quick and easy path to do-it-yourself digital photo retouching and restoration.

In addition to listing and linking the DPM products and services covered in the book, the website provides pointers to new DPM applications, hardware, post-processing techniques, and related topics by featuring the following:

- A periodically updated organized collection of links to websites that provide information about DPM techniques, trends, and products

- Concise summary reviews of DPM-recommended software products; reviews may include my original (and updated) evaluations and ratings as well as comments contributed by readers like you

- A discussion area where readers can exchange ideas, opinions, suggestions, questions, and answers

I intend to update and maintain the companion website as a resource for as long as *Digital Photo Magic* readers continue their interest in this book and the solutions it offers. Please send your comments, questions, and suggestions to author@update4dpm.com.

Disclaimer

Neither the publisher nor the author make any claim as to the results that may be obtained through the use of this website or of any of the resources it references or links to. Neither the publisher nor the author will be held liable for any results, or lack thereof, obtained by the use of this site or any of its links; for any third-party charges; or for any hardware, software, or other problems that may occur as the result of using it. This website is subject to change or discontinuation without notice at the discretion of the publisher and the author.

Introduction

Digital Photo Magic—What's It All About?

The world of photography changed drastically with the introduction of digital technology. Not only are people taking more photos than ever, but we've moved from using chemistry operations and manual processing into an environment of advanced personal computer hardware and software tools used to process our photographic images. In today's world, there's no more darkroom work for developing silver-based photo prints. And there's even more relief for the more exacting and time-consuming processing of color images: For color photographs, digital image processing has eliminated the need for precise timing, exacting temperature controls of chemical solutions, and intricate optical color filtration operations using glass filters.

Meeting the Needs of Libraries, Archives, Museums, and Schools

Libraries, archives, museums, and schools have incorporated photographs in their collections, exhibitions, and learning activities for as long as people have been taking them. Today, as digital technology proliferates and the number of available images increases exponentially, staff in these organizations are increasingly being called upon to make decisions about digitization, preservation, and restoration. They are expected to effectively support digital photo operations within prevailing budgetary guidelines, so a working knowledge of current technologies and processes is becoming more and more important, because most of these professionals have had little or no training in digital image retouching, restoring, and processing—in short, they are in need of some guidance.

That's the need I address in this book.

In much the same way that photographic processing technology evolved beyond the use of complex and demanding silver-based chemistry, digital photo-editing or "post-processing" software technology has now moved past the stage at which only computer geeks were able to use it.

"Post-processing" is the technical term for using digital photo-editing tools to change or manipulate photographic images. With post-processing, you can correct or improve full photo images or parts of images. You can apply unusual graphic or artistic effects, such as posterization, high contrast, geometrical pattern overlays, and more.

In just the first half of the current decade, we've witnessed the introduction of an array of powerful digital photo software applications that almost anyone can master. This new breed of photo-processing software is characterized by reasonable pricing and intuitive, easy-to-learn user interfaces. It's also preserved the digital editing power of high-priced, hard-to-learn professional products, equipping the average user with seemingly magical powers for transforming digital images. The speed and ease of changing an image makes me think of a magician's sleight of hand. It's with this metaphor in mind—and tongue firmly in cheek—that I use the term "Digital Photo Magic" (DPM) to describe what these wonderful tools let us do.

With DPM software, photographic post-processing has progressed to a WYSIWYG (what you see is what you get) style of editing that recalls the evolution of word processing and database software. The makers of these software tools have combined work process simplification with the addition of personal computer horsepower that significantly expands the average user's output capability.

DPM software strips away the need to master laborious and complicated technical procedures and editing operations. It allows the user to do faster, easier, more economical, and higher-quality photo-editing work than most professionals could have done just a handful of years ago. If you work with digital images, you can now benefit from the same productivity and quality improvements that word processing, database, and spreadsheet software programs have brought to office workplaces over the last few decades.

There's still one undeniable fact: *You absolutely, positively need to start with good photographic images in order to produce quality digital output.* Appealing photographs ultimately depend upon a skilled individual who has juggled and coordinated a spectrum of near-simultaneous activities and processes. The photographer must first conceptualize the final image he or she wants, then perform the multitasking magic of coordinating an enormous spread of mechanical and stylistic decisions that include proper lens and focal length selection, exposure setting, depth of focus adjustment, precise focusing, selection of camera-to-subject distance and viewpoint, and skillful visual formatting and composition of the image. Above all, the photographer needs precise timing to "capture the decisive moment." Not at all an easy task, despite the remarkable technological strides made by camera manufacturers that continue apace.

No way around it: Image quality is tied to photographer competence. I don't attempt to deal with the complexity of that wider topic in *Digital Photo Magic*: If you require knowledge of the overall craft of the photographic art, you'll need to gain it through study and practice. There are many publications and information resources available to help you, but this book is not one of them.

I cover Windows-compatible tools and techniques that you can use to do basic and effective photo image retouching and restoration. You can apply this new knowledge in a variety of ways, enhancing a library or museum exhibit, aiding teaching, designing an archives publication or display, or creating a website or other electronic display. DPM can provide professionals and technical specialists with the skills, resources, and confidence to produce high-quality digital images for a wide range of organizational purposes. When working with graphic images, you'll occasionally be faced with a problem in visual quality of an image. Whatever it may be, you must spot it using your own personal and critical visual perception. You need to use and trust your subjective eyeball evaluation here; it's a case of knowing it when you see it. If an image isn't up to snuff for the intended use, it's your job to recognize, address, and cure the problem. This is an essential talent for any prospective post-processing specialist.

The good news is that DPM software can easily correct or minimize most of the technical and accidental errors that cause or contribute to poor photographic image quality. A variety of factors in photographic exposure or processing can result in a low-quality image. An image may be over- or underexposed. It may be too flat or dull or too contrast either in the original exposure or as a result of errors during printing. An image may be marred by spots, scratches, stains, folds, tears, or abrasions, particularly in the case of a historical or antique image or illustration. No matter the cause, your visual problem boils down to something not being quite right with the image. After you have determined that some level of retouching or restoration is necessary, DPM will almost always provide a workable solution. Remember—no matter how bad a photo image may be, you should always be able to greatly improve it.

In Figure A, we're looking at a simple backyard Halloween snapshot; perhaps we'd like to turn it into an informal portrait of the individual pictured. Using DPM, it's surprisingly easy to remove the distracting pumpkin and witch's hat to produce the portrait shot shown in Figure B.

You may be surprised to learn that the physical format of an original image you wish to improve is basically irrelevant. Almost any image representation will do; essentially, you just need to be able

Figures A,B A backyard Halloween get-together snapshot is transformed into an attractive informal portrait by removing the plastic pumpkin and witch's hat distracting from the subject, followed by a bit of cosmetic retouching. (Work performed using Inpaint, Retouch Pilot, and Beautune in 15–20 minutes.)

to see it. You can begin from a digital image, a film negative or color transparency, a photo print, a printed or published image from a book or periodical, or even a computer or video display. DPM can handle all of these.

If you already have a digital image, you can start right off editing; otherwise, you can use a scanner or digital camera to convert one from another format. Unlike copying with film and chemical print processing, digital conversion is fast, easy, and inexpensive. No more than a few minutes of work is required to transform any image into a digital file that's ready for editing using post-processing software.

It's likely that the needed copy or conversion equipment is already available at your workplace, quite possibly even at your home. For fast copying from hard-copy images, all you need is an average-quality digital scanner. A multipurpose computer printer with a scanner function will work just fine. Alternatively, you can make digital copies from prints or film using a digital single-lens-reflex camera (DSLR) with an appropriate lens, a good-quality "point-and-shoot" (fixed lens) digital camera, or even a cell phone that has a decent camera function. A cell phone camera of 2 or more megapixels resolution is quite adequate if it has autofocus capability and you use good lighting, perhaps along with a monopod/tripod or some other stabilizer or anchor. Numerous free or inexpensive cell phone apps are designed specifically for enhancing the quality of cell phone camera images.

Photographic post-processing costs can add up quickly in both silver-based or digital working environments. In either case, someone must pay for digital rescanning or digital camera copying, extra post-processing corrective work, reprinting time and costs, and labor time. But corrective changes will cost you far less in the new digital environment than in the past. The traditional chemical film and print process, bringing with it costs for photo lab supplies, corrective print-manipulation time, and the possible need for manual brush or pencil retouching, saw significantly higher skilled labor and production costs.

But even though added processing costs may be small, your internal overhead and labor are still going to inevitably result in the equivalent of another $15–$20 per image, and possibly more. Yes, you will reduce your time and expense from using silver-image photographic processing methods or outsourcing your digital post-processing work, but the added expense will still be there.

I estimate that in-house post-processing may cost you roughly $15–$20 per image, when you include overhead; but you can be sure that outsourcing your photo-editing work to a retouching professional will cost you considerably more than that. The obvious out-of-pocket outsourcing costs added to your internal overhead expenses will probably come to at least $35, and possibly as much as $50, per image. Thus, if you're dealing with more than just a few images, outsourced post-processing work can easily run into hundreds of dollars per project. Although automatic digital retouching is supposedly easier and cheaper than silver-based photo processing, the added third-party profit margin will still drive the prices above in-house work. If you're concerned about budgets (and who isn't?), doubling your expense simply makes no sense.

The Digital Photo Magic Alternative

I use the DPM alternative as a practical approach to digital photo retouching. There's no real downside: You can easily and confidently switch to it for high-quality post-processing of your images. As I've explained, DPM doesn't require highly skilled or excruciatingly laborious work; the leverage added by DPM automation puts this formerly expert technique well within the capability of the average person, if he or she is willing to take the time to employ it.

The DPM approach is simple and easy to understand. You don't need to buy expensive proprietary software. You don't need additional hardware. You simply assemble a toolkit of free or

low-cost software tools, then mix and match the functions included in the programs to greatly leverage your editing power.

Here's a concise guide to applying DPM:

1. Choose a small, workable number of free or inexpensive, easy-to-use, and easy-to-learn photo-editing tools, making an effort to cover the range of post-processing tasks you're most likely to undertake.

2. Spend a short amount of time learning the nuts and bolts of the selected programs, experimenting and practicing on test images and learning the capabilities and shortcuts within the various applications.

3. As you work with the programs, identify the particular operations or functions that are the strong points of each. The programs that you find to be especially easy, fast, intuitive, and powerful for accomplishing specific tasks will earn a place in your post-processing toolbox.

4. Use the abovementioned "strong point" functions of your different software tools freely and interchangeably as you work on a single image to effectively handle the retouching and restoration tasks you think each tool is best suited to accomplishing.

After you've inventoried and identified the unique strong points of your chosen DPM applications, you'll find it easy to set up your own practical and efficient working routine. Let's say you decide you'll generally use Program A to quickly accomplish contrast and exposure touch-ups, whereas you may prefer Program B for the removal of spots, scratches, and blemishes, Program C for removing people or objects from a photograph and to "sharpen up" slightly unfocused images, and Program D for easy retouching of facial and skin blemishes.

Just as and when you select the most appropriate tool in your home workshop to do a certain job, you'll use the DPM tool that's best suited to a specific task. (You don't use a saw to drill a hole, right?)

You'll find that in addition to their ease of use, the use of the most appropriate DPM tools can significantly reduce the total working time for a particular image to a matter of minutes. The DPM approach takes less planning and operational time, and less conscious effort, than that required by complex post-processing applications such as Adobe Photoshop. DPM saves you a considerable investment in program learning time.

Reasons for Post-Processing

There's an endless list of problems that negatively affect the appearance of photo images. You'll often encounter such problems in image collections containing material produced by nonprofessional photographers—in donations or bequests to libraries or archives, for instance. These collections and individual images may have legitimate historical significance yet reach only the amateur snapshot level of quality. The images may be in dire need of post-processing before they can be viewed by the public—at least if one of your goals is to engender positive reviews and word-of-mouth publicity. Many of the types of problems you'll encounter may seem somewhat obvious, but here's my short list:

• Something about an image or graphic "just doesn't look quite right." It obviously needs a fix, something to tone up or spice up the image.

• Something needs correcting in the framing, composition, or orientation of the image. You need to do simple image post-processing, such as by cropping the image or flipping it left to right.

- Photographic quality issues are present in the image, including problems with exposure, contrast, focus, resolution, color shifts, white balance, and shutter speed errors.

- Physical defects are visible in the original image, such as dust spots, scratches, stains, tears, folds, and abrasions.

- Unsightly objects interfere with or distract from the primary subject of the image. Such unexpected or unwanted objects might include people, automobiles, buildings, machinery, tree branches, telephone wires, antennas or satellite dishes, and electrical towers.

These are examples of the cosmetic problems you may need to address before using photographic images for your intended illustrative or informational purpose. Although it's possible to make all these types of corrections using DPM, sometimes only retaking a photo will provide the desired result. Unfortunately, that's often not a practical option, and you may have to make an editorial decision to simply exclude a particular image. When feasible, DPM cosmetic post-processing is obviously preferable to eliminating an image, especially late in a project cycle, but even so, it's not a cure-all.

Keep in mind that post-processing may involve a policy matter in the particular organizational environment where you are using the image. A policy of "absolutely no manipulation of photographic images" is common in many publishing and news media operations. Such absolute prohibitions can be tempered; it still can be sensible to allow leeway for simple photographic cosmetic manipulation or repair of image damage so long as there's no deliberate distortion of reality. (I discuss such ethical and legal questions in some detail in the "Legal and Ethical Concerns" section of Chapter 1.)

Typical Post-Processing Examples

Use of appropriate digital image post-processing work occurs in many situations and environments:

- Personal, everyday life—post-processing applications in support of hobbies, personal or family historic photo collections, scrapbooks, memorials, and church, community, or similar displays

- Teaching and instruction—post-processing images for use at all levels of education and in professional and instructional training programs

- Publishing and broadcast media—post-processing for journalistic purposes, in newspaper and media libraries, to reinforce informational value, and to save time and money in institutional revenue-producing activities

- Marketing and promotional work for any organizations or small businesses—economical internal post-processing work for use in production of advertising, posters, handouts, displays, brochures, pamphlets, and other marketing materials

- Archival collection environments—post-processing in libraries, museums, private collections, corporations, organizations, and nonprofit and commercial archives

Legal questions about the acceptability of post-processed images can arise in all the above situations, ranging from issues of ownership and copyright to questions about the authenticity or legality of a particular image.

Reality Checks before the DPM Decision

Take time for reality checks before committing to any decision to use DPM on a broad scale in your organization. Yes, DPM is a quick, easy, and affordable path to editing and retouching images and illustrations for use in professional and personal projects, but as you probably learned early in life, there's no such thing as a free lunch. It will be prudent for you to carefully consider the factors relating to DPM and your particular situation before jumping in. These practical realities include considerations in areas such as quality-level demands, practicality of the technology, and user needs. We'll take a look at those concerns next.

Quality Level

Just how successfully can a beginner (you) be at improving photo images using DPM, in terms of quality and usability? To begin with, it's worth noting that DPM tools employ the same type of software technology found in the pioneering professional-level products. That's right—DPM software uses the same essential technology that began with Photoshop and GIMP. The main difference is that DPM apps have essentially added "automatic transmissions" to simplify and handle the intricate and often complicated control functions provided by the earlier products.

You may be aware that many of the operations used in the high-end products are widely supplemented by the use of third-party "plugins," modules designed to work within Photoshop and other commercial photo-editing programs. Plugins are created specifically to simplify and speed up the complicated photo-editing operations required with professional software tools. You can find scores of these plugin program modules, usually as freeware or inexpensive shareware.

As I write this, I've done a quick Boolean search:

 "+photoshop +plugins +best"

That got me 43 results, including many pages titled things such as "Top PhotoShop Plugins," "10 Best PhotoShop Plugins," "25 Professional and Incredibly Powerful Photoshop Plugins," "30 Awesome and Exclusive Photoshop Filters"—and so on. You get the idea.

DPM applications provide the same kind of "automated plugin" improvements, but they include them in photo-editing applications of much less power. The DPM applications have simplified their overall application design by purposely concentrating on narrower areas of useful and streamlined functions. They don't even attempt to include the broad functional toolkit (and high pricing and learning curve) of the high-end software—and that's why they're so much easier to learn and use.

Products such as Beautune and CleanSkinFX concentrate on cosmetic facial and skin corrections. Others, including Inpaint and iResizer, specialize in seamless object and background removal and inserting images into composite illustrations. These programs generally provide a limited palette of general photo-editing functions. The software innovators have deliberately narrowed their program functionality down to only selected certain operations, but they have developed sophisticated "automatic pilot" versions of those operations.

DPM programmers can typically afford to release their products as freeware or inexpensive shareware because they are not underwriting the large staffing, production, and advertising budgets of the big guys. They don't charge $150 or $500 to compete with the market leaders. But they've definitely succeeded in developing their own market niche, providing powerful automated post-processing tools that simplify sophisticated photo-editing operations and significantly improve substandard images.

Of course, I can't guarantee that all your DPM-retouched images will be perfect. You'll need to start with images that have good potential for effective improvement, and you'll absolutely require tenacity, the benefits of experience, and some sound visual judgment. When you make those personal investments, your retouching and restoration prowess can reach a level approaching that achieved by experienced professionals working with high-end photo-editing tools.

In addition to reading *Digital Photo Magic*, be sure to take a look at the examples of post-processed images linked from the book's companion website at www.update4dpm.com. You may also want to examine some of the many examples, demos, and tutorials provided on the websites of the DPM products recommended in Chapter 5. Finally, to gain some objectivity, check out some of the specialized non-vendor websites focused on digital photo post-processing. (The DPM website provides links to many of these.) These special-interest online resources often include user forums or discussion areas that offer "how I did it" examples, along with software demos and Q&A's on a range of topics. You'll find an abundance of subjective opinions about the effectiveness of various software products. You'll also find numerous helpful demo videos—posted by both vendors and users—on popular video sites such as YouTube and Vimeo.

For some comparison, look for coverage of the high-end products. Simply use your favorite search engine to find comparable practical information about products like Photoshop, GIMP, and PhotoImpact. As an example, when you search for the product name in Google, it's useful to use search queries such as the following:

+Photoshop +(best quality users tutorial review demos examples methods)
+"Photo Impact" +(best quality users tutorial review demos examples methods)

Using the Boolean plus signs (+) and a parenthesized list of synonym terms (having no Boolean connectors in a list defaults to the OR connector) will narrow your search results to webpages emphasizing *the use and quality* of the *specified software*, rather than simply returning an unfocused list of free text hits, vendor pages, and download links. You'll be able to concentrate on checking webpages related to end-user discussions, non-vendor tutorials and demos, user evaluations, quality judgments, and product reviews.

By the way, these online explorations will also demonstrate the abundance of tutorial and learning information on the full range of post-processing software applications. You'll probably be surprised by the considerable time and learning curve commitments taken for granted by the tutorial offerings for packages such as Photoshop and GIMP. This type of online content certainly affected my own decision when deciding between learning Photoshop in 27 (or more) lessons and the abbreviated DPM learning commitments described at webpages such as the following:

- graphicssoft.about.com/u/ua/freesoftware/freephotoeditwin.htm *About.com* page of user-recommended photo-editing tools, with strong emphasis on ease of learning and easy program use.

- dottech.org/91806/windows-review-retouch-pilot/ Dottech.org review emphasis upon Retouch Pilot ease of use and its excellent "live" online tutorial demos, available instantly from the program window.

- www.theinpaint.com/tutorials.html *Inpaint* vendor site tutorial guide to the various software functions. Demonstrates the significant image corrections that can be made using a minimum number of keystrokes.

I began my personal exploration of digital photo post-processing software by looking for an easier way. My searches quickly located the kinds of DPM product reports I've covered here. The material I found online encouraged me by demonstrating the relative ease of use of DPM products and the acceptable image quality I would be able to obtain by using them. I haven't been disappointed with my post-processing results in the three years since I began using DPM, and I don't think you will be disappointed with your results, either.

Practicality

As a reality check, it's important to recognize that DPM won't instantly transform you into a skilled image restoration artist capable of expert-level retouching work. You simply can't advance immediately to duplicating the hard-earned skills and high-quality output of experienced professional retouchers.

That said, neither will DPM stop you from doing excellent photo-retouching work with a minimal amount of practice. Consider that I created some of the before and after post-processing examples presented in the book after having used DPM software for just 3 months.

A well-developed visual sensibility and a creative aptitude are key components of the professional retoucher's skill set. But perhaps even more important is dedication to the hard work of learning and mastering a number of very demanding software applications and working processes. However, for a beginner, these new DPM tools will eliminate a great deal of the learning time and practical experience required in an earlier era. DPM software makes this possible by using post-processing technology horsepower to leverage your innate visual sensibility.

With a bit of practice, your retouching work should soon meet the minimum quality demands of your library, museum, school, or archival institution in the production of images for reports, publications, PowerPoint presentations, exhibits, and displays.

What I call the DPM "good enough" approach comes from what many management types refer to as the "Pareto Principle," or the "80:20 rule." This rule of thumb states that in most tasks or projects, 20% of the effort accomplishes about 80% of the desired results. The rule further concludes that striving to achieve that elusive remaining 20% of quality or results will wind up adding another 80% to the project's cost and effort. In other words, pursuing further steps in quality improvement leads to an increasing amount of effort in order to gain ever-decreasing results. Striving for perfection—going for that extra 20% or that last 5% of quality—may be an honorable goal, but it's going to cost you dearly in added time, effort, and expense.

I view DPM processing as a prime example of the 80:20 rule. Taking a pragmatic, results-based approach, when using DPM I recommend you observe the following guidelines:

- Decide at the beginning what's "good enough."

- Identify the important stuff that really needs doing.

- Do that stuff well.

Many people sum up this commonsense outlook as follows: "Don't let the perfect get in the way of the good." It's a rule of thumb that I certainly recommend for most, if not all, of life's endeavors.

User Requirements

The level of photo retouching and restoration in which you engage should be based on customer or user needs, so it's important to consider and address these needs early on. At the outset of a project,

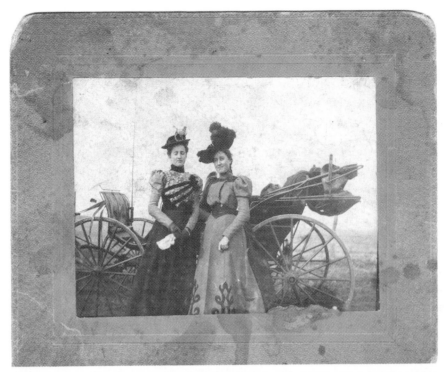

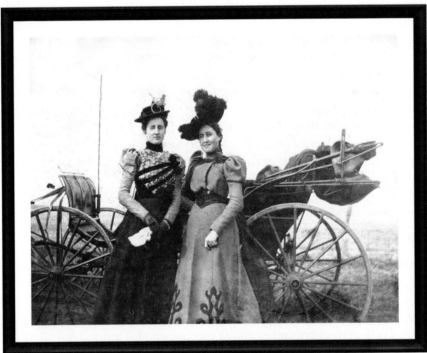

Figures C,D. "Don't let the perfect get in the way of the good." Here's an example of what you can accomplish in 10 minutes or less using simple photo-editing tools. (Restored family photo of Jessie Anna Gordon, at left; St Joseph, Missouri, 1898.)

begin by identifying and clarifying output quality issues. A prudent and inclusive planning process will address the concerns of all levels and types of customers involved and will subsequently be discussed with all appropriate managers and decision-makers**.**

There's a wide range of user need levels: restoration of cherished personal family images; reproduction of rare historic illustrations; restoration of important cultural or traditional images; depiction of the history or development of particular practices or processes; promotion and marketing of library, museum, or archival collections and services; and, probably most demanding, the production of high-quality images for publication or exhibition purposes.

Such varied requirements have to be located or defined on a sliding scale. Are you working to produce a good-quality photographic print, a fine-quality 16×20 photograph for display, a displayed or projected PowerPoint image, a webpage image, or a print or digital image for exporting into a printing or publishing process? Each of these possible uses will involve markedly different quality concerns and end product specifications.

For example, 300 dpi generally suffices for producing a quality glossy print of 8×10 or smaller size, whereas 72 dpi is considered satisfactory for electronic image display, this being the current resolution limit of a computer display. The size requirement for a print is usually a major concern. A high-quality 11×14 print requires 600 dpi; a 16×20 print calls for 600–1,200 dpi.

The variability of this sliding scale brings us right back to the "perfect versus good" guideline I mentioned earlier. Remember: First, you have to get everyone involved to agree on "what's good enough." Then you agree on what things are "the important stuff that really needs doing." Then it's time for the execution or production phase, during which you "do that stuff well."

It's a shared responsibility. Your end users must be clear about what they need. And you, the "in-house post-processing expert," must also be clear about what you honestly think you can accomplish. Reality must come into the negotiation; it's pointless to work to meet unrealistic objectives—or to put lots of work effort into a hopeless task. That said, you can see it's mostly a matter of getting everyone on the same page.

After that, it's going to be much easier to do the right stuff and to do it well.

DPM—What's In It for Libraries, Archives, Museums, and Schools

Why should busy working professionals in libraries, archives, museums, and educational institutions consider adding editing, or "post-processing," of photographic images to their workloads? There's only so much time in the workday, so why even *think* about increasing your duties and responsibilities with additional work?

The answer is simple. Digital Photo Magic (DPM) is easy to learn and use, a low-cost approach to digital image retouching and restoration that can pay off big in improving the quality of the images your institution uses, shares, and archives. For almost any presentation or exhibit, using DPM is like putting icing on the cake. You'll gain an extra special edge of presentation quality that can instantly enhance your output and upgrade a surprising variety of projects.

DPM Benefits Summary

DPM is a cheap and easy, yet effective and productive, approach to retouching and restoring digital photo images. It improves the appearance, usability, and visual impact of photographic and other images used in your informational and educational work. With just a bit of practice, you will find that DPM is among the simplest, fastest, and most practical approaches for improving the quality of your institution's photographic images.

A number of factors make DPM particularly useful in the cultural and teaching environments which I emphasize in this book. I'll summarize those factors here and follow with detailed analysis and comments in the section on expanded DPM analysis.

- *Capital and operational economies*—A large startup investment in computer and electronic hardware will probably not be necessary. Today's average institutional or office working environment should constitute an adequate working setup. DPM operations should thus add a little or no capital or operating expense to your budget. DPM *will* add a little staff labor expense, but this should be relatively minor unless—until—your organization experiences a robust and growing demand for the new photographic services. Many institutions would find that as a good problem to have.

- *Low learning curve*—DPM gets an A+ in this area, avoiding the often expensive labor and time commitment required to learn complex professional software products such as Adobe Photoshop or GIMP. Selecting easy-to-use DPM software tools simply eliminates "rocket science" user requirements. Aimed mainly at the interested hobbyist market, free and inexpensive DPM technology can and does produce high-quality photo images.

- *Personal skills and productivity*—Photo-editing expertise is a valued and relatively uncommon skill that can help employees expand the breadth and quality of their job performance and increase their productivity. Perhaps surprisingly, any competent computer user can quickly learn to use DPM. If you have mastered spreadsheet or word processing applications, you should have little trouble working with DPM tools.

- *Pinpoint precision image control*—I refer not to the digital camera's fine-focusing capability here, but rather to DPM's ability to produce precisely top-quality informational photo images needed by a user or organization. With DPM, it becomes easy to make cosmetic improvements, correct imperfections or damage, and markedly improve poor lighting or contrast in any photo image. DPM provides the capability to change an image so that you get just what you need.

- *Copyright area clarity*—Yes, there are legal constraints over the use and manipulation of photographs, and your institution needs to understand and respect the copyright rules and restrictions governing the images you will be using. Find these regulations, then produce and follow clear guidelines and decision aids for your staff that will provide easy and reliable warning of possible violations. Numerous publications and websites can aid in this area; some good resources are identified and listed in the "Expanded DPM Analysis" section of this chapter, under the heading "Copyright and Legal Area Clarity." After identifying potential copyright liability, seek guidance and legal advice as necessary to avoid or resolve problems.

- *Copyright licensing economies*—Significant usage fees are often not required for libraries, archives, museums, and educational institutions. Educational, public, and nonprofit agencies often have a valid legal defense under the fair use exceptions delineated in U.S. copyright law; this means that in general, such institutions are often not burdened by the licensing fees that normally apply to for-profit corporations. To maximize these savings, establish and follow a usage policy designed specifically to reduce copyright expenditures.

- *Fee waivers or discounts*—Many copyright owners will either waive or greatly discount their licensing fees for educational or nonprofit use of an image or collection, usually in response to a request by the user that includes an assurance of proper source credit.

- *Public domain materials*—Internet access to the enormous resources of graphic image materials in the public domain will result in no licensing costs for internal users, external users, or departments. (Detailed coverage of the public domain topic begins on page 15.)

- *External users or external units*—If we are providing photographic materials for the use of another department of our agency, or for external users of our services, then our own operation or unit is not responsible for any copyright licensing costs that may be incurred.

- *Legal and ethical concerns*—Prudent professional and organizational policy guidance is important in the broad area of ethical practice. Major concerns in this area include legal exposure to charges of fraudulent, deceptive, or malicious intent in altering an image; need for model or other personal releases; invasion of privacy; copyright infringement not defensible under fair use provisions; straying past accepted standards of professional practice; and copyright or legal violations. Many potential problems can be identified and addressed ahead of time by consulting authoritative government and professional publications and policy statements. Although not all questions that may arise are clearly defined or settled, it is advisable for organizations to have an institutional guide or checklist in place to cover the most common issues. Such a guide will be helpful to both staff and end users, and although it may not offer definitive answers to complex legal questions, it should provide sensible advice in regard to help identify potentially sensitive situations.

Expanded DPM Analysis

In this section, I'll provide expanded analysis and commentary on the topics outlined in the preceding section.

Capital and Operational Economies

It's unlikely that you'll incur any significant expense starting up your DPM operation. You probably already have the necessary computer, digital camera, scanner, and printing equipment in your office or elsewhere in your organization, and DPM software is inexpensive—even free. Your potential DPM staff "expert" practitioner already likely has the required workstation equipment, meaning that he or she can get right to work using DPM technology. An alternative approach is using shared or networked access to hardware or arranging simple physical access at some nearby location in the organization.

You probably won't incur any significant supply expenses, either—not in today's post-darkroom photo environment. Photographic-quality print stock and high-quality black-and-white and color inks are just about your only incremental expenses. *Consumer Reports'* "Printer Buying Guide" (Consumer Reports, 2013) reports that for most printers, "printing a 4×6 color photo costs about 25 cents, and the cost of printing a color 8×10 photo ranges from $1 to $2 or more, including ink and paper." That's bargain pricing for a good-quality color photo print. So if you make high-quality photographic prints yourself, in your office, it's certainly won't be a budget buster. But even if you don't have workplace access to a good color printer, it's still not a large expense item if you opt to use 8×10 color photo prints costing $3–$4 at your local pharmacy, office supply store, or big-box retailer.

Of course, most library, museum, archival, and educational projects won't require the production of large quantities of quality photo prints. (And if patrons or end users require prints, in many cases the cost can simply be passed directly to them.) Many of your DPM photo images will be regularly handled in electronic format, helping keep costs low. It's common now for direct digital file export to be preferred when providing images for publications or websites. Furthermore, *Consumer Reports* points out that a medium-resolution quality color print on plain paper is suitable for a great deal of production work: In other words, use the most affordable printing options whenever possible, and save the "pretty printing" for when it's actually needed—for example, for displays and exhibits.

One potential cost I'll mention here is an optional investment in a color ink jet printer capable of producing oversize photo prints—that is, prints larger than 8×10. Such printers can be a bit pricey, so you can expect to pay a premium for the ability to output good 11×14 or 16×20 prints. However, in most institutional operations the need for producing outsize prints may be infrequent. You'll have to make the decision depending on your particular needs.

You can always outsource the occasional enlargement, of course. Commercial labs can produce an exhibition-quality 11×14 for $5–$10, or a 16×20 for $15–$20. And don't forget about the bargain photo service outlets, such as Costco or Walmart. They offer 12×12, 11×14, and 12×18 enlargements for $3! I've personally not been unhappy with the quality of these enlargements, although I have occasionally requested (at no cost) second tries of prints to get a more pleasing version. Although we're certainly not talking about archival quality here, you may often be satisfied with bargain prints. At those kinds of prices, why not give them a try?

Copyright Licensing Economies

When thinking about how to reduce your institution's copyright licensing expenses, the first thing that may come to your mind is using more images that are royalty-free. Make this a routine approach

by taking full advantage of Google Images, which allows you to search for and instantly find photographs on practically any subject. While writing this, for example, I searched Google Images for a photo of a vintage 1946 Ercoupe private airplane, and hundreds of suitable images almost instantly appeared. A single click on a promising thumbnail immediately brought up an enlarged view, along with a bit of detail about the image—including a "Visit Page" link directing me to the original publication image.

All you need to do is follow the link and do a bit of work to contact the source. (Happily, photos are increasingly being annotated with handy email or telephone contact information.) Then ask whether you can use the photo, explaining (if applicable) that it's for nonprofit use, assuring the copyright owner of a prominent source credit or copyright notice. In my experience, it's usually quite easy to request and receive permission at no cost, especially when you are making your request of a private individual, community organization, or any nonprofit or for-profit firm that welcomes the source notice publicity opportunity.

Best of all, at the very beginning of your search, the Google Images advanced search function lets you specify the "usage rights status" of displayed images. Among the four, standard categories are "labeled for reuse," and "labeled for reuse with modification." This will aid your searches.

Other free or inexpensive image sources include local or national newspapers, corporate PR departments, and governmental agencies at all levels, especially legislative offices (always especially eager for public credit—and they have the leverage to get government photos for you, and very quickly). Even though some of these sources are not nonprofits, they all have a shared thirst for publicity and are often amenable to granting such requests to nonprofits. If you happen to ask a corporate source and your use falls within legitimate nonprofit guidelines, you might even point out that they can turn the waived licensing fee into a tax deduction. (Imagine that—a corporation can take a tax deduction for *not* doing something!)

As another cost control consideration, in our new digital image environment, you will rarely, if ever, need to request or pay a provider for a hardcopy print or photo negative, as was once customary. Now all you need is a digital format image file attached to an email message or placed on a cloud server. Free permission plus instant gratification—what more can you ask?

Significant operational economy is possible by a consistent routine of doing "free image mining" of online archives, other Internet sources, and appropriate local collections with the goal of locating useful royalty-free and public domain image resources. When you prepare formal policies and document your procedures, stress routine use of this "free image mining" approach. You want to make this essentially automatic in your operation—it pays off handsomely.

A general Google search for royalty-free images returns some 35 million results. Overwhelming, yes—but the Google ranking algorithm will show you instant evidence of the huge choice of free and commercial royalty-free image sources. Many of the commercial photo services and stock photo agencies actually offer a limited introductory number of freebie or bargain-priced images as loss leaders—handy, since you're probably not actually trying to obtain large numbers of photos. These royalty-free photo services make their money by charging for subscriptions or downloading of image files and charge no royalty fee for image use or publication. There are seemingly endless opportunities to find just what you need using these services. Keep in mind that many professional sites, museums, historical societies, private collectors, county records archives, and the like offer royalty-free photo collections:

- [Commercial] 123RF: Free Royalty Free Photos, Pictures, Images and Stock Photography (www.123rf.com/freeimages.php)

- [Commercial] ClipPix ETC: Educational Photos for Students and Teachers (etc.usf.edu/clippix/)

- [Commercial] Fotosearch.com: Stock Photography (www.fotosearch.com)

- Free Technology for Teachers: 9 Places to Find Creative Commons and Public Domain Images (www.freetech4teachers.com/2011/06/9-places-to-find-creative-commons.html#.UpVCF-Kd6fU)

- Hennepin County Library—The Minneapolis Photo Collection (www.hclib.org/pub/search/MplsPhotos/)

- Library of Congress: Prints and Photographs Online Catalog (www.loc.gov/pictures/) An enormous collection, with royalty and copyright restrictions always noted.

- Oregon State Library: Historic Photo Online Archive (photos.lib.state.or.us/exhibit2/vextitle2.htm)

- Salem Public Library: Historic Images of Oregon (photos.salemhistory.net/)

- Teacher Tap: Visual Resources: Photos and Clip Art (eduscapes.com/tap/topic20.htm)

Copyright and Legal Area Clarity

It should go without saying that you must always resolve copyright and related issues *before* using anyone else's image. As a legal and administrative matter, rather than a photo-editing concern, this particular activity is beyond the scope of *Digital Photo Magic*, but I will offer a few recommendations for your consideration. I am not a lawyer and none of my comments or suggestions should be mistaken for legal advice.

The Internet makes it easy to find simple, clear, and understandable copyright law information. The U.S. Copyright Office (www.copyright.gov) is the primary and most obvious source. Its website offers accurate and current information about copyright law and easy access to downloadable forms and documents.

Many other informative websites can help on this topic. A simple Google search for "photograph copyright" returns dozens of links to reliable sources. (And also, no doubt, to questionable information sources.) If you are in the position of reproducing images originating from outside sources, please remember that you must perform due diligence in evaluating the copyright status of those images.

Several handy online information sources at the time of this writing include the following:

- *Photography, Copyright, and the Law* (blog.kenkaminesky.com/photography -copyright-and-the-law) A brief, yet authoritative, overview summary of photograph and image copyright law. This concise blog post is based on an interview with photographer and attorney Carolyn E. Wright, a copyright specialist who literally wrote the book on photography law, *Photographer's Legal Guide* (ISBN 978-0-9790353-0-2 / 0-9790353-0-9, also available for Kindle).

- *11 Free Online Copyright Tools for Photographers and Artists* (www.plagiarismtoday .com/2010/06/17/11-free-copyright-tools-for-photographers-and-artists) Author Jonathan Bailey covers 11 free online tools to help you through the maze of photography copyright law. The page includes items on the copyright statute, on embedding ownership or watermarks to identify your own images, and on doing "reverse image search" online

(using an image recognition search engine such as Google to find a specific image, helping you determine copyright ownership)—and even a guide for stopping abuse of your own materials or restorations (cease-and-desist notices, infringement action guides). This site is a valuable resource for people involved with publishing or distributing photographic images in any format—whether hard copy or online.

- *Teaching with Digital Images* (www.iste.org/docs/excerpts/DIGIMA-excerpt.pdf) This is an online excerpt from Chapter 4 of *Teaching with Digital Images*, a book published in 2005 by ISTE (International Society for Technology in Education) covering copyright information and specifically aimed at teachers and students.

Google and other online search engines are well suited to locating specific or detailed copyright information. These search engines also enable you to focus your search on a narrow subtopic by simply adding additional topical terms to your query. Ensure that your query includes terms specific to your topic and your copyright and usage questions and concerns, including—for example— originating copyright owner, company, and activity. Effective Google queries include "copyright reprinting," "copyright permission contracts," "federal agency copyright," "grant research copyright," "state government publication copyright," and so forth. If you search for these and similar phrases, I think you'll be impressed by the results.

The *Digital Photo Magic* companion website (www.update4dpm.com) provides a categorized, hyperlinked listing of useful online resources, including a copyright category that will be of interest to professionals actively working in this area. Again, this is no substitute for legal advice.

Low Learning Curve

Adobe Photoshop is widely considered the premier photo-editing application. There are a few challengers to the graphic detail and control made possible by this complex and sophisticated program suite. (If you ever do decide to venture into this industrial-strength professional level of software, you might do well to consider the GIMP freeware package, a respected alternative to the very expensive Photoshop.)

Photoshop is routinely used across a spectrum of disciplines and specialties requiring precise control over graphic images of all types. Specialist users include the production departments of publishing companies, medical practitioners and illustrators, forensic investigators, graphic artists and designers, manufacturing designers and CAD (computer-aided design) specialists, advertising illustrators, website designers, architects, archaeologists, and essentially anyone else working professionally with visual or graphic images (Adobe, 2013).

Photoshop is an incredibly powerful digital image editor, partly because of the precise level of control it gives users. In fact, the expression "photoshopped" has become a popular English language colloquialism, used to mean that a photo or graphic image has been cosmetically altered, often also implying that the modification has far exceeded reality.

Photoshop makes this unlimited retouching or post-processing ability possible with its combination of exquisite control over visual images and effects, as well as the powerful automated image processing it uses to perform seemingly impossible photo image manipulations. Some of these functions seemingly provide the operator the ability to think and command: "Take that stuff that sort of looks like that and change it over to looking like this, and maybe even better, really." In other words, the digital retouching artist can simply tell Photoshop, "Do what I mean"—and the software does it.

The downside of Photoshop's power and complexity is that it's an exhaustively complicated program to learn. Despite all the built-in automation, it makes so many operations and techniques possible that becoming a skilled Photoshop user takes massive effort. Indeed, Photoshop has spawned an entire industry of freeware and commercial support tools, including guidebooks, tutorials, videos, seminars, credit and noncredit courses, and user groups, as well as a legion of third-party developers of plug-ins or support software modules, to further extend the software's power.

Photoshop is certainly not something you can pick up on the fly by just starting to use it and depending upon intuition and good online help to get you by. This level of software requires a serious investment of time, study, experience, and commitment.

I do fully respect and appreciate the power and control offered by Photoshop and GIMP. There are many reasons for the excellent reputations these photo-editing tools enjoy. But I think it's more productive for you to cut your post-processing teeth on some of the simpler DPM-recommended software products. You'll quickly and easily learn a lot about post-processing technology by using DPM tools for introductory photo-editing. You'll gain experience and confidence in the various techniques used in image editing, and this basic or introductory knowledge will make it much easier for you to learn one of the high-end photo-editing tools down the road—if that becomes necessary. It's a little like learning about sports car handling on a Miata or an MGB before graduating to your dream Ferrari or Maserati.

DPM Software Alternatives

I advise that you begin with DPM software programmed in an easy-to-use yet powerful style and with a simple user interface. The simplified or "baby steps" computer tools make it easy to learn the basics of photo-editing. Such an approach provides intuitive controls combined with the power of highly automated functions. This approach delivers the maximum photo-editing leverage to help you achieve the desired results.

PhotoScape, for example (see Figure 1.1), provides many of the functions that appear in programs such as Photoshop and GIMP. In DPM-style applications such as PhotoScape, these functions are clear and obvious to the user. The operations are easily accessible through well-designed menu structures. The program routinely and automatically pops up hints and tips, providing pertinent and essential coaching and user help. These popup guides typically appear immediately after selection of a particular function, keeping you on track by giving you information on what the function or operation does, the shortcut function or command keys for using it, how to change the degree or strength of what it is you're about to do, and even how to easily undo what you've done (oops!).

For example, even though PhotoScape contains the standard Ctrl+Key shortcuts and undo/redo buttons that help you recover from mistakes, it's also comforting to see hints and have instant access to on-the-fly tutorials. These tutorials offer great support for those just learning the craft of photo-editing and the program functions, and they also serve as useful refreshers even for more experienced users. PhotoScape provides you with the photo-editing equivalent of an automatic transmission as opposed to the more effective, but harder to learn, manual transmission you get with Photoshop.

Retouch Pilot is another application whose user interface is designed in the same spirit. At any time, you can simply save wherever you may be in your work and then quickly call up onboard multimedia demo videos of any of the major functions. This is a great help in your moments of—"Oh, yeah, I haven't done <operation X> for a while Hmm, just how was it that I'm supposed to do that?"

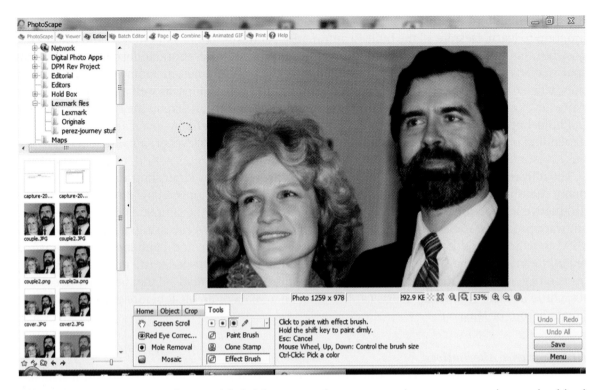

Figure 1.1 PhotoScape's clear and helpful user interface starts with an easy-to-understand tabbed menu at the bottom of the work screen. All menu and command buttons are grouped together at the bottom of the screen. Here, the user has already selected the Tools menu from the Tab headings, then the Effect Brush submenu, and finally the Paint function from a popup list. Brief and helpful usage notes are automatically displayed just below the center of the photo image.

iResizer and Inpaint are two additional specialized photo-editing applications offering similar user help interfaces. Both programs simplify and automate complex image editing operations. For example, iResizer can automatically alter the spaces and ratios between user-designated objects within a photo image. It can completely remove objects or people from the image, seamlessly replacing missing background detail. iResizer makes it easy to change a photo in a rectangular landscape format to a square format image, automatically moving image contents to fit correctly. iResizer can also remove people, buildings, trees, telephones, roadways, and more from an image, seamlessly replacing or filling in the missing background detail.

Inpaint provides more of these same kinds of capabilities. For a preview of its automated functions, check out "Photo Restoration and Improvement Made Easy with Inpaint," at www.theinpaint. com/tutorials.html. And keep in mind that both iResizer and Inpaint offer the same kind of helpful instant tutorial demonstration I described earlier for PhotoScape. It's like having your own coach, mentor, or retouching guru available 24/7, something that's immensely helpful when you're in the midst of some operation and suddenly realize you've lost the thread of what you're doing. Many other DPM applications also offer neophytes instantly accessible tutorial guides or even seamless online connection to full help advice and tutorials.

As an example of how effective these tutorials can be, consider my own recent experience using iResizer to produce a photo image for the cover of my wife's and my 30th wedding anniversary

souvenir scrapbook. I needed to move the two of us closer together (in the photo!) to fit the image into a defined square area. The original landscape image proportions unfortunately included a good deal of space between Sandra and me, and when I tried reducing the photo to clearly show both of us, it resulted in white bands across the top and bottom of the square space. After reviewing the online tutorial, I was able to make the necessary fix in fewer than 4 minutes. The end result was perfect. If you go back to Figure 1.1, you'll see that the top two small images in the thumbnail display on the left side of the photo are the closer-together square versions I made using iResizer.

Within my personal collection of DPM software tools, the PhotoScape freeware is probably my most-used "serious" photo-editing application. Even so, it's only one of a number of excellent DPM software tools we will examine more closely in Chapters 5 and 6.

Personal Skills and Productivity

DPM is a low-investment/high-return approach to expanding the skills and increasing the productivity of a broad range of staff members in your operation. Photographs add value to many types of projects and activities, and you'll quickly find the application of photo retouching and restoration skills far wider than you'd first imagined.

From a human resources point of view, these are terrific staff development skills to teach and learn within an organization. Generally speaking, staff members will find using DPM enjoyable, creative, and satisfying. DPM is easy to learn and produces quick, useful, and highly visible results. Many employees will find DPM proficiency rewarding, not least because of positive reactions from customers and colleagues. In addition, they'll probably find DPM useful in their personal life, including in family, hobby, and community activities—and more. DPM can also represent an external business opportunity for some individuals in light of the growing demand for photo retouching and restoration services.

Using DPM successfully requires basic computer expertise, good eye–hand coordination, and, ideally, a visual or creative bent. Anyone who has a professional certification or graduate degree can benefit from learning DPM, a skill that will present them with an opportunity to add or expand photographic and visual graphics expertise—a useful augmentation to such an employee's expert knowledge. It's also appropriate to assign DPM work to individuals in technical or clerical positions, who may welcome the opportunity to learn new, highly valued computer skills and competencies.

There will be cases in which DPM cross-training or assignment to multiple staff members may also be appropriate. Staff can benefit from working collaboratively with colleagues, both during the formal or informal group-learning process and later, as a shared work activity. Such cross-training adds desirable skills redundancy within an organization, and the collaborative working group approach is an effective means of boosting morale, improving job satisfaction, and increasing productivity.

Personal Skills and Productivity—DPM in Libraries

I've been an amateur photographer since my high school days. But I really became interested in digital photo editing after retiring from nearly 35 years working in libraries, where I spent more than half my career managing editorial library operations for large newspapers. I had the good fortune to actually take part in the transition from the old-time "morgue" clipping file operations to computerized full-text editorial content databases.

But I was also fascinated by the archives-style operations involved in building and maintaining the enormous editorial department image collections. These housed literally millions of photographic prints, transparencies, and photographic negatives. Both as an advanced amateur

photographer and a professional librarian responsible for sizable collections of image resources, I became quite interested in preserving, improving, and restoring photographic images.

In recent years, we've seen rapid evolution of digital photo technology. My previous experience with the old manual retouching methods showed me that the new digital photo-editing tools allowed virtually the same kind of creative control over photo prints and images while having remarkably smaller requirements in terms of time, labor, and expense.

The extensive image collections held in libraries have enormous historical and cultural value. These collections are not meant simply as an exercise in hoarding: They are intended to be seen, appreciated, and used. Improvements in accessibility and usefulness of images can greatly benefit society while also enhancing the stature of the libraries that so diligently curate and maintain such collections.

As part of the background research for *Digital Photo Magic*, I contacted photo collection operations at numerous libraries, intending to identify and document current practices with respect to restoring and retouching digital images. I interviewed photo collection managers at several academic, state, and public library institutions but was surprised to find that no program actively offered digital retouching or restoration services to internal or external users. Here's what I discovered:

1. A few of the libraries responded that individual librarians might occasionally offer limited image correction or cosmetic service. This generally depended completely upon the specific librarian's familiarity with Photoshop or similar tools. There appeared to be no active educational or in-service training efforts in this area. This made for uneven customer service, at best, in promoting the use of photo and other image resources.

2. Many of the libraries partnered with a selected commercial photography service as a means of offering digital photo services to patrons, with any commercial fees paid by the patrons. An example is the Salem (OR) Public Library Historical Photo Collection, which partners with PhotoVision, a local commercial photography service. I spoke with Steven Wood of PhotoVision, who told me that the firm rarely does any post-processing work for library patrons. Their normal minimum service level ($10) covers routine image cropping, contrast adjustment, lighting/exposure adjustment, and preparation of a print or digital image copy. Not terribly expensive—but it's really just about the same level of service that you can expect in the photo department at the drugstore or a large shopping center retailer. More sophisticated image post-processing work is done on a quote-only basis and generally runs $25–$50. (At press time the Salem Public Library printing service was described as "not currently available;" hopefully they are working to restore it.)

3. Many library photo collection departments commented that they'd seen a significant drop in requests for photo prints. Users now instead prefer digital photo files, and they specifically request them. Some of these libraries also depend on the personal talents of the particular librarian on duty, who—we hope—can scan a photographic print or printed image to produce a digital photo image. Most users are satisfied with scanned JPEG files, though TIFF files are actually a preferable starting point for use in most reproduction processes.

4. Most of the libraries have no professional staff member who has significant knowledge of digital photographic technology. In fact, several of the libraries depend on volunteers to manage the photo collection. At one of the libraries, a volunteer was the person who actually organized the photo collection and storage system.

Only within the last 20 years has digital photo technology become the driving factor in the photographic industry. This has occurred in both camera hardware and in photo-editing applications. As I assert frequently in this book, early generations of photo-editing software have been characterized by complicated and demanding high-end programs such as Photoshop and GIMP. Fortunately, we now have a range of easy-to-use DPM alternatives available.

Critical Observations about Library Photo Collections

My informal survey of the current state of library practice in the management of photo collections yielded disappointing results and suggests a significant need for improvement. I offer here a list of critical observations that I believe merit consideration by library managers, graduate library school programs, and responsible individual professional librarians.

The *casual and disorganized approach to the management of library photo collections* is evidence of deficiencies in library education and training. This profession is, after all, devoted to the storage and retrieval of information. Visual images certainly are part of that spectrum.

Improvement and standardization is urgently needed for photo collection management systems, collection organization, retrieval technology, and end user collection access software. There are established systems and protocols available throughout the country for just this. Good examples may be found and studied at newspapers and other media organizations, commercial photography sites, wire services, and local photo processing operations. It is also relatively simple—and free—to use Google to index the online image content of a particular collection, offering easy user access, descriptive text and data field searching, and even image recognition searching at no cost.

Library managers and educators must require higher skill and training levels for professionals working in the photographic collections area. By way of contrast, we don't employ librarians who are not professionally up to snuff in specialized reference fields, online information technology, or the use of print and online indexes.

Photo collection library services need to catch up with digital photo technology. The current head-in-the-sand approach feels equivalent to retaining daguerreotype or collodion-glass-plate negative collection management practices in a silver-print photo environment.

Libraries need to plan and standardize fee-based photo and image services across the board. Many libraries currently "partner" with commercial photographic services for production of user materials from their photo collections. This basically sets up a third-party monopoly with arbitrary pricing for using library collection materials. It also turns over income and potential profit to the favored outsourcing service rather than letting the library generate income in support of its collections.

Cost-recovery pricing of material from intellectual property collections needs re-examination. We don't charge for circulating books (except rental collections). Another conundrum: Current practice often involves charging the same price for both photographic prints and digital photo files. There's no rationale for this. In our current practice, this means a library can charge $10 for scanning a photo print as opposed to 10¢ for a photocopy of a printed page—or nothing at all for an Internet file or online document copied from a library PC to a user-owned flash drive or CDR/W disc. I believe that's simply not justifiable.

Libraries need to study the pricing rationale for user amenities and for planning infrastructure equipment and facilities. We currently provide users with free broadband Internet access, inexpensive copy machines, free pencil sharpeners, and free remote access to library catalogs and licensed databases. Should we not, then, also provide photo collection users with free or very inexpensive multifunction printers that can scan and print black-and-white or color photographs? We should be

able to say, "Oh, if you need a color print copy of <photo X>, you can print a color 8×10 glossy on this printer for 25¢ a print."

Libraries need to further investigate storage and preservation practices for digital photo image collections. We need to arrive at archival best practices that maintain order and accessibility, as well as to ensure that our collections remain viable as image formats evolve and obsolesce over time. We need to develop methodologies for digital format storage, for digital backup security, and for migration of obsolete image formats to current established formats. We must do this to respond to evolving image representation formats, just as we had to develop practices to deal with handling stereoscopic images, tintypes and *daguerreotypes*, nitrate films, and obsolete videotape formats. We need answers to questions as simple as the following:

- Is the photocopying illumination used in scanning silver or digital photo prints destructive to those images?

- Should copying of prints be restricted to digital camera copying using only ambient lighting?

- What are the current archival qualities of digital photo prints?

- Is pigment dye superior to inkjet ink for production of digital color prints?

And there are many more such questions.

As I wrote earlier in this section, my small survey of some sizable institutional image collections greatly surprised me. I have explained that I found practices to be lacking in this area. This somewhat casual approach to photo collection is not surprising in light of the rapid evolution of digital image technology. I anticipate that library and archives professionals will thoughtfully begin to develop more standardized and effective practices in this specialized area.

As I explain in the "Low Learning Curve" section of this chapter, DPM tools enable even technologically unsophisticated professional and technical/clerical library staff to provide high-quality photo and image services to patrons and internal customers. DPM helps knowledge professionals both guide their clients to identifying and locating desired image resources and provide timely delivery of digital files and prints. Copyright licensing matters aside, I believe that the image resources of a publicly supported library should be available to users at reasonable cost, and DPM supports that goal.

Personal Skills and Productivity—DPM in Education

DPM operations can certainly contribute to the adoption and expansion of new technology in modern educational institution operations. A superb example of digital camera and digital image applications is found, for example, at the website of the Forsyth County Schools, in Georgia (www .forsyth.k12.ga.us/page/1543).

The Forsyth County public school system has totally committed to expanded integration of technology to enhance and improve educational outcomes. It has published its intent to lead in the adoption of "a system-wide standard of providing . . . a system-wide standard of providing a 21st century learning environment in every classroom[,] which includes an interactive whiteboard, a ceiling mounted projector, teacher notebook computer, sound system, and connections to the closed-circuit broadcast system, the instructional technology department works with the ITS and Media Specialist to provide professional learning and model best practices in the use of these

technologies. In addition, student response systems in a ratio of one system per six classrooms are available to increase the formative assessment tools available for teachers." (www.forsyth.k12. ga.us/page/1526)

Forsyth County's emphasis includes providing a digital camera for every teacher, along with solid instructional technology and technical support. An active instructional program helps teachers ensure competence in the productive use of their technological infrastructure. Teachers participate in ongoing professional development to experiment, initiate, and create new models of teaching and learning for dynamic and changing curricula. Instructional technology specialists are also assigned to each school, working directly with teachers to help model teaching and learning strategies for technology integration.

The Forsyth.com website previously contained a teacher-directed page (now removed) describing numerous digital photo classroom applications. This page was much linked to by the national education community and was entitled, "Why I Should Use a Camera in the Classroom." It contained numerous practical examples of the Forsyth system's approach to technology support for teachers.

"How can I use a document camera in my classroom?" (www.edtechnetwork.com/document_cameras.html) includes a similar list of recommendations from the Educational Technology Network. The digital photo and video suggestion list section for preschool and primary-level teachers includes items such as show-and-tell, science experiments, photo enlargements of small items to better show detail, documentation of mathematical operation sequences, demonstration of letter formation, display of introductory images to call attention to scheduled topics, teacher modeling of filling out worksheets, recording or capturing classroom or document images for future use, documenting classroom activities for display to parents or beginning teachers, and capturing images for use in PowerPoint or Windows Movie Maker presentations, among many other uses.

Using the Forsyth district model of implementation of digital photos, and wide instructional adoption and support from professional sites such as edtechnetwork.com, it's evident that DPM technology can supplement the generous use of photo images in all such activities. Simple DPM image improvement tools will ensure that the images are not amateurish or mediocre, also reducing time, expense, and necessity for restoration or re-creation of desired photographic images.

DPM processing should be valued within the educational professional mainstream, as demonstrated by increased attention to the use of photo image teaching materials by professional groups and educators. The use of digital photos and other visual images in the wide range of communications, exhibition, display, instructional, informational, and publications applications in the teaching field has received wide attention within the community. By way of illustration, searching the website of the International Society for Technology in Education, www.iste.org, for "digital camera" produces more than 6,000 results.

DPM Online Resources for Professionals
Beyond primary and secondary education, training professionals and a variety of organizations and groups are actively developing educational offerings and curricula for learning in the visual image and photo-editing areas. A collection of links to online resources for library, archival, museum, and teaching professionals is available on the DPM companion website.

Pinpoint Precision Image Production
This brief explanatory note clarifies my terminology in the earlier summary list at the beginning of the chapter. I speak specifically of DPM's capability *to improve a single photograph to best fit a user's*

specific need or purpose. A DPM operator or technician works with the intent of improving or restoring a photo, focusing on producing precisely the type of image the planned use calls for. DPM tools provide easy fine-tuning capability to produce just what you want and need when incorporating photographic images in a given project. In addition to the basic photographic operations such as cropping, exposure, and contrast control, DPM adds the power to make quality improvements or corrective modifications to existing images. Whatever the image origin—whether it's a newly produced digital photograph, a file image, an archival or historic photo, or even an image or illustration scanned from some other source—DPM enables you to quickly alter or tailor the image to suit your needs.

Legal and Ethical Concerns

Most information and education professionals are fully aware of the value and benefits of using photographs and other visual images in their work; these are widely documented both generally and within our respective professional areas of literature. It is, however, inevitable that the question of whether and how augmented or altered images should be used will arise, and we need to remain sensitive to such concerns in respect to our professional work output. There are well-founded controversies about the deceptive nature of "photoshopping" images; of photographs doctored into idealized or fantasized depictions of reality; of presenting images of "things that never were," and even things that cannot be.

Photoshopping is now commonplace, with the airbrushed perfection of advertising models and centerfold beauties being perhaps the most obvious example. Concern about the accurate portrayal of visual reality is particularly important when it comes to educational and archival image collections such as those found in our schools, museums, archives, and libraries. Ethical issues are critical to all of us who work for these institutions of culture and learning, both because of our professional responsibilities and as a matter of organizational policy and practice.

Especially in our environments, we are duty-bound to address the question of whether an image is true and accurate or is a modified, perhaps even a fraudulent, copy or version. Copyright law is always the basic legal guide here, but our concern is focused on the professional demands of due diligence. Here, you may be obligated to make an editorial, management, or organizational judgment call, seriously considering a specific legal and policy question.

In archival collections, for example, the prime professional and organizational intent is to maintain a collection of authentic and original materials; if you retouch or modify an original image, you are obviously exceeding the limits of your archival role. Some typical archival examples include the following:

- Newspaper or publishing archives, in which the material is kept not only for information and internal use, but also as "proof of publication." There are legal and regulatory compliance requirements to be met; you obviously can't tamper with the printed record.

- Government archives, in which the integrity of the "real stuff" is strictly regulated—for good reason.

- Special-purpose archives that store medical, legal, financial, insurance, property/title, and similar records.

Even in these formal archival settings, post-processing is sometimes tolerated or viewed as necessary. I discussed this "alteration" issue with retired archivist Virginia Newton (Newton, 2012) of

San Antonio, Texas, whose background includes management at the Alaska State Archives and later at the archives of the Organization of American States (OAS). She immediately confirmed that although an original archival item must always be preserved in its original or pristine state to meet archival collection requirements and policies, she also believes that the retouching and restoration of photographic images is appropriate in many cases. For example, retouching a damaged or defaced historic image or document purely for restorative, cosmetic, or reproducibility purposes is professionally acceptable—in her view.

Summarized, Newton's interpretation and practical guidance is as follows:

1. Never modify or make changes to any original print or image, but confine post-processing work to digital or photographic copies of the original.

2. Never present an image as the authentic original unless it is *and* you can prove it.

3. Take the prudent precaution of clearly labeling or identifying a post-processed image as a "restored" or "altered" copy.

4. Always require printed credit for an image from the archival collection, and ensure prominent notification of any alteration or restoration to the original image that may have occurred.

Beyond applying professional ethics as your guide, your own organizational and legal policies must, of course, always be paramount in this area of ethical concern.

Journalistic Accuracy Concerns

The "reality" controversy extends to the use of altered images in "real" journalism. News publications, broadcasters, and other mass media outlets must especially avoid the modification of photographic images in their editorial products to preserve their implied validity, accuracy, and credibility. Most publishers certainly want to avoid giving any impression of trying to change or rewrite history, but it can happen.

A classic example of photographic historical revisionism is the well-known Soviet alterations whereby which likenesses of Leon Trotsky and others were removed from photos that showed them in the company of Joseph Stalin.

A more recent American example of this same revisionist issue was *Time* magazine's alteration of a police mug shot of O. J. Simpson, used on the magazine's cover of June 27, 1994. Simpson's face was altered to appear as darker, blurred, and unshaven. The photographer who manipulated the picture said he "wanted to make it more artful, more compelling" (Lucas, 2012), but the point here is that the modified image artificially portrayed Simpson as a more sinister and suspicious character than the original shot might have suggested. *Time* received widespread negative criticism for permitting the alteration and publication of this particular photograph.

There's often a fuzzy line of reality versus acceptable professional photo alteration. Most professional photographers exercise artistic license in making relatively minor cosmetic changes in exposure, brightness, contrast, and minor retouching of unsightly facial blemishes. In many situations, this is considered a normal part of producing a good photographic image or print.

However, we can see television news broadcasters pushing this line daily with their use of "green screen" composite images in regular news broadcasts. This technical effect portrays persons as appearing "on the scene" in front of courthouses, buildings, political conventions, bookshelves,

stormy background scenes, or background cityscapes, whereas in reality they are in a studio, posed in front of an artificially generated background. Another example of this televised "artful deception" is the substitution of better lit, more flattering or attractive close-up shots of interviewers or interviewees asking or answering questions—shots that were actually taken on location *after* the actual interview was completed. I personally don't think it's right that a "hard-hitting, on-the-scene" investigative reporter or broadcast news team should have the option of splicing "Question 4, Take 3" into an interview and then representing the video as reality—but, for all I know, it may be within established broadcast guidelines.

In contrast, we expect this kind of artistic excess when employing a local portrait or wedding photographer. They certainly don't represent their idealized portraiture or dreamy, romantic representation of a wedding event as anything remotely resembling reality; we all know and accept that it's essentially a staged representation of a memorable actual event.

And then there's the case of "serious photography." Surely, we expect authenticity from photographic masters such as Ansel Adams, Edward Weston, Robert Capa, and Dorothea Lange. Those greats may not have employed a great deal of post-processing in their work, but they were all pre- and post-processing geniuses in their mastery of photographic technique. They controlled and manipulated exposure times, lens f/stop settings, and burning and dodging (deliberate over- and underexposure of smaller areas within printed images).

But even in serious photography, it's expected that a photographer will make efforts to remove dust and spots—maybe even an intruding housefly—from an otherwise gorgeous image. Furthermore, we don't criticize Mathew Brady for meddling with reality in his Civil War depictions. We all know that he was restricted to staged after-action scenes, when he was able to set up his bulky view camera equipment along with all the apparatus needed to support his wet collodion glass plate negative processing. His technology didn't give him the luxury of being a realist, as are modern combat photographers, but we knowingly accept and respect the validity of his photographic representations.

In any case, digital image manipulation technology has completely changed our view about the dependability of photographic depictions. As recently as 1932, Ansel Adams wrote that "the camera is incapable of synthetic integration" (Brower, 1998, 94). In his 1998 *Atlantic Monthly* article, Kenneth Brower noted, "Synthetic integration . . . is now [actually] full upon us. . . . More and more digitally-doctored images are appearing in the media." Brower further concluded, "Digital technology now allows photographers complete freedom to rearrange reality according to their whims" (Brower, 1998, 111).

We must allow that retouching and restoration is completely legal and appropriate in many everyday applications. Perhaps television "virtual reality" and fine-art photographic printing are concerns distinct from the responsible use of post-processed images. But I think we must pay attention to ethical concerns about the alteration of reality, because we have the responsibility to evaluate it in the contexts of both our particular projects and our specific professional environments. Thus, when there's a question of using altered photo images, you must be guided by your personal ethical standards, the policies of your organization, and any statutory and regulatory law that may apply.

Journalistic Policy Models

It is instructive to examine the question of professional practice in the area of journalism. This industry predictably shows a wide spread of ethical practices in the use of post-processed images. University of Miami faculty member Michelle Seelig conducted a case study of photographic

retouching practices at the *Philadelphia Inquirer*, which she published in *Visual Communication Quarterly* (Seelig, 2006). She observed, "With recent developments in photographic retouching and refinement, such as airbrushing and digital imaging software, and as laypeople learn they are capable of manipulating images, the construction of photographs, including news photographs, has become a matter of popular public discourse."

The *Inquirer* cooperated fully in Seelig's analysis of their practice, which covered their use of photographs from 2001 to 2003. Her examination of the newspaper's photo archives revealed that a significant number of photographs from the 1950s–1970s had been hand-retouched or airbrushed, including by adding and deleting backgrounds and even removing persons from photos. Seelig reported that these altered photos were often published with no printed notice of the changes that had been made. She documented an organizational sea change in the 1980s, resulting in a written policy being inserted into the *Inquirer* style manual late in that decade. The new policy stated that under no circumstances were photos to be manipulated. This explicitly included prohibition on sharpening and blurring images, deleting and adding information, coloring specific elements in an image, and distorting or stretching images. Seelig commented that, "This new policy was put in place by a person who believed that regardless of what the technology can or cannot do, you do not manipulate a news photo" (Seelig, 2006, 18).

In her 1987 paper, Sheila Reaves of the University of Wisconsin–Madison reported on her early investigation of the ethical concerns arising from the new digital publishing technologies (Reaves, 1987). She selected the *Santa Ana* (CA) *Register* (circ. 300,000), the *Chicago Tribune* (circ. 755,000), and *USA Today* (circ. 1,352,000) as a representative sample of the industry. She interviewed at least two senior editorial managers with photographic responsibilities from each newspaper, as well as three former presidents of the National Press Photographers Association. Her findings revealed many similar views on the topic of photo alteration, as well as some surprising disagreements.

Reaves's interviewees were unanimous in their support of minimal post-processing of news photos. They agreed on the propriety of cropping, burning, and dodging but stated that reversing or flipping images, changing or deleting backgrounds, and splicing together different images were all unacceptable practices. ("Reversal" means inverting an image left-to-right, resulting in text and left/right orientation being reversed; "flipping" means inverting the image top-to-bottom, with the new image appearing upside down, but not reversed.)

Writing about the ethics of editorial responsibility and commitment to truth, Reaves quotes the late Robert E. Gilka, one-time director of photography at *National Geographic*, from a *New York Times Magazine* article. Gilka, referring to the retouching and manipulation of news photos, said, "It's like limited nuclear warfare. There ain't none" (Reaves, 1987, 43).

Perhaps surprisingly, a number of Reaves's interviewees felt that a strict prohibition on using altered photographic images should be limited to a newspaper's news department. These editors felt that feature photographs could be responsibly post-processed. One individual noted that although his news department was opposed to any alteration or manipulation of photos, his features and advertising departments openly supported the practice, the reasoning being that these latter divisions are not represented as providing factual reporting, but rather as entertainment, enjoyment, and diversion.

Some of the examples given of acceptable alterations outside the newsroom included the changing of background color in a fashion photo, substituting background imagery to fit a story concept, introduction of cosmetic changes such as removing background clutter, and retouching facial blemishes. The editors agreed that splicing photos to produce collages or constructed images for use in

feature sections was also permissible, because it was obvious, purely stylistic, and clearly done for illustrative or design purposes. There was general agreement that images of this sort are not intended to represent reality, and that readers understand and accept the practice.

These interesting points demonstrate the breadth of interpretation possible among experienced and responsible media professionals, as well as a number of areas in which there is agreement. Although I understand their reasoning for a "sliding scale" of ethics, I recommend caution and alertness to gray areas. Take sports page photos, for example: Are they provided for news, or for entertainment purposes? What about fanciful images cobbled together to accompany a story about winter blizzards or global warming? What of the book review section? The cooking section? What properly distinguishes the acceptable use of enhanced or subtly exaggerated "illustrations" from that of unambiguously fictive cartoons and caricatures?

As we have seen, a wide spectrum of policy views and practice exist in the American media, ranging from no alteration whatsoever to minor cosmetic alteration to improve the general visual appearance of an image to playing fast and loose with image modification. This wide range of practice and policy will probably continue, depending largely on how individual media operations view the editorial accuracy and objectivity of their brands. No federal regulation currently covers this area of practice, but some individual states, regional, and local political entities; nonprofit organizations; and corporations have established their own rules and guidelines.

As an example of an effort to support sound policy in this area, the Photographic Society of America Nature Division (PSA ND) has long observed the rule that "any form of manipulation that alters the truth of the photographic statement" renders an image ineligible for exhibitions or competitions recognized by the PSA ND. This guideline, developed during the silver print era, continues to be widely followed by member professional photographers in respect to their digital work.

The PSA ND has adopted the following short statement into its code of practice:

> No techniques that add to, relocate, replace, or remove pictorial elements except by cropping are permitted. Techniques that enhance the presentation of the photograph without changing the nature story or the pictorial content are permitted. All adjustments must appear natural. Color images may be converted to grayscale monochrome. (www.psa-photo.org/index.php?nature-code-of-practice)

The PSA ND statement is restrictive in regard to any modification of "factual detail" or information content, yet it does not exclude the conscientious use of cropping and other techniques for optimizing image presentation "without changing the nature story or the pictorial content." I recommend this as a responsible model for library, archives, museum, and education professionals working with photographic images.

Automated Detection of Photo Image Retouching

One might think it would be difficult, if not impossible, to determine whether a particular image has been modified, and even more challenging to judge the degree of modification. Surprisingly, this appears not to be true. Dr. Hany Farid and Eric Kee, a Dartmouth University computer science professor and a PhD student in computer science, respectively, have published a paper describing a software approach to conducting this type of analysis (Kee and Farid, 2011).

Farid and Kee recruited hundreds of people online to compare "before-and-after" photo images. They ranked the pairs from 1 to 5, from minimally altered to starkly changed, respectively. The

human rankings paired with the actual final image files were then analyzed to guide the creation of an algorithm that would analyze the modified final images and produce closely similar rankings of the human test rankings. I conclude that these researchers did not measure the degree of change between original photo A and modified photo B, but rather the minute physical post-processing changes to the pixels in the final modified photo. However, I don't believe this is a practical guide for ranking image modification. For example, a post-processing adjustment in brightness level or contrast or the "sharpening" of a blurred image would make changes over a wide area, changing a large number of image pixels. This is actually a relatively innocuous technical *improvement* to an image, not actually something to produce a higher critical ranking level. Humans looking at such an image might easily grade such a post-processing change as an improvement.

Dr. Farid suggests that his software offers an objective practical approach to effective self-regulation by media companies. Professional organizations, publishers, and corporations could evaluate and fine-tune the software performance, perhaps using or developing the resulting ranking scale as a guide or tool for publishing practice. This would be similar to the established media use of objective "reading-ease" or "grade-level" software tools for judging the readability of editorial content. Such software includes the Flesch Reading Ease Formula, the Flesch–Kincaid Grade Level scale, and the Gunning FOG Formula. (For more information, see www.readabilityformulas.com.)

As demonstrated by the preceding discussion, I agree that there is a sensible spectrum or range of allowable photographic image alterations. One must always be sensitive to any possibility of the deliberate and subjective modification of reality or information. It is also important to allow professional publishers or media practitioners some flexibility in editorial control over the appearance and quality of their published products.

Farid feels that such an evaluation tool could easily provide monitoring indices to control or reduce excessive retouching: "Models or photographic subjects, for example, might well say, 'I don't want to be a 5. I want to be a 1.' " (Lohr, 2011) Similarly, an organization might adopt a requirement that its photo-editing manipulation processes not produce a photo with a rating above 2.5, or some other selected level of post-processing.

Neural Network Programs as an Alternate Approach

I think it might be more productive to use the artificial intelligence approach of neural network processing. A neural network program could instead analyze the human-decision ranking values of the "before" and "after" photo images, comparing these to the corresponding actual before and after photo images. The software would analyze all the rankings to the corresponding image patterns and try to construct a "brainlike" reasoning process to approximate the human decisions. It would then run its "best guess" process against the full test set, trying to arrive at the same human rankings.

When the neural network's rankings differed from the human rankings for the full set outside a defined accuracy level, the software would then automatically repeats the analysis, modifying some of the processing details, trying to correct the ranking variances, thereby creating an improved process. This operation would then be repeated over and over again, for tens or hundreds of thousands or millions of cycles (as many as are needed), until the human rankings and computed results are similar within the desired accuracy level.

The neural network approach is literally "machine learning," whereby the computer automatically creates some kind of automated process to mimic the real-life human test data. It thus "learns" how to become an expert at a given process. Humans will have no idea of the details of the automated analysis and operations. If it works, that's because *it just works*. The neural

network creates a "black box" (closed or unknown process) that nevertheless produces the desired results.

Neural networks don't have to depend on "test sets." Many existing business, control, and intricate monitoring and pattern recognition processes are now produced with neural networks that have analyzed years of actual transaction data records or output results. Neural networks are commonly used to evaluate investment strategies, complex manufacturing or production controls and processes, home loan applications, inventory control, insurance actuarial methods, fleet vehicle maintenance and repair, and hospital operations, among many other complex processes.

These neural network operational applications benefit from existing archives of detailed computer records of years of actual practice and results, which provide excellent learning data sets. It is quite productive to let a computer run a neural network application analysis for hours or days or weeks to produce an "expert system" that can perform complex analysis and decisions and match the performance of the enormous historical sets of actual experience. Even the cost of providing a dedicated personal computer or workstation for doing this will only be a fraction of the cost of system analysts and programmers needed to manually devise a comparable "intelligent system."

The neural network approach can thus package heuristic judgments into a fast, efficient, and effective automated ranking tool. Instead of simply calculating "the degree of visual detail postprocessing" in a final image, it would deliver reliable, accurate, and reproducible judgment of the human perception of the degree of post-processing changes. Such neural network post-processing ranking judgments could easily be regularly revised and overseen, perhaps by comparing the choices made professional practitioners or industry representatives working toward a valid professional guidance method.

The Professional's Bottom Line

The Digital Photo Magic approach was designed to help librarians, archivists, teachers, and museum professionals responsibly retouch, use, share, and preserve photographic images in digital formats and environments. In this chapter, we've explored the potential benefits of DPM and considered issues affecting its adoption, including legal and ethical issues that need to be considered. In the following chapters, I cover digital image and post-processing basics, explain specific fixes and results you can achieve with DPM, and introduce a solid collection of free and inexpensive tools and methods for retouching and restoring your valued photographic images and collections.

If you have read this far and still intent on saving time and money while improving your ability to deliver quality results to your users, then read on. The best is yet to come.

References

Adobe, Inc. 2013. "Who Uses Photoshop?" www.photoshop.com/products/photoshop/who#.

Brower, Kenneth. 1998. "Photography in the Age of Falsification." *The Atlantic Monthly*, May, 1998:92–111. www.theatlantic.com/past/docs/issues/98may/photo.htm.

Consumer Reports, Inc. 2013. "Top Printer Reports," www.consumerreports.org/cro/printers.htm.

Kee, Eric, and Hany Farid. 2011. "A Perceptual Metric for Photo Retouching," *PNAS: Proceedings of the National Academy of Sciences* 108(50):19907–19912.

Lucas, Dean. 2012. "O.J. Simpson's Dark Day," *Famous Pictures: The Magazine: Altered Images*, www.famouspictures.org/altered-images/#OJSimpsondarkday

Lohr, Steve. 2011. "Retouched or Not? A Tool to Tell," *New York Times*, November 29. www.nytimes .com/2011/11/29/technology/software-to-rate-how-drastically-photos-are-retouched.html?_r=0.

Newton, Virginia. 2012. Telephone conversation with the author, October 17, 2012.

Reaves, Sheila. 1987. "Digital retouching: Is there a place for it in newspaper photography?" *Journal of Mass Media Ethics* 2(2):40–48.

Seelig, Michele. 2006. "A case study of the photographic principle," *Visual Communication Quarterly* 13:16–31.

Digital Image Basics

Before delving into the specifics of Digital Photo Magic (DPM) post-processing, we can benefit by briefly reviewing digital image basics. A digital image is simply a collection of electronic bits and bytes arranged according to a defined electronic *protocol* or format used for storing visual images. Digital images are not analog images, as were the silver-based photographic negatives of yesteryear. Silver-based negatives were created using a light-sensitive chemical emulsion, spread on a film or glass plate, that captured a small inverted negative image of the original photographic subject. When the film or plate was chemically developed, the inverted negative image was visible to the human eye, albeit much reduced. A transparent photo negative is actually a reversed, miniaturized analog representation of the real photographic subject. Printing an enlarged positive image, or developing it as a positive transparency, produces a recognizable photograph.

In contrast, digital image files use standardized electronic formats, or encodings, to store visual images. A digital image consists of instructions recording the locations and intensities of the colored areas that make up the patterns and shapes in an image. When you open an electronic file to view its uninterpreted contents, you see only the undecipherable gobbledygook of seemingly arbitrary letters and numbers. Because those gobbledygook characters are actually instructions for rendering the image using an appropriate program, such a file must be opened using software designed to translate the instructions into an image that can be viewed on a screen, printed to hard copy, and transferred to other electronic hardware. The output hardware will correctly translate the electronic instructions contained in a standardized format file, in order to produce an accurate visual image.

Many different digital image formats exist, each having different qualities, characteristics, advantages, and disadvantages. Most of these formats are, by necessity, industry-accepted standards allowing for interoperability between digital image creation, rendering, and manipulation hardware—including cameras, printers, and computers—and software. Some widely accepted image formats may have originally been developed by major industry players such as Adobe (Portable Document Format, or PDF) or a professional group such as the Joint Photographic Experts Group (JPEG or JPG). Despite their proprietary or professional origins, such formats are now commonly used throughout the industry.

Cameras must be able to produce image files that are usable across the market spectrum of computer hardware, operating systems, and image software packages. Use of industrywide standard formats enables all vendors to accurately produce, exchange, transport, interpret, process, modify, and store digital image files. Such vendors include printers, typesetters, and other output processors, who must be able to interpret, print, and transfer such images while keeping the output faithful to the original input. Purpose-built hardware units do this using device drivers, self-contained computer instructions that interpret standard image formats into machine instructions used to output accurate images. (This is why you may find yourself directed to install or update your device drivers when you plug a new type of printer or scanner into your computer.)

In other words, my Epson, your Hewlett-Packard, and someone else's Canon printer—hooked up to a computer running Microsoft Windows, Mac OS, or Linux—must be able to faithfully print an image stored in a JPG, TIFF, or PNG file produced by an Olympus, Samsung, Nikon, or Fuji digital camera. This entire collection of hardware and software must flawlessly produce, transfer, process, and render accurate digital images no matter their source—hence the need for standard visual image formats, defined industrywide or by a particular group or vendor. Vendors must create or adopt standard formats to be able to interact across the competitive marketplace. It's akin to the use of various code pages such as ASCII, ANSI, and Unicode—just a lot more complicated. (But, after all, automatically handling all that complicated stuff is what computers are for!)

Origins of Your Digital Image Files

Digital image files come from everywhere—even more so than ever in today's computer-networked environment. Nowadays, the digital image you want to use in your post-processing work can travel innumerable paths from a variety of electronic and network sources. Yes, you might get your image directly from a digital camera's memory or SD card. But you might also access it from your local or personal digital image archive. Or it might originate from a remote digital archive located at an external commercial or license-free archive—perhaps even from some shared remote location on the Internet such as the Facebook, Flickr, Google+, or Picasa networks. You might transfer a digital file using the HTTP or FTP protocols, or you might send it as an email or smartphone message attachment. And you might transfer it using USB, Ethernet, or Wi-Fi connectivity. You may even get it on a CD, DVD, flash drive, or some other portable memory medium, which is often the case when someone decides to donate images to your library or archives collection. (Note that I didn't even get into where any of the remote sources I've mentioned got *their* digital images.)

Scanner Hardware Approaches

Scanner hardware approaches are so common and varied that it's easy for you to use the roll-your-own approach of creating your own digital image file from some existing visual image resource. When you start off with hard copy—say, an existing black-and-white or color photographic print—you can digitize it using either a digital camera or a scanner. The current marketplace offers many economical hardcopy scanners, ranging from $35 to about $150. There are also, of course, expensive high-quality image conversion scanners that can carry price tags in the thousands of dollars.

Some budget-friendly scanners can also digitize color slides and film negatives, many of them priced in that same $35–$150 range. And some of these scanners are dual-purpose, able to produce digital images from slides and film as well as from photo prints.

New Smartphone Film Scanner

A new scan technology was introduced in early 2013 by Lomography, Inc. (microsites.lomography. com/smartphone-scanner). The company's new scanning approach uses a smartphone (including iPhones and many Android smartphones) to digitally scan 35mm film images. The Lomography Smartphone Film Scanner is currently priced at $59.

The device clamps onto a compatible smartphone, pointing the camera lens down into the lower part of the unit. The unit's base section houses the light source and optics, as well as a carrier for

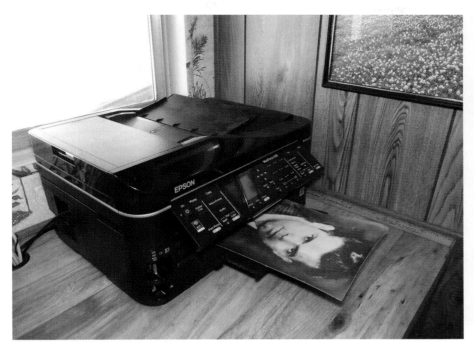

Figure 2.1A My own multipurpose Epson WorkForce 630 All-in-One, which offers print, photocopy, fax, and scan functions. This economical unit can scan photo prints at 50–2400 dpi (9600 dpi interpolated). It also produces good-quality color photographic prints.

Figure 2.1B My own vintage Epson Perfection 1200 Photo Scanner, capable of scanning prints at up to 1200 dpi. This flatbed scanner includes a backlight attachment, here shown leaning on the basket just left of the unit. The attachment is laid flat on the scanner glass, and provides a rear, or "backlight" source that illuminates film transparencies or photographic negatives being scanned.

Figure 2.1C The backlight attachment is shown laid in position at the center of the Epson scanner platform, with a film carrier loaded with 35mm color negatives inserted. A 35mm slide carrier is shown lying flat just below the negative film carrier inserted at the center. Mounted slides or color transparencies can be placed directly on the scanner glass or in a slide carrier like this one.

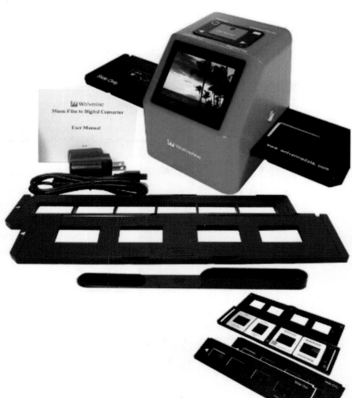

Figure 2.2 The Wolverine F2D20. This economical scanner unit, which scans 35mm images only, scans at up to 20 megapixels of resolution and includes carriers for 35mm color slides and photograph negatives.

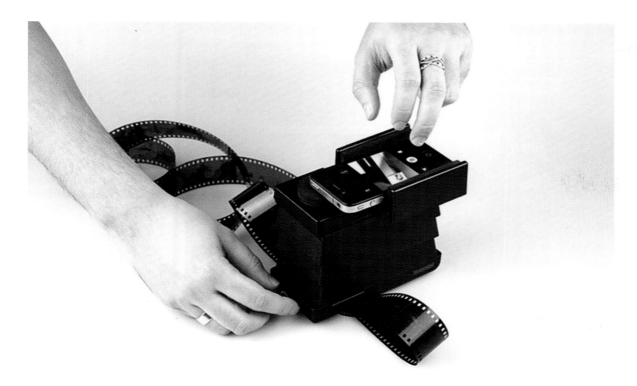

Figure 2.3 The Lomography Smartphone Film Scanner provides fast and accurate digitization of 35mm color slides, color or black-and-white negatives, and even 35mm video film.

holding 35mm slides or film. The phone's LCD display faces the user, clearly rendering the illuminated slide or film negative. You don't need any computer connection: It's a straight image-copying system.

The package also includes an app, the LomoScanner 2, a compact software product offering digital capture and simple digital image editing capabilities. (More extensive image editing capabilities are available with some of the software packages covered in Chapters 5 and 6.)

If you already have an iPhone or compatible Android smartphone, your total investment for this scanner hardware platform is $59. That's a very budget-friendly price point, and it provides you with easy access to digital archives of your 35mm slides and photo negatives.

We'll examine inexpensive scanner options in greater detail in Chapter 7.

Web-Hosted Digital Post-Processing

Web-hosted digital post-processing services expand the spectrum of photo retouching and restoration resources. You no longer need to install an image editing application on your local computer or even to provide your digital image files locally. You may instead use one of the numerous web-based image editing services available for remote post-processing work. Such an approach can eliminate the need for on-site post-processing setups and even for any extra hardware resources.

Figure 2.4 The user interface for Thumba. net, one of the newer remotely hosted services, providing up to mid-level post-processing power for editing digital images.

Using online post-processing services, you can handle a retouching or restoration job by simply sitting down at your web browser, uploading your "disadvantaged image" to the remote site, and handling the image editing work remotely using the interface provided in your web browser. When you're done, you can download the corrected image to your own local storage or even email it to an address of your choice. You can also receive a link, or a URL, from which anyone can download the image. It couldn't be easier.

Actually, it *could* be. When using a web-hosted image editor, you can import images directly from the web, from Google Images or any of many other sources of online images. Now we're talking *complete* outsourcing. But remember that you are still responsible for acquiring all necessary copyright or republication permissions for the image you want to use; as you know, just because you found it on the web doesn't mean you can use it any way you like.

We'll take a closer look at online photo-editing services in Chapter 5, in the section "Online (Web) Digital Photo Editors." First, however, let's turn to Chapter 3 where we'll learn about a range of easy photo fixes.

Photo Image Fixes

There are easy photo image fixes, and there are hard ones. In this chapter we'll concentrate on the easier methods, the 80:20 approaches delivering the most bang for your buck—meaning cheap and easy choices. Think of it as the realm of the possible.

The easy corrective work I cover here will improve existing photo images to render them satisfactory for a specific purpose. I won't be discussing how to *take* good photos, a complex topic that's well beyond the scope of the book.

One important goal of this chapter is to provide a broad understanding of what can be accomplished using Digital Photo Magic (DPM) post-processing software, and I'll begin by briefly explaining and illustrating the cosmetic and restorative horsepower that's available in such programs. I'll cover post-processing methods in greater detail in Chapter 6.

In the following pages we'll take a look at basic and practical approaches to image manipulation, and the tools used for specific operations. I'll also provide estimates on the time it takes to complete the various tasks. These estimates are not for the amount of time you'll need to *fully* post-process a photo image; rather, they're intended to give you an idea of the hands-on editing time required to complete a particular function or operation.

Of course, nobody *looks* for images that will require a lot of work: You will always start a project by selecting the best images you can obtain from the resources that are readily available to you. If you find a given image to be subpar in quality or appearance, you indeed have the ability to improve it using DPM tools and techniques, but consider your replacement options before spending time and effort to restore or retouch it. You may be able to procure a replacement image from a colleague, a partner organization, an Internet image search engine, a website, or some other source. Some of these potential replacement images will be freebies, either license-free or with permission freely given. Others may involve copyright fees or publication rights costs. Depending on your available resources (time and money) it may be preferable to pay for the use of ready images than to attempt to post-process them yourself.

After Choosing Your Image

Once you've chosen the best possible starting images for your purpose, your first decision will typically be how to crop them. Cropping simply requires you to select the part of an image best suited to your use and apply standard or appropriate image sizing and ratio choices.

No matter what the extent of the post-processing you perform—whether it's simple cropping or more complex restoration work—you'll need to ensure that the final image size, proportions, and subject orientation align with your image display settings and requirements. (On this subject, while some readers may wish to study image composition, publication layout, and exhibit/display aesthetics, these topics are also beyond the scope of the book.)

Meeting "appropriate" display requirements means that you will always fine-tune image selection, format, and other variables to best suit your final presentation medium and format. There are a wide variety of presentation options, from computer monitors and the Internet to PowerPoint presentations, high-quality photographic displays, and print publications, to name just a few of the possibilities. Specific requirements for photo image size, resolution, pixel count, visual characteristics, color representation, brightness, contrast, and printed output surface texture will vary from one presentation format to another.

Fine-Tuning an Image Is Easier Than You Think

Fine-tuning manipulations are far easier to make than you might think. Photo-editing software technology has advanced to the point where it can automatically apply corrective modifications that take into account all the image display factors just mentioned. We no longer need to rely on skilled human labor to perform darkroom manipulation and retouching work in order to address most image shortcomings.

Using new WYSIWYG (what you see is what you get) photo-editing tools, with their simple graphic user interface (GUI) controls, you need only instruct the software tool to "make it darker," "make it larger," "make it a little more reddish," "crop it differently," and so forth. The software application will pretty much do the rest. With most current photo-editing applications, a computer mouse or interactive digital pen or stylus accessory is all that's needed to seamlessly communicate the operator's intent.

A hyperlinked list of software packages and related online resources is available on the DPM companion website at www.update4dpm.com.

Minor Technical Decisions

While a number of technical decisions must be made by the human operator, many are well within the capability of the beginner. Readily-available instructions along with a bit of trial-and-error experience will help you handle such decisions and tasks as

1. choosing and visibly tailoring an image for reproduction;

2. eyeballing an image to determine the kinds of fixes or corrections that may be necessary;

3. selecting the best digital file format to use for processing and delivery; and

4. selecting the best photo-editing software for a specific post-processing task.

The first two items on the list are the easy ones—foreshadowed a bit earlier in this chapter—and mainly require you to make instinctive or "eyeball judgment" calls. If you've got doubts on either of these points, you can always ask a friend or colleague "Which of these looks better to you?" "Would it be better to have her facing left?" "Does it need to be darker?" and "Does this cropping look nicer than that one?"

You won't need to seek an expert opinion, in most cases—it's more important to get input from the end users of your images: the person or persons producing the publication, creating the display,

making the presentation, and so on. In cases where you yourself are the end user, give your personal preferences plenty of weight.

Most of the photo-editing software tools covered in *Digital Photo Magic* make it super easy to try doing one thing, then another. It's almost as straightforward as trying out different values or calculations in a spreadsheet application. You can quickly produce, print, and save alternate versions of an image. And if your brilliant idea doesn't work quite as expected? Just use the undo button, or press Ctrl+Z, to backtrack to earlier iterations, remembering to delete or discard any digital file or hardcopy version you find less than satisfactory. (Still, be sure to always save a copy of your original image before experimenting.)

The third and fourth items on the list are more techie-oriented. These decisions affect the final post-processed image (3) and the ease and speed of the work required to get the job done (4).

The preferred graphic file format(s) to use (3) is a major concern, but it's actually a simple and practical decision. I've personally chosen to use the PNG format, which provides optimal post-processing quality control. I provide a workflow chart for using PNG to maintain optimal image quality in Chapter 4, and also cover other recommended digital formats.

When I talk about selecting the "best" photo-editing software (as in list item 4), I don't literally mean the *best*; I mean *your* preferred software for a given post-processing task or operation. You won't need an exhaustive comparison or in-depth evaluation to determine which software packages work most effectively. Chapter 5 will steer you to a number of excellent products, as I describe my DPM toolkit favorites and why I like using them, but ultimately it's going to come down to what works best for *you*.

Post-Processing Functional Operations

Post-processing functional operations aren't hard to understand. Photo-editing software does simple, obvious things to modify or alter images. Programs in the current range of free or inexpensive software provide a huge selection of image post-processing functions, but they all pretty much do the same types of things. The photo applications and utilities I describe in *Digital Photo Magic* are among the most productive of these.

Photo-editing software reduces basic functional operations to simple image manipulations and changes using GUI controls; a computer mouse or stylus is a common choice of input device. The programs don't force you to minutely edit an image pixel by pixel, or to apply skilled artistic manipulation to change the image's appearance (although in many cases you can, if you want to). The program GUI generally allows you to accomplish complex post-processing operations by (1) identifying the area for application of a particular operation and (2) configuring the specifications or extent of the desired changes. GUIs generally offer command selection through dropdown menus, mouse selection of image areas, and mouse dragging of visual bars or indicators to configure the operational settings. The final operation isn't generally applied until you issue a "Do It" command by a final mouse click or an "Enter" keystroke.

Even after you've executed an operation, you can usually undo it or backtrack to return to previous stages of the image. This is a WYSIWYG interface, not a command-line experience, supporting the "try it and see" approach pioneered in the spreadsheet genre.

Photo-editing software almost always gives you the option of backing out or aborting in the case of mistakes, so you're in little danger of completely ruining an image or losing your investment in time. Even in the rare instance where you've messed something up and can't use the undo function, all you need do is simply close the file or exit the current editing session *without* saving the recent changes. Then you can resume your work from the most recent "good" version of the file, rather than being forced to start over again from Step 1.

You can reduce the remote chance of accidentally ruining a valued image by following two golden rules: (1) Never work on the original digital image file, and, (2) frequently save your work to disk, using numbered or coded versions of the original filename. Following this approach, you should always begin work using a copy of your original digital file—named, for example, "Dandelion2. jpg"—and proceed by regularly saving an intermediate series of working copies.

I recommend using a sequential series of standardized filename forms and suffixes, such as Dandelion2.jpg, Dandelion3.jpg, and so forth when working on digital files. In addition, develop "naming tags" that flag common steps—variations and operations such as "sharp," "high-contrast," or "cropped." This will allow you to view a file directory of varied original files and versions, along with timestamps, and easily determine the file contents.

How often should you save intermediate versions? It comes down to how much time you are willing to lose in the event of a power outage, computer crash, accidental file deletion, or similar setback. I save copies of my in-progress files every 5–8 minutes. By regularly clicking the "save file" icon or pressing Ctrl+S to save a backup file I put myself in a position to chuckle if—or rather *when*—a loss occurs. However, whenever I've finished a significant editing operation, something representing a major stage of revision, I use the "save as" command and save the file under a new name, using the iterative naming methodology described above.

Full Image Modifications

Full image modifications are broad post-processing functions applied to the overall or full photo image. Many can be applied to a smaller selected or defined area. Software packages commonly name or label the localized application of these effects as *filtering* and refer to the menu command choice as *Choosing a Filter*. The following list provides some examples of common post-processing software tools or functions. Individual software packages offer many variations on these kinds of editing operations.

Cropping the Image

Cropping an image trims or removes unwanted boundaries or edges from an image. You generally do this to better fit the image into a standard print or display size and format, to emphasize objects in the photo, or to focus visual perception of the photo subject. The user generally selects the area that will remain by using the mouse to move dotted-line trim boundary indicators. After the image dimensions are acceptable, a mouse click then issues the final cropping command. Cropping establishes not the actual print image dimensions, but rather the ratios used for the image's width and height. The print may vary in actual size but will retain the desired display ratio.

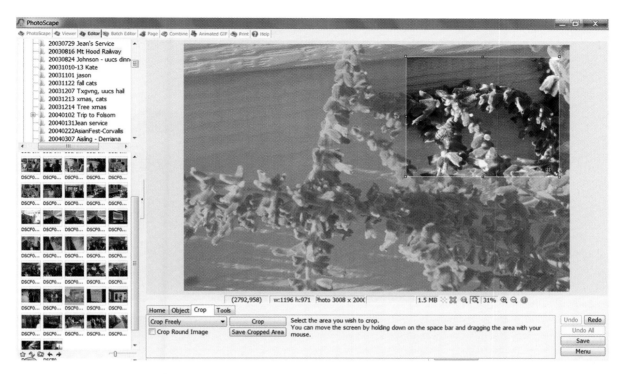

Figure 3.1 In most photo editors, you hold down the mouse button to "draw" the cropped area, and to adjust the area size or position. Approximate selection and cropping operation time of 5–10 seconds to crop this image using PhotoScape 3.6.3.

Resizing the Image

You can resize a digital photo in two ways: (1) Use the software to change the image's *resolution*, or (2) change the image dimensions by *resampling* it. Image resolution sets the definition of the number of pixels appearing per unit of area. Depending on your location, resolution settings are generally defined as pixels per inch or pixels per centimeter. The pixel display is also sometimes given as "dpi," or dots per inch.

1. *Changing resolution* reduces the size of an image by *increasing* the number of pixels per unit of area. Increasing the pixel count or density places pixels closer together and reduces the size of the image. Conversely, you can increase image size by *decreasing* resolution, or placing the pixels further apart. You won't notice any change in image display appearance on the computer monitor, because monitors normally display images at 72 or 96 dpi. You'll only see the difference when you actually print the image. Increasing or decreasing pixel spacing doesn't normally change the file size, although you run the chance of degrading an enlarged image when you resize using a change in resolution.

2. *Resampling* an image uses automated processing to change the total number of pixels in the image. The software synthesizes or approximates the actual changes or translation needed for increasing or decreasing image size. Resampling is generally used to change the monitor display size of an image or to make an image file size smaller to improve online display speed, email transfer time, and similar productivity gains.

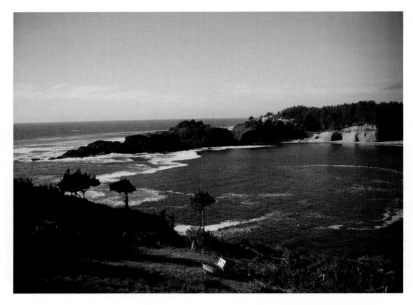

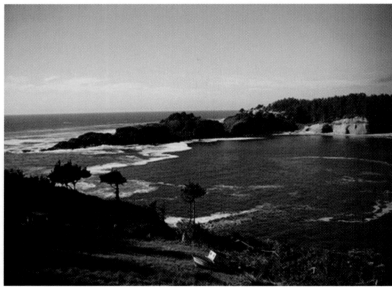

Figure 3.2A,B Resizing a photo—here, changing from 300 dpi (top) to 72 dpi—will speed up online display time by reducing image file size from 1.39 MB to 117KB; approximate setup and resizing time is 30 seconds using Picture Resizer Personal 3.0.5.

Image Rotation

Photo-editing software can quickly *rotate* an image, using 90-degree increments either clockwise or counter-clockwise, or modify from *portrait* (vertical) format to *landscape* (horizontal) format. Photo apps often also include precise controls for small-angle rotation controls. Most photo-editing tools include some level of rotation function capability.

Figure 3.3A,B Rotating a photo; approximate setup and operation time is 20 seconds using Retouch Pilot 3.5.2.

Lighting and Color Modifications

Lighting and color modifications are sometimes needed over an entire image. These functions are used to correct problems such as over- or underexposure, poor lighting, bad contrast, or problems with the tint or coloration of the full image. These operations may also be used to achieve creative artistic effects or to stylize an image.

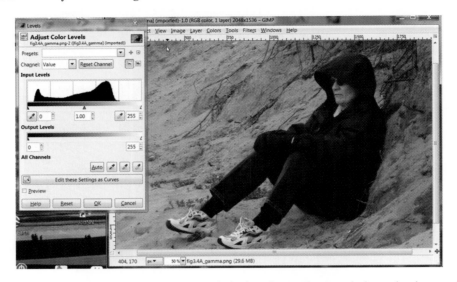

Figure 3.4A A contrasty photo with compressed dark values. The Levels box display is shown at the left. Just below the histogram display, the Levels bar has three small triangle markers. The left (black) triangle, at value 0, marks the darkest image values; the right (white) triangle, at 255, marks the lightest image values. The gray triangle, at the center of the bar, shows the midpoint value (gamma) at 1.0.

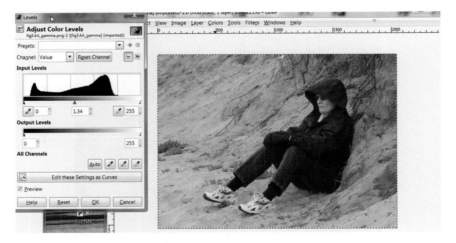

Figure 3.4B The effect of dragging the gray triangle midpoint to the left (darker). This expands the levels in the darker tones, as you can see by the opening up of the detail in the dark jacket. You couldn't do this by simply altering the contrast level. Now, yes—the photo has shifted over to being too low-contrast. But you can fix this easily by changing the contrast setting. This operation was performed in GIMP 2.8.4 in about 5–10 seconds.

Figure 3.5A,B Lighting and contrast adjustment show quick modification of the same image using automatic brightness and contrast correction; operational time 5 seconds using PixBuilder Studio 2.1.1.

Gamma Adjustments

Gamma is the index used to calculate correction of the brightness values of digital image displays. Because human vision is much more sensitive to changes in dark tones than to similar changes in bright tones, you can "tweak" gamma to alter the display values so they more closely match the visual perception of the human eye. This lets you change the brightness of the midtones

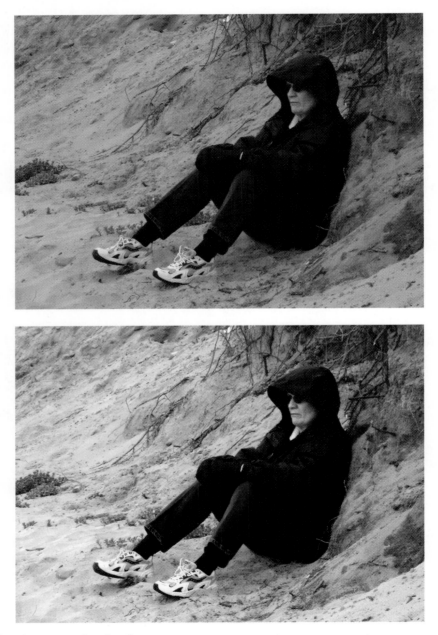

Figure 3.6A,B Automatic level adjustment to improve an image; approximate operational time is 5 seconds using PixBuilder Studio 2.1.1.

without substantially affecting the highlights and shadows. Gamma adjustment is a powerful tool because you can selectively expand or compress display of details in either the highlight or shadow values. You can thus fine-tune the brightness range of the image. Changing gamma may also have a negative effect on the image contrast, but you can correct this fairly easily using other controls.

Details on gamma setting adjustments for scanning photo prints for digital image conversion are discussed in Chapter 7.

Brightness and Contrast
Brightness and contrast adjustments allow you to improve an image by fine-tuning the brightness and the contrast range of pixels in the image. You can usually select changes using defined preset levels, by making customized changes using slider bar indicators, or by moving points on graphic curve representations of the tones in the image.

Levels
Adjustment of level settings can correct the tonal range of an image by modifying intensity of the shadows and highlights. You can generally select from preset level values or use a histogram graphic display to guide you in setting appropriate correction levels.

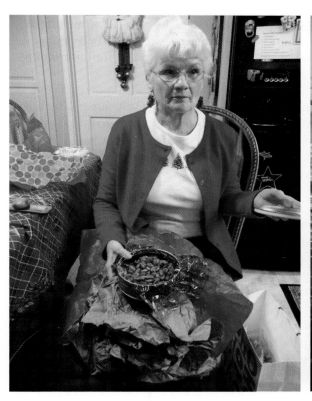

Figure 3.7A,B Figure 3.7A is an indoor photo taken under yellowish tone light from incandescent lighting; Figure 3.7B shows color correction using the automatic white balance function; approximate processing time is 3 seconds using PhotoScape 3.6.3.

Color Correction (White Balance)

The "white balance" function allows you to easily correct *color temperature* problems. These variations result in incorrect color casts affecting an image. You can commonly set white balance by using the mouse to select a "normal" white or gray point in the image. The program automatically shifts overall color values to reflect the defined white balance basepoint, as demonstrated in Figures 3.7A and B. Some software allows color balance correction by selecting two base colors in an image, which are then used for automatic color value correction of the image. Sometimes other manual controls or guided methods are available for correcting or improving color temperature appearance.

Several other color correction functions are often provided in photo-editing software to help in post-processing an image. These can include specific adjustments of color hue, saturation level, and lightness. The color modifications you make are temporary and reversible until you approve the final appearance adjustment and save a new copy of the digital file. As a safety measure, remember to frequently save successively numbered or code-named versions of your images as you progress through your post-processing tasks.

Enhancements Over the Full Image

Controls are available in most photo-editing software that help you to quickly improve or modify overall image appearance. These are purely cosmetic functions that enhance the general appearance of a photo rather than addressing a specific image defect, but they can often turn a so-so image into something quite impressive, providing even amateur users with a power akin to the "secret" retouching techniques of professional photographers. (And let's be honest: even images created by such remarkable photographers as Edward Weston and Ansel Adams owe much to their hard work in the darkroom.)

Sharpening

Sharpening a blurred or out-of-focus image is quite easy using post-processing software products that provide a sharpening function. This function enhances the "edges" of objects in a photo image by using either automatically or manually selected levels of sharpening. Over-sharpening may result in grainy or unacceptable images, but, here again, the results are not permanent until you finally accept them and save the image file. This gives you the freedom to experiment until you achieve the look you want.

Blurring

Essentially the opposite of sharpening, a blurring function artificially diffuses or blurs an image, creating a softer image. Blurring will often redeem or correct the impression of an overly stark or harsh image. Blurring functions usually provide preset selection levels and may also allow incremental adjustments. Many post-processing programs also offer a variety of blurring methods to simulate different effects. Among the most common of these are simple blur, Gaussian blur, and motion blur, along with pixelizing.

The *simple blur* is a fast, automatic operation that calculates new display values for every pixel based on the value of neighboring pixels. In effect, every pixel gets averaged, softening the whole image. The *Gaussian blur* uses the same kind of pixel averaging calculation but varies the changes by mathematically calculating smoother mixing with the values of neighboring pixels. Gaussian blur is adjustable in its degree and produces a softening of edge and color differences. The *motion blur* emulates the effect of photographing moving objects. It can be applied to a selected object or area within a photo, producing the blur effect locally while retaining the sharpness of surrounding areas. *Pixelizing* simulates reducing the resolution or number of pixels in an image, offering another variation on blurring.

Figure 3.8A,B Sharpening a soft or blurry photo; approximate operational time is 3 seconds using Picasa 3.9.0.

Figure 3.9A,B Examples of blurring an image using the Simple Blur function; approximate operational time is 25 seconds using VirtualStudio 1.0.38.

Noise Reduction

Noise reduction eliminates or reduces the random "noise" pixels that introduce confusion or interference into an image—a problem caused by either poor lighting or an inappropriate ISO value (light sensitivity) setting in a digital camera. Noise is also an interference characteristic particular to the use of digital sensors, which are not perfect in their capture of visual images. Digital image noise is similar to the pronounced graininess or lack of sharpness/resolution that often occurs when using higher-speed films in silver film photography.

Figure 3.10A The noise reduction possible in an image containing a high level of noise or "static." This example demonstrates the ability of the Neat Image program, designed to remove extraneous noise from the photo image. Approximate operational time is 30 seconds including all preliminary user settings.

Figure 3.10B Neat Image can also analyze and remove regular patterns from an image. The original image (left) was scanned from a print with an embossed paper surface pattern. It's obvious this utility package could also handle the dot patterns from a screened printed image. Approximate operational time is 30 seconds including preliminary settings.

Selected Area Modifications

Selected area modifications or manipulative functions can also be applied to a smaller area within an image instead of to the full image. These functions are often a "downsized" or local application of the same functions available for full image modification, covered in more detail during the examination of post-processing operations in Chapter 6. You generally select or define the targeted area by using the mouse or slider bars to mark the area, using a visibly identified function "paintbrush" or some other visual control to highlight the section of the image you wish to modify.

Beautify Skin

The beautify skin function smoothes coarse or rough skin textures, reducing or eliminating blemishes, complexion problems, scars, lines, and the like. The function is best applied to a defined or selected area rather than to a full image. Other functions are generally available to reduce detail or texture in non-skin-texture areas of an image.

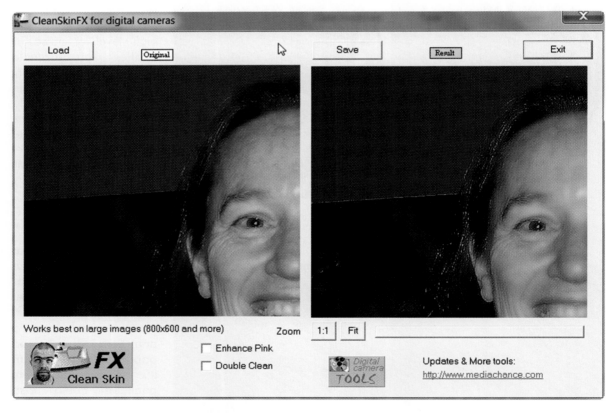

Figure 3.11 CleanSkinFX's beautify skin function applies an overall cosmetic effect to smooth out skin textures. After about four clicks to load the file and check the two boxes near the bottom, CleanSkinFX took approximately 35 seconds to do its job. This "quickie" first step to clean up and begin post-processing removed a good deal of the noise caused by poor exposure and will be followed by additional work with other photo-editing tools.

Scratch or Spot Removal

Scratch or spot removal functions are applied to small areas of a photo image containing imperfections such as scratches, spots, abrasions, or stains. This can even work on crease or fold marks or paper tears common on photo prints that have been digitally converted using a scanner or digital camera.

Scratch or spot removal is not usually an automatic function. It is often completely subjective which image variations (if any) are actual defects as opposed to deliberate or accurate patterns, textures, or surface features. Thus you will usually perform scratch or spot removal selectively using the corrective functions in your chosen photo-editing software package. These functions include scratch/spot removal, cloning, blurring, and adjustable color blending.

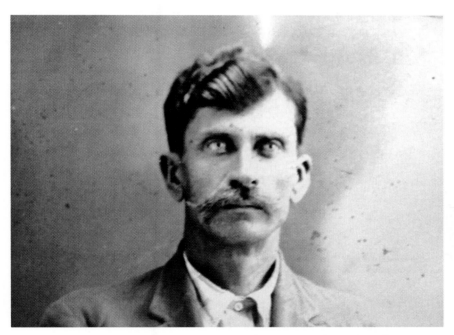

Figure 3.12A An original historic image marred by spotting and discoloration. Also note the apparent abrasion of the right side of the handlebar mustache.

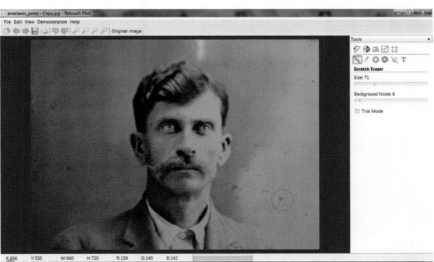

Figure 3.12B The starting image loaded into Retouch Pilot 3.5.2. The scratch eraser function is selected in the toolbar at right, indicated by the box around the pencil icon in the second row. The small circle at lower right of the image shows a spot selected for removal. Circle size is adjustable using the slider bar in Tools or by rotating the mouse wheel.

With scratch/spot removal, the software analyzes the broader area surrounding an imperfection, automatically applying a soft or "fuzzy" blend of the correct image values to replace the unwanted defect. You need only "mark" or identify the defective area and issue the Go command when ready. The cosmetic operations may vary in effectiveness, however, depending upon the size of the area selected and the variations between local image values, and this may result in slightly differing applications of corrective action. This function is almost always completely reversible using the undo command, so experiment until you achieve the desired effect. If the scratch or spot removal function is not sufficient to correct a problem, try the cloning function, described later in the chapter.

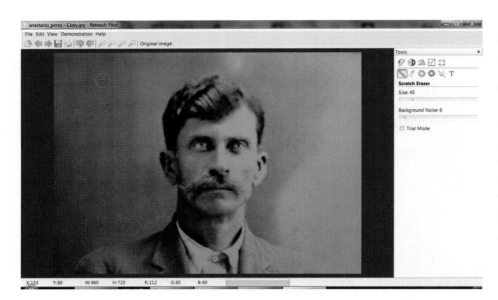

Figure 3.12C The photo with spot removal mostly completed. The scratch eraser, smart patch (cloning), and tinting functions were used to touch up or blend the areas to match the overall background. Total cleanup time was about 4 minutes.

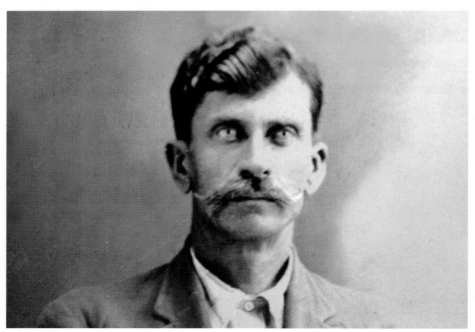

Figure 3.12D The results of a bit more fine-tuning. The smart patch function was used to patch in a reversed image of the mustache over the missing section on the right side of the photo, followed by a final tweak of overall appearance using the contrast and brightness function. This part of the operation took about 2 minutes.

Selective Blurring or Sharpening
Selective blurring and sharpening is applied to a user-selected portion of the full image and is often useful for improving appearance of an image by emphasizing or de-emphasizing parts of it. For example, you may wish to blur or soften a distracting background behind a primary object in the photo or use sharpened detail to emphasize a specific object.

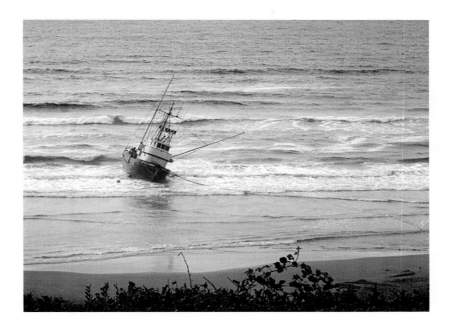

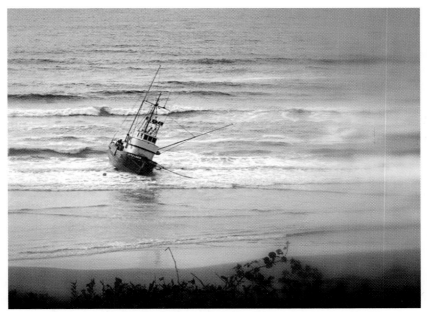

Figure 3.13A,B Selective blurring of features to the right of the boat area; approximate processing time is 5 seconds using Picasa 3.90.

Selective Brightening or Darkening

Selective brightening or darkening can be applied to parts of an image to enhance overall image quality or to emphasize or de-emphasize objects or areas. Many photo-editing applications enable selective manipulation of highlights and shadows to better display hidden detail or to remove excessive highlight glare.

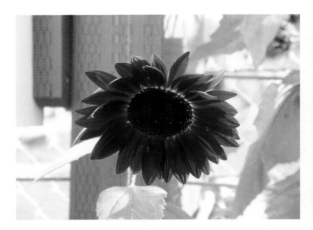 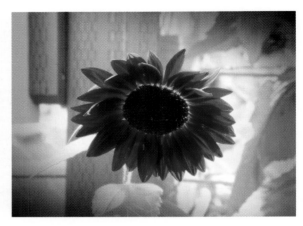

Figure 3.14A,B Emphasis can be given to a central subject image by using selective darkening of the less important peripheral areas of the photo; approximate processing time is 10 seconds using PhotoScape 3.6.3.

Color Modifications

Color modifications involve changes to the color characteristics of an image, usually for cosmetic or corrective purposes. Color modifications are generally applied over the full image, but some post-processing applications offer the option of limiting the modification to selected areas.

"Complex Modifications" Using Automated Assistance

"Complex modifications" using automated assistance apply advanced high-horsepower processing to make sophisticated modifications to an image. These functions provide highly automated combinations of multiple processing steps that perform drastic modifications to an image. These complex functions involve sophisticated programming and can save considerable human labor time and effort. (It's one place where you will really see the "magic" in digital photo magic!)

Smart Removal

Smart removal operations let you select an object in the image or a portion of an image for seamless removal. The program analyzes the surrounding area or background, deletes the selected portion, and replaces the selection with an artificially synthesized image that softly blends into the overall photo.

The smart removal function is a powerful post-processing tool. It allows quick and easy removal of distracting or unwanted parts of an image. This smart function gives you the ability to quickly correct and improve an otherwise blatantly unusable photograph. If you haven't used it before, the speed and ease of using a smart removal tool may astonish you.

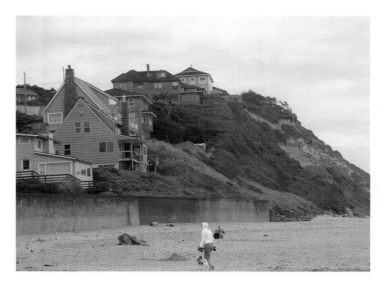

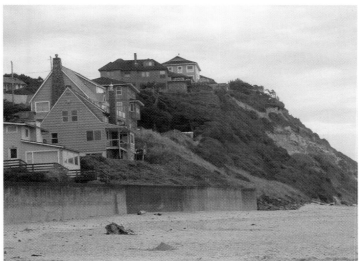

Figure 3.15A,B Smart removal of people in beach foreground of scenic view; approximate operational time is 20 seconds using Inpaint 5.0.

Smart Resizing

The smart resizing post-processing tool includes the smart removal function, but it adds a degree of intelligence by shifting and resizing background and surrounding objects while it does the removal. Smart resizing processing can work such magic as

1. seamlessly removing people or objects from the midst of a group of companions while simultaneously adjusting the background to account for the horizontal loss of space;

2. resizing an overall image, eliminating or adding space while ensuring that selected "important" objects are not removed or distorted;

3. changing the aspect ratio of an image, while not distorting important objects in the photo—for example, changing from 4:3 standard image proportion to a 16:9 widescreen display ratio while simultaneously "spreading out" the people in the photo (although you could also simply resize and crop the image, this will often produce unsatisfactory results).

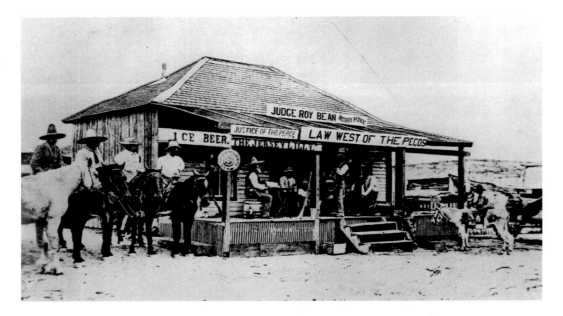

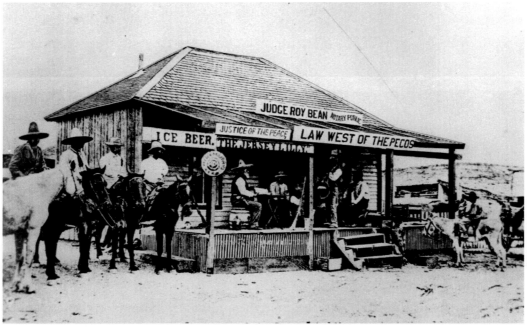

Figure 3.16A,B Quick smart resizing of a historical photo (top), changing it to a 4:3 display ratio; approximate processing time is about 15 seconds using iResizer 2.2.

Figure 3.16C,D The same kind of resizing can be applied to a modern digital color image; approximate processing time is about 15 seconds using iResizer 2.2.

"Exotic" or "Artsy" Manipulations

Exotic manipulations generally involve substantial modifications of a digital image. These are generally applied to achieve purely artistic or creative effects and may also involve artificial mixing of different photo images or importing selected parts or areas of other images.

Vignetting

Vignetting is the stylized photographic technique of enhancing an image by darkening its edges. This darkening effect may involve an oval or other artificial pattern for the darkened area. Commonly used in 19th century portraiture and landscape photography, it's especially handy for the restoration or simulation of antique images, such as historical scenes or old family photos. The vignetting creates a framing effect, focusing attention on the selected central subject area, which retains normal lighting values.

Posterization

Posterization modifies a realistic or continuous-tone image into a starkly contrasted graphic representation using a limited number of color tones. This technique can transform a realistic photo portrayal into a dramatic, poster-like graphic image.

Figure 3.17A,B A vignette; processing time instantaneous using PhotoScape 3.6.3.

Figure 3.18A,B The dramatic posterization effect applied to a continuous-tone color photo image; processing time near-instantaneous using Photo Impact Pro 13.

Panoramic Stitching

Panoramic stitching is the process of combining or "stitching together" multiple images with overlapping edges to create a dramatic horizontal or vertical panorama view. Numerous post-processing tools offer this capability, which usually involves a fairly simple or even automatic process. Your success will ultimately depend, of course, on having a viable selection of overlapping images.

Panoramic stitching is more suited for application to original photographic composition sessions, in which the photographer intends from the outset to take a series of overlapping images from which to create a panoramic view. (Nevertheless, stitching is post-processing.) Be aware that some of these applications rely on rough manual positioning of the images prior to stitching.

As seen in the PhotoStitcher example, (Figures 3.19A and B) some software can examine a selected batch of digital image files, automatically identify similar adjoining and overlapping views, then completely assemble the panoramic image. The pioneering software utility introducing this capability was a freeware byproduct of a research project by Canadian graduate student Matthew Brown (www.cs.bath.ac.uk/brown/autostitch/autostitch.html). His automatic panoramic constructions produce some impressive images. (One of the sample panoramas at his website, automatically produced from 57 overlapping images, might just blow your mind.) Brown offers bargain pricing for the iPhone ($1.99) and iPad ($2.99) versions of his software.

Specialized Utility Programs

Utility programs are generally smaller special-function programs designed for single- or limited-purpose image manipulations. Because they do not try to provide a wider range of image-editing capabilities or functions, they are usually very fast.

Some of the specialized tasks performed by these programs include assembling multiple images into "mosaics," converting digital image files between formats, stylizing images, resizing images without quality loss, "skin beautification" (smoothing skin, removing blemishes), performing super-easy color cast correction, automatically "glamorizing" images, and "unshaking" (correcting blurriness or shaken, fuzzy images) images.

Many post-processing utilities offer "batch processing" capability that allows them to efficiently carry out the same or similar functions on a number of different image files simultaneously. If you have a group of photos that have similar exposure or lighting errors, batch processing can provide a quick path to making corrections on the whole group of images.

Along with many other types of tools, I provide a comprehensive list of specialized utility programs on the DPM companion website.

The Best Sequence of Post-Processing Fixes

The sequencing of post-processing fixes seems awfully important, right? Someone must be able to explain not only *what* to do, but what order to do it in. It's a worrisome question. You think: "I've got all these things to fix, all at once. Can anybody tell me what's the best order for doing my retouching or repairing operations? I mean, I don't want to accidentally mess up things I've already done."

Truthfully, there is no one ideal way to order this kind of work. It's a subjective decision, and you'll want to experiment to determine what works best for you. There are some common-sense approaches, to be sure, but a lot of what you'll hear is just plain opinion based on personal preference and personal working habits. Still, I'll offer some suggestions here, drawing on my own experience.

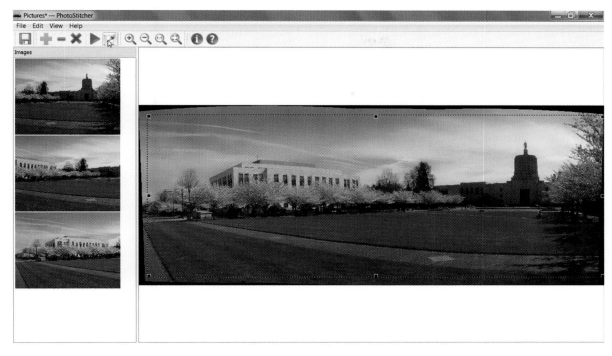

Figure 3.19A The work screen for the PhotoStitcher application. Click the + icon button just to the right of the disk (save) icon to allow selection of a batch of images, taken with overlapping sections, from which to assemble a panoramic image. The images are stacked up in the left column, with no ordering necessary. Next, click on the triangle icon (next to the X icon) to start the automatic panorama assembly. Finally, click the crop icon on the toolbar (to the right of the start triangle) and use the mouse to move a cropping outline to select the final image.

Figure 3.19B The final panorama produced by combining the individual images. Image assembly for this example took about 45 seconds using PhotoStitcher 1.0.

The simplest and shortest recommendation I've seen is "The best sequence of work is this: resize, adjust color balance, do any other adjustments, and sharpen last." Not bad. This statement captures a lot of strategic guidance in just a few words.

More extensive guidance is available from a web tutorial series posted by Cambridge in Colour (www.cambridgeincolour.com). Their approach is logical and quite instructive, with clear and detailed explanations. Here's the list (Cambridge, 2013), prefaced with a statement that the operations are "roughly in the order" of application:

1. White balance: temperature and tint adjustment sliders

2. Exposure: exposure compensation, highlight/shadow recovery

3. Noise reduction: during RAW development or using external software

4. Lens corrections: distortion, vignetting, chromatic aberrations

5. Detail: capture sharpening and local contrast enhancement

6. Contrast: black point, levels and curves tools

7. Framing: straighten and crop

8. Refinements: color adjustments and selective enhancements

9. Resizing: enlarge for a print or downsize for the web or email

10. Output sharpening: customize for subject matter and print/screen size

It's a sensible order of operations, detailed in a way that should remind you about the numerous things you *can* do. Following this list, Cambridge in Colour offers additional details along with numerous cross-links to in-depth information about each area of post-processing.

That said, I'd consider reordering a few things. For example, other sources put number 7, framing, higher up in the sequence of operations. They note that reorienting from portrait to landscape (or vice versa) and cropping should be done early on. Their reasoning? You don't want to waste your time working on and correcting details (here at Number 5, including "local contrast enhancement") in areas that you may later remove. Thus, I'd put framing up above Number 5. I'd probably also move contrast (now at Number 6) above Number 5 in order to put general contrast improvement before local contrast enhancement.

In the "Photography Basics" section of the Manfrotto School of Xcellence's website, Michael Freeman presents a similar guide (Freeman, 2013). At "Michael Freeman: Easy-to-Go Post-Production in 11 Steps," Freeman's list includes the following items:

1. Color balance

2. Set black-and-white points

3. Brightness/contrast

4. Saturation

5. Lens correction

6. Noise reduction

7. Recover highlights/shadows

8. Local adjustments

9. Retouch

10. Sharpening

11. Multi-shot comps (his term for stitching together multiple images of the same subject, adding or repairing items or objects, or creating a panoramic view)

Freeman elaborates on each of the items on the same page, giving excellent explanations and visual examples of the varied operations in what is essentially equivalent to a post-processing mini-seminar. He points out that his first six steps are "tweaking" what you (or the photographer) have already done, the seventh to tenth steps are improvements to the image, and the eleventh step is unique to post-processing capabilities.

Among the sound practical advice Freeman offers: "This is all about workflow. Develop for yourself a sequence, an order, that suits the way you work, but which also makes sense technically (for instance, brightness and contrast are best adjusted *after* the black-and-white points are set, and sharpening, if any, should always be last). Here are my steps, in order. Not all are needed—sometimes one or none—but I tick then off mentally. . . . Develop your own sequence, like the one I suggest here. Depends on the software, but for safety in guaranteeing no loss of image quality, make the image 16-bit rather than 8-bit before you start" (Freeman, 2013).

I'll echo him on this: Get a routine going, work it out for yourself, fix it where necessary, and standardize what you're doing. I'll have more to say about standardizing in Chapter 8.

DPM Web Updates

You may want to periodically check the DPM companion website (www.update4dpm.com) for updates on information presented in the book.

References

CambridgeInColour.com. 2013. "Digital Photo Editing Workflow," accessed April 27, 2013, www.cambridgeincolour.com/tutorials/digital-photo-editing-workflow.htm.

Freeman, Michael. 2013. "Michael Freeman: Easy-to-Go Post-Production in 11 Steps," accessed August 25, 2015, stage.manfrottoschoolofxcellence.com/2011/06/michael-freeman-easy-to-go-post-production-in-11-steps/?cat=1946#.VdzNByVViko.

Digital Image Details

There's no denying it—you'll encounter some heavy-duty tech-speak when learning about digital photo files, formats, and related technology. You can spend endless hours studying the technical aspects of the subject, if you like, or you can read the short introduction provided in this chapter. I wrote it to prepare the average reader to begin productively using DPM photo editing tools.

Effective digital image post-processing requires that you make informed decisions in regard to the multiple steps involved in editing and saving your output. This chapter will provide a basic understanding of your choices, sufficient at least for your beginning efforts in using post-processing software.

Graphic Image Formats

Graphic image file formats used for storing digital images are defined by precise technical specifications. Industry-wide cooperative and ISO (International Organization for Standardization) definitions delineate formats such as TIFF or JPG.. Numerous proprietary definitions are also issued by vendors, such as for the GIF (CompuServe) and BMP (Microsoft) formats. The proprietary formats may well become established and eventually become widely adopted by software and hardware vendors. For example, Compuserve's patent on the GIF file format expired in the early 2000s, but it is now commonly used. The PNG (Portable Network Graphics) file format was created by the ad hoc PNG Working Group in 1995-1996 to improve upon and, in some respects, replace GIF.

Precise format definitions are essential for effective standard usage. These enable hardware and software developers to effectively tailor their products for wide cross-platform compatibility. Brand A Camera must be able to accurately create and transfer Image B, which must be able to be saved by Computer C to Hard Disk D. That file must also be flawlessly loadable and editable by Photo Editor E, and it must be able to be printed by Printer F. No problem—you hope.

Each community standard file definition offers numerous content and coding options to cover the allowable variations in image representation within a single format. These options allow needed flexibility in photo image representation and descriptions within the single format, including innumerable image description variations or alternatives, such as choice of color or black-and-white images, gamma values, color hues, image size, image resolution, brightness, contrast, and screen display methods.

Understandably, then, because you'll need to be transporting the photo images you work with through the maze of photo-editing tools and your own unique mix of hardware, you absolutely, positively need basic knowledge about digital image file formats.

Common Photo Image Formats

The most widely used digital photo image formats are TIFF (Tagged Image File Format), JPEG (Joint Photographic Experts Group), and PNG (Portable Network Graphics), but numerous other specialized formats are also in use, including the following:

- RAW: The original file format created and saved by digital camera hardware

- GIF: A compact and less detailed image format, used mostly for simple line art or graphic illustrations (described near the end of this subsection)

- Proprietary formats: Working file formats defined by software vendors for their own applications—for example, Adobe's PSB and PSD, ULEAD PhotoImpact's UFO and UPI, and GIMP's XCF

TIFF files require the most disk space, by a significant margin. The reason TIFF files are so large is that they represent a "lossless compression" format. TIFF files use file compression algorithms that lose no detail while saving successive versions of files. This means that when you decompress a TIFF file for display or printing, you get exactly the same image as the original one. That holds true after all subsequent editing and post-processing manipulation. TIFF files use "raster" image depiction, essentially describing the color values of every pixel or dot needed to represent an image. As this results in both higher-quality image depiction and larger file sizes, there is both an advantage and a disadvantage. TIFF files are also not editable by as many file-editing tools as some other formats: Many simpler photo-editing applications are restricted to operating on the smaller and more popular JPEG, PNG, and GIF formats.

JPEG uses a "lossy compression" algorithm, applying a much higher compression ratio for image storage. It typically achieves a 10:1 compression ratio, with little perceptible loss in image quality. But using the lossy compression method means that a small amount of the image detail is lost during each successive file save. The human eye can't easily distinguish the small amount of image quality loss, but using JPEG for storage means that you will suffer cumulative quality loss after multiple generations of file saves. JPEG has generally been the most widely used photo image format, although it is now being overtaken by the PNG format for online uses.

The JPEG compression ratio is user-selectable. A JPEG file can be written to disk with a very small amount of lost detail, but this file will be considerably larger than a higher-compression JPEG file.

The newer PNG format—like TIFF, a raster format—uses lossless compression. Its file size, smaller than that of a comparable TIFF file, means faster transfer of images online and faster display time on computer screens. PNG files are thus optimized for transfer speed and online display; they can't quite achieve the print detail of TIFF files. However, the difference is not easily detectable with the naked eye.

Image Types

An image's type refers to one of two principal methods used to actually build or represent an image in a graphic file:

- *Raster images* use a bitmap representation of an image, a dot matrix data structure representing a generally rectangular grid of pixels, or points, of color. Raster images cannot be rescaled without losing quality.

- *Vector images* are built using "graphical primitives" such as squares, circles, and curves, created during processing using geometric formulas to describe the shapes. These files are smaller and are in fact preferable for representing graphic line art or simpler images.

Raster or bitmapped images are better than vector imaging for complex continuous-tone images, such as photographs. However, simpler black-and-white or "line art" images may be efficiently saved as lossless raster images in the GIF file format. These GIF images result in extremely small file

sizes, far below even those saved in the (lossy) JPEG format. The highest-quality and most detailed TIFF and BMP format files use raster image processing and are generally, accordingly, much larger in size than vector images.

Until recently, image file size significantly affected choice of format, which often involved a delicate balance between disk storage size (or transmission speed) and image or visual quality. This was a more important consideration "back in the old days," when storage space was much more limited and expensive.

Relative file size of the file formats clearly illustrate the tradeoff of space versus quality. For example, I recently worked with a TIFF image that was 8.5 MB (8,704 KB) in size, yet the same image in a moderate-quality JPEG format was only 482 KB in size. By way of another example, in "A Few Scanning Tips" (Fulton, 2013, "Image File Formats") Wayne Fulton compares the sizes of identical 4×6 images from a 12-megapixel digital camera, saved as RAW, TIFF, JPG, and PNG files. Table 4.1 summarizes his data, depicting the extreme range of file sizes produced.

Fulton concludes, "Large images consume large memory and make our computers struggle. . . . When we double the scan resolution, memory cost goes up 4 times. Multiply resolution by 3 and the memory cost increases 9 times, and more. So this seems a very clear argument to use only the amount of resolution we actually need to improve the image results for the job purpose. More than that is waste" (Fulton, 2013b).

Table 4.1 Compare the sizes of a 4×6 image saved used different formats. (Data taken from Fulton 2013a)

File Type	Size/Proportion
RAW camera data, 12 megapixel	36 megabyte
TIFF LZW (65–80%)	23.4–28.8 megabyte
PNG (50–65%)	18–23.4 megabyte
JPG (5–20%)	1.8–7.2 megabyte

Table 4.2 Rick Matthews, Wake Forest University, has presented similar comparisons of identical images stored in different formats, as well as at different levels of compression (users.wfu.edu/matthews/misc/graphics/formats/formats.html).

File type	Size
Tiff, uncompressed	901K
Tiff, LZW lossless compression (yes, it's actually bigger)	928K
JPG, High quality	319K
JPG, medium quality	188K
JPG, usual web quality	105K
JPG, low quality / high compression	50K
JPG, absurdly high compression	18K
PNG, lossless compression	741K
GIF, lossless compression, but only 256 colors	286K

As things now stand, more powerful computers, less expensive computer memory, and enormous decreases in the cost of file storage space actually make this much less of a cost/space-driven decision than ever before. Image quality considerations are much more important now, along with the consideration of image file size effects on online display speeds. However, remember that network bandwidth speeds are also rapidly increasing—this also is a less important consideration than before.

Preserving Image Quality

Preserving image quality depends greatly on your photo-editing working approach if you do elect to use lossy JPEG files. Accordingly, it's important to think about and plan your editing work flow more carefully when you're using JPEG images than when using other formats. Using a lossy compression file degradation degrades image quality whenever you save a modified file. Unfortunately, the losses are cumulative over repeated generations of file-saving, much as when you make repeated generations of photocopies or analog audiotapes. It's like compounded interest: A 3% or 5% quality loss is

Table 4.3 This simplified comparison depicts the positives and negatives of each of the image file formats we've been reviewing.

	TIFF	JPEG	PNG
What you use it for	**Ideal for editing and making large prints** because it contains the largest amount of image information.	**For most printing jobs and sharing through email and over the Internet**, JPEG is the perfect file format.	**Excellent for website display and Internet transfer** due to smaller size and good quality.
Benefits	**TIFF supports layered image files**, good for use with software programs like Photoshop. **TIFF files can be saved with very little compression** making it ideal for printing large sized high-resolution images.	**JPEG has the highest compression** of the older formats and therefore offers the smallest file size. Also the most common file format in use. **Supported by largest number of photo-editing applications.**	**PNG uses lossless compression**, along with high compression and image quality. **Lossless compression and smaller file size** also suit it for archival master use. **Extremely rapid adoption for web and Internet usage**, with increasing compatibility among web browser applications.
Drawbacks	**TIFF files are large.** Depending upon image resolution, you can easily find yourself working with files in the 5–15MB range. **TIFFs are not widely supported by Web browsers**, making them a poor choice for online use.	**A JPEG file degrades each time it is saved**, due to "lossy" compression. Best to save a high-quality copy of the original, then edit copies of that file.	**PNG is not supported as widely by photo-editing applications as the other formats**, although this is changing for the better.

not much, but if you imprudently save multiple versions or generations of the image file, you can reach 20% or 30% degradation, which means you'll pay for multiple lossy file saves in visible loss of final quality.

If you try for higher resolution or photo image detail and don't research methods of doing so, it's almost always going to cost you in much larger file sizes, and you'll unfortunately gain little advantage in resolution quality. Many knowledgeable photographer specialists have investigated the visual improvements of using high-resolution scanning, and they report that most people cannot accurately identify improvements and differences resulting from high-resolution scanning of prints.

Common-Sense Scanning Decisions

Common-sense scanning decisions should always include a judgment of just how much quality you *really* need, as well as the practical arts and skills of scanning methodology. I recommend the following practical guides to photo print scanning.

- Ed Hamrick's "Batch Scanning Tips," to which a link appears on the DPM companion website (www.update4dpm.com), is a must-read on its topic.

- Luisa Simone presented a practical and still useful guide to scanning in her May 7, 2002, *PC Magazine* article "Solutions: Tools and Tips for the Internet Age—Boost Your Scanning Skills" (www.pcmag.com/article2/0,2817,1163604,00.asp). She covers the practical aspects of pixel resolution setting, brightness and tone control, and the mysterious gamma setting.

- Eric Goodnight's article "How To Properly Scan a Photograph (and Get An Even Better Image)" (www.howtogeek.com/109409/how-to-properly-scan-a-photograph-and-get-an-even-better-image) is an easily understandable guide to scanning prints. Goodnight clearly explains histogram preview charts, as well as scanner software controls and settings you can use to get the best-quality scans possible.

- Steve Hoffman's Photography website (www.sphoto.com) provides an immense amount of information covering both digital photography and photo print scanning. Offering more than just Hoffman's gorgeous nature photography, this is a valuable source for anyone who needs to learn about the digital photography and photo print scanning topics. His "Tech Articles and Tutorials" page (www.sphoto.com/techinfo) makes his technical tutorials directly available.

Minimizing Image Quality Losses

Minimizing image quality losses by adhering to good working practices will pay off in both the short and the long run. I highly recommend that you choose the PNG digital format for standard use in your routine post-processing work.

There are several good reasons for this: The PNG format is widely used in post-processing tools. It uses lossless compression, which does not degrade image quality after repeated editing sessions. PNG files are significantly smaller than comparable TIFF files, requiring less storage space and speeding file transmission times. And file conversion utilities are widely available for speedy conversion of PNG files to all other commonly used digital image formats.

When using PNG files, remember the following in your post-processing work:

1. Begin with good-quality images. If you need to start from hardcopy original photo images, perform your original digital scans to PNG format files at an appropriate DPI resolution setting. Resolution of 300 dpi is widely recommended as an excellent default setting for scanning photo print images. Initial scanning to a PNG digital file starts you off with a high-quality image. PNG's lossless compression prevents image degradation if you use multiple editing sessions during your post-processing work.

2. You'll have no difficulty finding quality photo-editing tools compatible with PNG format. When you've completed post-processing work, you can easily convert PNG files to essentially all commonly used digital file formats as needed for your final output.

 More detail on techniques for productive use of scanning software hardware and software is provided in Chapter 7.

3. *If—and only if—they use lossless compression formats*, use the proprietary file format of your photo-editing applications during the editing phase. Some of the better applications that can load and save standard image formats nevertheless use their own lossless compression formats for intermediate working files during the editing process. These applications apparently do this to avoid the problem of accidentally introducing image degradation from using lossy file compression during multiple editing sessions. Some examples of such "safe" proprietary formats are PhotoShop's PSB and PSD files, PhotoImpact's UFO and UPI files, and GIMP's XCF files.

 At the end of your post-processing editing work, you can then save the proprietary intermediate file format to a high-quality PNG file or a file in whatever other format is required for delivery of your output.

4. Use what you need to use. Be practical: If your standard photo-editing toolkit can't handle some unusual digital photo format you happen to receive, go ahead and use whatever you can find that will get the job done.

Standardize on PNG

Standardize on PNG for your digital image post-processing work. There are simply too many advantages to doing so, and no valid reason to avoid it.

Digital Image Expert Opinion

Digital image expert opinion from Sue Chastain bears out the advantages of using PNG as your preferred format. Chastain is the guide (topic editor) for About.com's widely consulted Graphics Software page (graphicssoft.about.com). She offers a good many practical facts and suggestions for preserving image quality during your post-processing work:

- If you have to use JPEG files, they do not lose quality *every time* they are saved. "Repeated saving *within the same editing session* won't introduce additional damage. It is only when the image is closed, re-opened, edited and saved again" (Chastain, 2013a). In other words, you can minimize quality loss by avoiding the use of your photo-editor's "Save As" function for the purpose of copying, duplicating, or renaming JPEG files. It's preferable to use your file manager or directory utility to perform these functions.

- Get your image files into a lossless format as early as you can during your working process. This minimizes quality loss during editing processes.

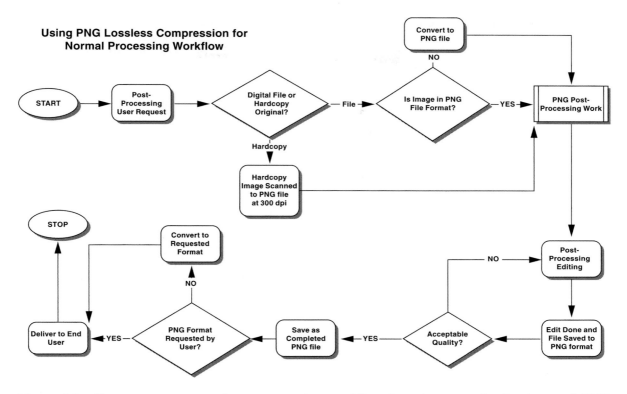

Figure 4.1 illustrates a suggested post-processing workflow based on standardized use of PNG lossless compression digital image files to minimize image editing degradation. At the beginning of the processing, non-PNG files are converted to PNG format, and hardcopy original photo prints or graphic images are scanned to PNG files. These are then directed into the same main post-processing workflow. At the end, PNG files can be converted to another digital image format that is required or preferred.

- Use a file conversion utility to transform an original JPEG file directly to PNG. A conversion utility generally will not add extraneous space during a conversion to a new PNG file. *Above all, don't use the "Save As" operation in your photo editor for file conversion.* "So with a JPEG that has been converted to PNG you will often get a larger file in kbytes than if you would have gone to PNG to begin with. In other words, it lowers the efficiency of the PNG compression." (Although Chastain doesn't mention it, I like NCH Software's freeware Pixillon Image Converter, a link to which is available on the DPM website.)

- Chastain states that repeated JPEG file saves don't really add all that much cumulative image degradation if you consistently use a high-quality setting of JPEG compression, such as 95% or 100%. However, if you ever save any intermediate version of your work at a lower quality compression—for example, at 70%—you'll permanently lose image detail. Saving it later at 95% or 100% *does not* recapture the lost detail (Chastain, 2013a).

- She recommends using only a lossless format master copy in a format such as PNG or TIFF for any important archival storage, especially for files that you expect to edit again for future use. JPEG images lose quality each time they are opened, *edited*, and saved

again, so you should avoid archiving with this format. Always keep a lossless master copy of any image you expect to edit again. JPEG, she says, should only be used for archival storage when disk space is your primary consideration. (Given the low cost of today's storage space I don't think it should be: my Hitachi SimpleTech 500 GB external disk drive, for example, cost just $70 during the Christmas sale season of 2012.)

- Chastain recommends PNG as a good archival alternative, because PNG files are considerably smaller than TIFF or BMP files. She writes, "PNG is an excellent choice for archiving. In fact, I use PNG for almost everything, especially when I need to port images between various programs" (Chastain, 2013b).

Digital Image Format Geek Knowledge Summary

At this point, I've pretty much conveyed all my geek knowledge about digital image formats. That's about all the technical stuff you need to understand to use the DPM post-processing work approach. As you can see, it's not really all that difficult; the practical guidance in this chapter mostly boils down to the following:

- TIFF and PNG formats give you the highest-quality images.

- Begin with the highest-quality image file (in whatever format) you can get or produce.

- Convert lossy format files to lossless format image files to preserve image quality during post-processing.

- If you must use the lossy JPEG format, consistently save intermediate file versions using the option for the highest-quality, lowest-compression setting that you can use.

- Save as many intermediate versions as you wish during a single editing session. An editing session *ends* when you close the file and exit the program, *not when you just save an intermediate file version for security backup.*

- Conduct as few discrete editing sessions as possible.

- Don't use your photo-editing software's Save As function to convert file formats; it will add extraneous space within the file. Instead, use a good image format conversion utility.

Finally, for most purposes keep in mind that you really don't need to worry all that much about image quality so long as it "looks good" to you. Major quality differences aren't all that obvious to the naked eye except in very large photographic prints. For an idea of how difficult photo image quality is to assess, try out the JPEG quality perceptual test by Marcus Ranum (www.ranum.com/fun/lens_work/papers/jpegquality/index.html). You may be surprised at how you do on the test. (I certainly was, even after more than 50 years of experience with silver-based and digital photography.) Ranum's visual judgment exercise bears out Sue Chastain's conclusions that incremental differences in image quality are quite hard to identify using only simple visual examination.

References

Chastain, Sue. 2013a. "JPEG Myths and Facts,"*About.com Graphics Software*, graphicssoft.about.com/od/formatsjpeg/a/jpegmythsfacts.htm.

Chastain, Sue. 2013b. "png format vs jpg," *About.com Graphics Software. User Forum,* Message 1609.1, April 5, 2001. forums.about.com/ab-graphicssoft/messages?lgnF=y&tid=1609.

Fulton, Wayne. 2013a. "Image File Formats—JPG, TIF, PNG, GIF—Which to Use?" *A Few Scanning Tips.* www.scantips.com/basics09.html.

Fulton, Wayne. 2013b. "Color Bit-Depth, and Memory Cost of Images," *A Few Scanning Tips.* www.scantips.com/basics1d.html.

Recommended Post-Processing Software

In this chapter, we'll browse through a range of free and inexpensive Windows-compatible software packages you can use for quick and easy image post-processing. As you begin to use these products and assemble your personal software toolkit, you'll be well served by using a variety of information sources—search engines, topical webpages and blogs, and (of course) the DPM companion website—to keep up with new and improved applications released since the book's publication. As useful tools come to my attention, I'll link to them from the DPM site. In addition to information about selected software and utility programs, I'll include operating tips and techniques, hardware recommendations, and suggestions for organizing and planning image post-processing projects.

Software tool selection is a highly personal and subjective decision that's also tied to your unique constraints and conditions. Your computer system environment and output requirements will often narrow or dictate your choices. A few examples: you may be working with a large archival file of photo images in JPEG format; you may often need to scan images from hardcopy originals; your users might require TIFF format for their working file output. You get the idea. There are innumerable options and variations in workflow and format requirements, so be sure to analyze and consider your total process, user requirements, and anticipated changes before you make a software decision. In doing so, you can avoid digitally painting yourself into a corner!

The purely subjective part of your choice is important, too, with personal preferences playing an important role. Your software choices may sometimes come down to an intuitive reaction you have to a particular program's interface, to the internal logic of the workflow and processing steps of a given task, to your comfort with the design of a tool, to the ease with which the program automates complex operations, to how much hands-on control you have over detailed functions, and so forth.

Post-processing software can also boost the level of scanning horsepower contained in your system tool box. Keep in mind that many interactive image-editing packages include the TWAIN protocol functional ability to control external scanner hardware units. (Covered in more detail in the "Third-Party Scanning Software" section of Chapter 7.)

Combining scanner hardware ability with the TWAIN scanner functions offered by the better photo-editing software often provides serendipity or synergy far exceeding the basic capability of the proprietary software packages provided by the scanner manufacturers. The first two categories of software package described in this chapter generally position their TWAIN functionality in the Edit menu, where it is usually identified under "acquire images," "scan images," or some similar labeling.

Software Selection Tools

Software selection tools give you a head start picking out your preferred software packages. Many established print and online sources exist to pass along hearsay wisdom and evaluations by other

users. These may be experienced reviewers or simply interested users like yourself. In any case, I recommend taking advantage of other people's experiences and willingness to share. Use your favorite search engine to find forum or discussion list exchanges on the topic of photo-editing software, as well as to locate good online review sources. A few examples follow.

TopTenReviews.com (www.toptenreviews.com) researches and compiles product information based on a wide spread of print and online reviews, producing cumulative reports on major product areas. The site, which features reviews with ratings, side-by-side comparison charts, news, articles, and videos about product groups, greatly simplifies consumer research.

Photo-Editing Software Review (photo-editing-software-review.toptenreviews.com), one of the most popular topical report areas, is an excellent source of information about commercial photo-editing software. Their side-by-side comparison chart presents ratings (based on reviews), lists software features, and provides links to numerous reviews. It's a great research tool.

The *Photo-Editing Configurator* (www.toptenreviews.com/configurator/photo-editing-software -review) is an interactive guide for package selection. After you answer questions about desired features, capabilities, output requirements, and so forth, the configurator recommends the package that it has determined will best fit your needs. Along with this tool, a side-by-side comparison chart helps you to quickly select a commercial photo-editing software package.

My own selective (and subjective) listing that follows is grouped into several broad categories. Photo-editing and post-processing software is plentiful and becoming even more so. In fact, I've included a number of new packages that appeared while I was writing the book. Each category begins with a summary of general characteristics followed by brief descriptive entries on the specific packages I recommend. Version, pricing, and other details are subject to change.

At the start of each package description I assign a letter grade, from A+ to C. (I do not include below-grade software products in the list.) I also include before and after images demonstrating featured post-processing operations for some of the listed tools.

High-End Photo-Editing Horsepower

High-powered photo-editing packages come first. These offer an enormous spread of photo-editing functions and capabilities and are polished, sophisticated, and complex. As a result, they have a high learning curve, demanding experience and skill to master.

The two applications in this first category—Photoshop and GIMP—have spawned an array of learning tools which are readily available online. YouTube alone offers dozens of useful video tutorials for each of these products. The videos are generated by the software vendors, third-party reviewers, and often by private individuals. Both of these premium software packages are superb photo-editing tools, but they are actually outside the general track of my coverage: one, due to their cost, and two, given the time and effort needed to learn how to use them fully. (I *do* occasionally use GIMP, which I appreciate for its power and the ease of use of certain post-processing functions, but I've not invested the time necessary to become a power user.)

In any case, both of these high-end applications provide a comprehensive spread of post-processing functions. The following are on my short list of highlights:

- Light/Dark Controls
 - Brightness, darkness, gamma
 - Contrast

- Photo-editing, Retouching, Image Manipulation
 - Layering—adding or superimposing "layers" above the base image, permitting extensive editing or modification "on top of" the base image without directly affecting it. If a layer's effect isn't what you hoped for, it's simple to delete it; if it works—great. You can use it for final output or even merge it with the base image.
 - Spotting, scratch removal—removing distracting image objects, such as dust spots, abrasions, and tears.
 - Overall sharpening or blurring.
 - Cloning—replacing an image area based on duplication of a selected source area.
 - Painting—using an adjustable local "paintbrush" to apply functions such as adding or removing colors, textures, shading, brightening, darkening, sharpening, blurring, and so forth.
 - Vignetting—artificial darkening of the perimeter or border area of an image to emphasize or frame the focal point of the image. (You know—the Victorian photo portrait effect.)

- Color Controls
 - Hue, Shading, Saturation, Depth—both for overall image application and local area "paintbrush" application.
 - Color transformation or deletion—changing or eliminating selected colors.
 - Color cast—shifting the range of color portrayal.
 - White point—automatic color balancing of an image based on user selection of a neutral white or gray image area.
 - Filtering—selection of colors and other factors to control shifting color emphasis or appearance.

- Image Characteristics
 - Cropping—selection/deletion of designated areas within an image.
 - Resizing—control over the size of the print or displayed image.
 - Resampling and resolution functions—control over area/pixel count: the detail capability of an image.
 - File format abilities—for compatibility with different digital image formats and ability to import and export selected formats or convert image files to other formats.

Photoshop CC (Creative Cloud), combined with LightRoom (starting at $9.99/month for an individual subscription plan; $119.88/year)
Adobe (www.adobe.com/plans/photography.html)

A+ Photoshop is the definitive photo-editing software product. It provides comprehensive editing capability along with a full family of related products including both photographic and video management tools. As mentioned previously, it carries an extremely high learning curve and demands true perseverance for mastery. Photoshop CC is a complete set of professional tools for retouching, compositing, and editing down to the pixel level.

Photoshop's Lightroom product offers a simplified, automated, and speedy approach to digital photo post-processing, using a similar approach to some of the mid-range products mentioned

later in this chapter. It has powerful photo file collection management tools and image-sharing functionality. Lightroom works across a number of platforms, including desktop computers, laptops, tablets, and even smartphones.

Photoshop is supported by a wide range of commercial workshops and courses, online tutorials, educational websites, YouTube videos, and the like. It also offers add-on capabilities, accepting many third-party functional additions that markedly increase its ability to perform complex specialized effects and processes.

Adobe has recently moved to subscription or rental pricing for its software, as opposed to the premium-price licensing approach they previously employed. You cannot subscribe only to the basic Lightroom application, however; this tool is available as a component of Photoshop CC for the basic $9.99 monthly individual subscription price.

GIMP (GNU Image Manipulation Program) 2.8.14 (free)

Gimp.org (www.gimp.org/downloads)

A　The free and open-source GIMP package is another iconic photo-editing application, considered by many to be the equal of Photoshop. It is a similarly complex program, carrying the same kind of steep learning curve. GIMP also has a wide selection of learning and tutorial resources easily available online. Hands-on GIMP courses and workshops are available in many areas.

Mid-Level Photo Editors

The software products I'll introduce next offer solid, dependable photo-editing tools. These mid-level packages don't provide the power of the high-end products, but neither do they require the time and effort it takes to learn to use them. Packages such as these don't individually provide the wide functional range of the high-end tools and don't always offer a comparable level of control over the editing functions, but they are nevertheless worthwhile tools that support high-quality work.

The first two listed products are available for under $100, which seems quite reasonable given their utility. Following these packages, we'll consider a number of mid-level freeware and shareware applications, listed alphabetically.

Photoshop Elements 13 ($99.99)

Adobe (www.adobe.com/products/photoshop-elements.html)

A　Although some users may be inclined to think of Adobe's Elements 13 as a "baby steps" version of Photoshop, it stands out as a powerful and easy-to-use photo-editing product in its own right. With a clear and logical interface providing fast access to various post-processing functions, it is currently the top-selling consumer photo-editing software package.

Elements 13 augments its photo-editing capabilities with extensive image file management and organizational features. It provides automated handling of many complex post-processing functions such as creating panoramas by combining multiple images, controlling lighting effects, and creating group photos through mixing or "pasting" faces, objects, and other image elements between different photos. All in all, this is a high-performing photo-editing application, quite reasonably priced.

PhotoImpact Pro 13 ($99.95)
Nova Development (www.novadevelopment.com/software/photoimpact-pro-129013)

B PhotoImpact Pro is a reasonably-priced photo-editing package that incorporates an impressive range of post-processing tools and automated functions. Personally, I find the interface a bit confusing, with some useful functions buried deep inside categories that are not always obvious. That said, it is one of the most versatile image editing software programs around, offering an array of specialized filters, automated visual embellishments, and other sophisticated photo-manipulation effects.

PhotoImpact Pro provides numerous non-editorial functions, such as slide show creation, scrapbook page design, and webpage design; thus, it's more than a photo-editing tool and can be particularly attractive for users who require the added functionality.

FotoMix 9.0.9 (free)
Digital Photo Software (www.diphso.no/App/FotoMixV9Setup.exe)

A FotoMix is a pleasant surprise, being primarily promoted as a special-function photo-editing tool for "mixing" or combining multiple photo image elements into single photo images. You know those special effects: adding people and objects to a scene, putting an animal head on a human figure, and so on. FotoMix gives you the ability to easily do these types of flashy special-effect manipulations, but it's also a very powerful and intuitive general post-processing tool. It provides a broad selection of editing tools—and notably the ability to use layers during editing operations—along with excellent online help and learning tools, all housed within a no-brainer user interface. The combination delivers a level of sophisticated power-user editing capability to a broad range of less-experienced users.

According to the well-regarded CNET.com software archive and reviewing website, "We think that FotoMix is a great choice for users who don't have much photo-editing experience but need a basic way to combine elements from different images or just perform basic edits and improvements on a single image; if nothing else, it's an easy way to crop, rotate, and add text to images. We recommend this program to all users" (download.cnet.com/FotoMix/3000-2192_4-13039001.html).

With its wide array of image editing functions and layering capability, FotoMix will make a handy and powerful addition to your DPM toolkit.

PhotoScape 3.7 (free)
Photoscape.org (www.photoscape.org/ps/main/download.php)

A PhotoScape is a powerful and extremely easy-to-use photo editor, noteworthy for its wealth of functions, clear command interface, and ease of mastery. It offers the usual post-processing tool suspects and bundles together a solid array of photo processing modules and functions, including an image viewer, image editor, batch editor, screen capture utility, RAW converter, multi-image combination, creation of animated GIF images, and its own "PrintSplitter" tool.

The PhotoScape opening screen contains a rotating display that provides one-click access to regularly updated online tutorials. Internal menus and popup prompts continually display detailed function and command guidance. The Save function offers easy version renaming, and automatically backs up original images to an "Originals" folder—just in case you imprudently ignore the prompted version-renaming option and save a new version with the original filename.

Wide functionality, quickness of operation, and all that helpful guidance result in an excellent post-processing package for users at virtually any level. PhotoScape's speed and intuitive controls make it my favorite of the mid-level tools. (You'll find my personal PhotoScape "cheat sheet" at the DPM companion website.)

PhotoFiltre Studio X 10.9.2 (shareware, 29 Euros, free 30-day trial); PhotoFiltre 7.2.1 (free)

photofiltre.com (shareware: www.photofiltre-studio.com/download-en.htm; freeware: www.photofiltre-studio.com/pf7-en.htm)

B Photofiltre is a well-regarded French shareware package, with an earlier version available at no cost to individuals, educators, and nonprofits. (Note that the freeware version does not offer layering capability.) This is a general photo editor application featuring a broad selection of post-processing tools. Oddly, it lacks photo dodging and burning tools for local application of image area brightening or darkening—a significant omission in an otherwise excellent package.

The PhotoFiltre site hosts a nice selection of free third-party add-ons, most of them contributed by users. The English-language version of the program is well and clearly presented, with an elegant and intuitive interface. It offers both menu and keystroke shortcut command approaches, detailed online help, and easy access from within the editor to the main website, user discussion forum, and video tutorials.

The online user forum reflects PhotoFiltre's broad international user community, with many posted offers by users willing to help language-challenged English speakers. Unfortunately, much of the text documentation and user help is available only in French, although browser users are pointed to Google translation tools.

Picasa 3.9 (free)

Google (picasa.google.com)

A+ Picasa 3 is an extremely easy-to-use and powerful Windows desktop photo editor and post-processing application, provided by Google as a free download. The package offers a full array of desktop photo-editing tools and incorporates full network-integrated functionality. The post-processing package is moderately powerful and quite accessible for beginner users. Google software developers have again produced an impressive desktop application, this one specifically to provide simple, effective image editing and photo collection management functionality. Additionally, Google has integrated the following features:

- Free cloud storage for up to 1 GB of your images using the Picasa Web Album service, Google Photo, and Google+ (up to 400 GB of storage is available for a fee)

- The ability to manage an online Picasa Web Album archive, with automatic uploads and file synchronization

- Facial recognition search capability for automatically searching, retrieving, and indexing human images "that look like this" (this feature reduces the time spent on subject name tagging, in addition to letting you quickly "find this person")

- Convenient access to high-quality commercial printing services for photos and bound albums

- Easy online publication options, with access to your hosted photo images as a remote display resource for other websites

- Integration into the Google+ social networking service for easy online sharing of photos and albums with friends and relatives, as well as designated public access to your stored images

- Integration into Android smartphone and tablet networking and communications, with Android devices able to manage your local photo collection and Picasa Web Album archives

- Integration into the ever-growing range of Google functionality

Picasa 3 is a fully loaded mid-range photo editor, offering a wide variety of extremely easy-to-use, yet powerful post-processing tools. Almost any level of user can benefit from using Picasa as a basic photo file organizer, manager, and post-processing application. You may find yourself using it for routine photo processing and printing, as well as for its cosmetic retouching capabilities.

Keep in mind that Picasa doesn't actually *store* your photos. Rather, it automatically finds, indexes, and uses all photo files that are stored on your hard disk. You can easily configure the program to recognize the digital image files that you wish included or ignored. You can also identify disk folders or directories that you don't want it to scan. However, you will manage the actual file storage process via standard disk management commands and utilities, your camera photo file utilities, or other file-handling tools.

One great advantage of Picasa is that photo-editing never changes your original image files. All image-editing modifications are recorded in a separate change log file; the stored post-processing effects are automatically applied to the original image only during image display and printing. (You can also easily export high-quality or "corrected" copies of your improved images.) The good news is, you're not likely to ever accidentally overwrite your original image files.

Picasa is a free photo-editing application that I highly recommend as a standard tool for serious digital photo hobbyists or semiprofessionals, as well as for beginners. It is my own most-used photo software tool; in addition to routine "touch-up" and printing of photo images, I'm currently using it to manage an archive of more than 13,000 images.

PixBuilder Studio 2.2.0 (free)
Wnsoft.com (www.wnsoft.com/pixbuilder)

A PixBuilder Studio is another free and useful program for digital photo editing, image processing, and resizing. It supports the use of image and text layers for editing, multi-step undo, and the use of gradients and masks—all of which make this an attractive and effective photo image editor. The layering function is important for any user who is serious about image post-processing. The program also provides easy access to color management functions, allowing control over brightness, contrast, and color balance, as well as the use of levels. The numerous built-in post-processing functions include blurring and sharpening, cloning, and a paintbrush. A variety of selection tools and a mask mode, along with the aforementioned layering capabilities, make it easy to manipulate specific image elements and areas and provide access to optional editing panels for display and monitoring of zoom, tools, layers, undo history, and channels.

Pixbuilder Studio has an intuitive user interface, incorporating extensive and easy to find help and learning information. Overall, this is a solid and powerful free photo-editing tool, amateur-friendly yet with fast editing functionality that is certain to make converts among professional users.

Automated Post-Processing Software

Next I will address an emergent category of tools representing one of the most exciting developments for DPM users. Having not seen this approach named or categorized, I've coined the phrase "Automated Post-Processing Software" or "APPS."

In a nutshell, APPS products employ clever programming to automatically perform complex tasks. These "smart" operations involve multi-step processes that normally require human judgment, whether for evaluation of values and intermediate steps of image editing or for identification of the degree of similarity for matching patterns, textures, or details in surrounding areas.

Software is actually quite well suited to performing this kind of "best guess" operation. The great advantage here is that smart operations can reduce time-consuming tasks to a mouse click or two, yet ensure that the human operator can quickly decide if the results are acceptable. If the software's best guess works out, great. If not, the operator can undo the operation with a single button click or Ctrl+Z keystroke. Then the operation can be easily repeated using slightly different settings or values.

This type of iterative processing is fast, and the human operator always has the opportunity to evaluate the results. The skilled labor time- and labor-saving potential can be enormous even if the best guesses are successful only, say, half the time. In my experience, users will generally get acceptable or good results more frequently than that, but it's no big deal either way: You're accomplishing something in 20–30 seconds that might otherwise take 15–20 minutes of tedious and exacting work.

As my college programming instructor used to say, "Hey, that's what computers are for!"

High-end and mid-level photo-editing software has long included automated smart operations, such as single-click optimization of contrast or lighting levels, easy cloning of image source areas for retouching, automatic sharpening or blurring, instant vignetting, and so forth. These newer APPS applications simply kick things up a few notches in order to automate such tasks as

- removing of image subject objects or persons, with "inpainting" to automatically fill in image gaps using visual "details" synthesized from background image detail in the surrounding area;

- removing image objects while resizing or shifting proportions of the overall image to make up for the gap areas;

- removing text, watermarks, copyright notices, logos, and other unwanted marks or symbols from an image;

- mixing or "pasting" detail from one photographic image to another (yes, you can put a dog's head onto a man's tuxedoed body, but the same smart processing technique is also useful for restoring or revising an otherwise unusable image);

- adding a bright blue sky, storm clouds, and the like to a useful photo that suffers from a lackluster background; and

- colorizing to add natural looking color to the appropriate areas of a black-and-white photo image.

APPS tools make these seemingly magical image transformations with remarkable accuracy. Innovative software technologists have given us the power to make major image changes, additions, and deletions while simultaneously smoothing out unnatural edges, distortions, and telltale irregularities in an image. I liken these smart tools to automatic transmissions or autopilots for handling exacting and time-consuming photo-editing tasks.

Well-made APPS products are a particular boon for beginner post-processing artists, as they can produce results that would otherwise be far beyond their grasps. Following is an alpha list of selected and recommended APPS packages, again including my own letter-grade ranking. For more information on the use of APPS packages see Chapter 6.

Inpaint 6.2 ($19.99)
Teorex (www.theinpaint.com/download.html) free trial demo (www.webinpaint.com)

A Inpaint is a simple and speedy tool that does essentially one thing—and does it very well. The "inpainting" operation completely deletes a user-selected photo image area, replacing the blank space with intelligently generated images synthesized from surrounding image data. Inpaint is used for removing people, automobiles, trash, power lines, aerials, edifices, or whatever else offends you; for performing quick facial retouching including wrinkle, blemish, and discoloration erasure; and for eliminating watermarks, text, and logos from an image.

The Inpaint user interface is sparse, offering a limted number of command options and resulting in extremely simple operations. The "Multi View" mode permits the use of details from multiple photos of the same scene to create "the image you really meant to photograph." For example, if you have two or three similarly oriented images of a striking landscape, which unfortunately include tourists wandering about in different locations, Inpaint will select parts of each and construct an idealized version that magically has no people in it. Multi View also allows you to clone several images or action sequences featuring the same person (or object) into a single photograph.

Inpaint is a powerful time-saver that can help you salvage mediocre photo images. Not bad for 20 bucks!

iResizer 3.0 ($19.99)
Teorex (www.iresizer.com/download.html)

B What Terorex's iResizer does is a bit difficult to describe, since you're not merely changing the dimensions of an image, but take a look at Figures 3.16A, B, C, and D in Chapter 3 for a visual example. The iResizer application rescales an image without altering designated "important" visual content such as people, buildings, animals, and the like. Normal inpainting resizing operations simply replace all pixels in a selected image area, but iResizer mostly inpaints pixels into unmarked or "unimportant areas" that do *not* include critical visual content. For example, you can transform a wide landscape picture with a few people in it into a square picture by simply "closing up" the space between the people or objects in the image. It also works in reverse: You can use it to expand a square photo and make it into a larger view by "adding space" between the important objects.

iResizer can change spacing between the main objects in an image, or even completely remove objects, and can also change overall image aspect ratios: Simply use the mouse-controlled green marker tool to identify the important elements you want to keep in the image. Conversely, use the red marker tool to select features of the image you want discarded or overwritten. It may take a few tries to get the results you want, as parts of an image that you didn't notice, think about, or mark properly the first time will become distorted; still, the controls are simple and straightforward. If you find you've gone astray, just use the Undo command then add further marks to tune up your image. In the end, it may take you 8 minutes instead of 5 to magically transform that image. Darn!

PhotoUpz 1.7 (personal, $19.90; business, $29.90; free trial)
PhotoUpz.com (www.photoupz.com)

B PhotoUpz, another automated photo enhancement program, contains a relatively small but powerful set of tools. The user interface is lean and mean, within the narrow limits of its post-processing functionality. The program is easy to install and is intuitive to navigate and operate. You'll get your photo fixes over and done with in short order.

PhotoUpz displays easily identifiable icon-based commands to rotate and resize images; remove dates, logos, watermarks, objects, people, and more; sharpen photos; remove noise; and improve contrast and brightness in poorly exposed photos. To start, use the mouse to add simple markers identifying areas to remove. You can also use "guide lines" to mark locations where different intersecting background edges adjoin the objects marked for removal; this enables accurate blending and matching of an inpainting area surrounded by multiple backgrounds, allowing you to accurately identify and match grass, sidewalk, and structural background areas that intersect behind the person or object you've marked for removal. A powerful and easy-to-use application available at a very economical price, PhotoUpz offers limited but highly useful APPS functionality.

PhotoWipe 1.21 (free)
Hanov Solutions (www.hanovsolutions.com/?prod=PhotoWipe)

B- A freebie inpainting tool, PhotoWipe removes unwanted objects from your photos, "smartly" filling in visual detail based on the surrounding background detail. All you do is paint over unwanted items with a black marker and click the Go button. This type of deletion using smart inpainting can reveal or correctively refocus attention on previously obscured photo details. You can remove cage bars from zoo images, vanquish your ex from party photos, eliminate wrinkles, and even remove entire facial features.

PhotoWipe inpainting may not produce perfect results, but you can use it for a down-and-dirty fix, then do additional image clean-up with PhotoScape or a similar DPM tool. A limited but quick and easy-to-use post-processing tool, PhotoWipe is a real bargain at zero cost.

Recolored 1.1.0 (personal, $29; business, $49; free 21-day trial)
Bertheussen IT (www.recolored.com/recolored_info.php)

A Recolored makes it unbelievably easy to add natural-looking color to black-and-white photos—traditionally an exacting and time-consuming task. Drawing on the latest developments in computer-assisted image colorization, this software allows just about anyone to produce professional-looking colorized images.

To add color to a photo, simply use "brushstrokes" to roughly apply desired colors to objects, features, and image areas, then click the Colorize button. Recolored automatically "expands" the application of your chosen color markings using natural gradient coverage, pushing the area of color out to the point where it identifies a natural boundary or "edge," as identified by image characteristics that differ from those you marked. The color expansion stops completely when it reaches boundaries containing other assigned color values.

It's easy to improve and perfect your colorization job using iterations of simple color marking adjustments, inspecting the results and continuing to make cumulative corrections. Recolored offers options for erasing color line markings or replacing them with different color value selections.

After you select a "replacement" color, simply click on a color line to locally transform a single line area, or click a line while also pressing the Ctrl key to globally change all the line marks in the full photo with that original color value. (Of course, you can always Undo if you make a mistake.)

Recolored offers a simple and very practical alternative to the standard colorization approach employed by the high-powered products. The more advanced packages generally guide the user to the application of layers for doing colorization and similar complex photo-editing tasks. With that method, single or multiple artificially defined layers are applied over an image. Editing and other manipulative changes to a layer are restricted to affecting just that particular layer; thus, changes do not actually modify the underlying image.

Layering enables delicate or drastic adjustments to image color, contrast, brightness, darkness, and other such characteristics. The user can also control the degree of effect to the overall image appearance by varying the transparency or opacity of each layer. This allows for very fine adjustment of changes. If a particular editing approach is found ineffective or inappropriate, the user can add another layer or simply delete the unsuitable layer. Remember, the "independence" of layers means that modifications, adjustments, or even the deletion of a layer will not impact the base image.

While using layers is quite powerful and effective it calls for considerable user skill and experience. The application and interaction of multiple layers and the gradations of intensity of the effects quickly complicate matters, and the process can be quite time-consuming.

Recolored, on the other hand, offers quick, simple application of coloring effects while also providing the same sort of protection for your original image. When you begin editing a photo with Recolored, you load and display a copy of your original file. You start choosing colors and drawing the color guide lines on top of the original image, checking your results using the Colorize instant display function. As soon as you achieve a version of the colorized work you want to keep, you save it using an RCL file format extension.

This does not overwrite the original JPG, PNG, or TIFF (or whatever format) image, because when you save the RCL file it stores a copy of the original base image, along with all your cumulative color line instructions. Load the file and click the Colorize button and the software will quickly generate a new colored image, applying all your stored instructions. Continue to fine tune your colorization, and when you finally see a colored version you'd like to print, save it again, this time as a JPG, PNG, or TIFF file—or in whatever format you desire. Now you can produce your final print.

A quality colorizing job with Recolored will probably take you 10–30 minutes per photo. The work is accomplished simply by brushing a minimal number of colored lines using your mouse. There's no need to struggle with layers, color gradations, color-mixing, multiple editing sessions, or complicated settings. The Recolored package automatically takes care of the otherwise difficult and time-consuming tasks of accurately colorizing black-and-white photo images, applying gradient colors, and automatically providing for smooth, seamless transitions between different color edges or boundaries.

Recolored is a truly elegant example of the new APPS image post-processing technology. Take a look at the online web demos—you'll be impressed. (By the way, your friends and relatives will absolutely love you for your colorizing and retouching skills; at least mine do. It can really pay off in cocktail and dinner invitations!)

Online (Web) Digital Photo Editors

Numerous useful photo-editing applications are now offered as remotely hosted online services, providing an alternative to installing and maintaining local desktop software. Remote users can

select a photo image from their local disk storage and upload it for a hosted editing session. The refinished version can then be downloaded for printing or sharing online or offline, and, in many cases, may also be stored on user-reserved space at the remote location. Most of these hosted services are free, with optional subscription-based pricing for premium or added-feature versions.

Google's Picasa Web Album service, discussed earlier in this chapter, was an early leader in this genre and remains among the most popular.

A significant advantage of hosted post-processing sites is that users are spared from managing large photo-editor applications on their own computers. You begin by uploading photos from your device or importing image files from photo sharing and social networking sites. You can then instantly begin editing these photos and images without the hassle of re-uploading, resaving, and keeping track of file versions on your own drives and disks. Many hosted services allow users to upload directly from their digital cameras, mobile phones, and other personal devices, and several of the online services offer tools for exporting finished images and photos directly to mobile devices.

Increasingly, these sites also incorporate commercial photo printing services or have seamless affiliations with such services. This makes it easy for users to order photo prints and bound photo books, and have their images screen printed onto posters, greeting cards, coffee mugs, and even as artsy simulated paintings on canvas, just to name some of the many options.

Online Image Editing Review (online-image-editing-review.toptenreviews.com) is a solid source for objective articles, reviews, tutorials, and tips for using hosted photo-editing services. Additionally, the site features a quality comparison table of some of the top services.

Most of these services provide post-processing functions similar to those offered by the mid-level photo editors described earlier in the chapter, and their interfaces are geared to the experience level of the average Internet user. Following are several examples.

- **Citrify** (www.citrify.com)—The Citrify online photo editor offers free access to very basic photo-editing tools, cosmetic functions to improve facial features, and special-effects features. It's an entry-level post-processing tool well-suited for beginner experimentation.

- **FotoFlexer** (www.fotoflexer.com)—FotoFlexer is a solid, power-packed free hosted photo-editing service offering a wide array of post-processing tools. It offers a mix of basic and advanced retouching functions, application of special-effects, and addition of text and shapes and outside images, as well as the ability to work using layers—currently rare among the hosted services.

 FotoFlexer provides easy uploading of your stored disk images and also allows you to grab images from other locations online. It seamlessly imports and edits images from Picasa, Facebook, MySpace, Flickr, Phanfare, and SmugMug. It offers a few demos of special features, but not much else in the way of tutorials or help features. It's a great service if you don't mind a bit of experimental learning.

- **Google+** (https://photos.google.com/)—Google+ Photos provides simple photo-editing functions closely integrated with the Picasa Web Album platform. Google+ incorporates the same kind of folder and album organizational tools as Picasa and integrates photo sharing with designated users or public access. With the "Lightbox View" you can use basic photo-editing functions, add names or titles, use sharing features, and so forth. Google+ Photos is another easy and flexible route to beginner-level photo post-processing. While it's free, you'll need to download and use the Google Chrome browser and create a free Google+ account to take advantage of this service.

- **PicMonkey** (www.picmonkey.com)—PicMonkey is an advertising-supported, free remote photo-editing service that provides basic and advanced post-processing tools, templates, themes, framing effects, apps and browser extensions, and more. The Facebook app lets you access all your Facebook photos and edit them from within the social network. When you're done, the photos automatically pop into your PicMonkey Facebook album. You can upgrade to the enhanced, ad-free Royale Premium version for $4.99/month or $33/annually; a free 30-day trial let's you take Royale for a test drive.

- **Thumba** (www.thumba.net)—Thumba is a free hosted photo-editing service providing access to a wide and powerful spectrum of post-processing functions. It offers simple menu-driven access to photo manipulation tools, usually with slider bar control over the strength of the desired effects, which allows for more precise work. Thumba offers good networked image retrieval capability, including easy uploading of webcam images.

As is true of many similar services, Thumba offers little in the way of help functions or online tutorials: Users are left mostly to their own devices when attempting to master the fine points of this powerful photo-editing tool. There's no obvious Undo/Redo button or function, though that's not to say it's not there—you'll just need to learn on your own which functions appear under the Edit command bar menu, or that Thumba responds to the standard Windows keystroke commands of Ctrl+Z for undo and Ctrl+Y for redo.

Utility or Special Purpose Programs

Utility programs perform specific tasks related to the management of computer functions, resources, and files, or perform standard processing for certain routine purposes. They often include a "batch processing" option, through which a defined operation or process may be simultaneously applied to multiple files or objects. In photo file processing, this saves time and labor for routine and multi-step operations.

Batch processing in the post-processing environment can include such tasks as digital file format conversion, printing, resizing, resampling, and special formatting or modification of groups of images. Many standard photo-editing programs offer batching ability for these types of routine tasks. Picasa 3, for example, allows automatic image resizing and emailing, conversion of selected batches of images to different digital formats, and creation of slide shows or self-executing video presentations. Commercial or hobbyist software programmers often produce small utility programs of their own to automate repetitive tasks.

Many worthwhile photo processing utilities are available as freeware or carry a very low price tag, including the following.

AltaLux Technology Demo (free)

Stefano Tommesani (www.tommesani.com/index.php/software/altalux-in-irfanview/5-altalux-new-major-release.html)

A AltaLux is a superb, easy-to-use, and super-fast tool that can significantly enhance the quality of poorly lit or exposed images and videos. You need only use the key combinations Ctrl+0 to Ctrl+8 to adjust the degree of lighting correction, and the key combinations Alt+0 to Alt+4 to toggle scale adjustment. (Scale adjustment changes the size of the area squares used in processing and also balances the image quality improvement and preservation of detail within the overall image.)

Plugin versions are available that allow you to use AltaLux inside the popular IrfanView and XnView freeware image viewers. This is great for quickly inspecting and viewing multiple photo images, while retaining access to the AltaLux's powerful enhancement capabilities.

An animation that demonstrates lighting correction possibilities using AltaLux is available at www.tommesani.com/index.php/software/altalux.html.

CleanSkinFX (free)
MediaChance USA (www.mediachance.com/digicam/cleanskin.htm)

B CleanSkinFX (CS) is a single-purpose photo retouching utility designed to automatically and efficiently enhance facial complexion. A powerful automatic retoucher for portraits, the application smoothes the skin of the photographic subject while preserving the details and crispness of hair, eyes, and background. According to the website, "CS works with well balanced portrait image of Eurasian skin type. The face shouldn't be in shadow and it should be the dominant part of the image. For best results the image must be 1200x700 and more pixels."

CS offers just two adjustable settings: "Enhance Pink" pushes skin tone a bit toward pink and reduces the appearance of red spots, while "Double Clean" does extra-strength skin correction with minimal disturbance of skin details. This handy tool can fully process a large portrait file in about 2 minutes.

Digital Photo Resizer 2006 (limited functionality: free; full functionality: $10)
IceGiant Software (www.icegiant.com/dprz.shtml)

B Digital Photo Resizer (DPRZ) quickly and accurately does batch resizing for a wide range of photo formats including JPG, GIF, PNG, TIFF, and BMP. Simply point DPRZ at the directory containing the images and press "Resize." DPRZ goes to work, producing a new subdirectory of resized images while leaving your originals untouched. In addition, the utility can add watermarks, copyright notices, logos, and similar enhancements; package your images as executable slide shows or screensavers; and automatically generate image-based websites, among other options. It's a useful photo-processing tool and one you may want to check out.

FastStone Photo Resizer 3.3 (free)
FastStone Soft (www.faststone.org/FSResizerDetail.htm)

A This image converter and renaming digital photo utility allows users to quickly and easily convert, rename, resize, crop, rotate, change color depth, and add text and watermarks in single image or batch mode. Users can search and replace text in filenames, renumber images sequentially, preview conversion and renaming, and save and load operational settings. This excellent multipurpose utility supports the JPEG, BMP, GIF, PNG, TIFF, and JPEG2000 formats and has received a five-star quality rating from the respected CNET.com software archive.

Image Enlarger (beta) 0.9.0 (also known as SmillaEnlarger) (free)
Mischa Lusteck (sourceforge.net/projects/imageenlarger/)

B Image Enlarger is an open-source product that can greatly enlarge images with minimal added graininess, blurring, or random "noise." It offers a limited number of controls, including (1) a slider to set the zoom percentage; (2) a small movable crop area marker to select the desired area;

(3) adjustment sliders for fine-tuning sharpness, dithering, and flatness; and (4) a preview button to check predicted results. You can quickly evaluate your needs, set the adjustments, preview the results until satisfied, and finally click Calculate to produce your enlarged image. Image Enlarger is an easy way to generate fine-detail enlargements quickly and at no cost.

Picture Resizer Personal 3.1.6 (free to try; $19.99 to buy)
The Professional Developer (download.cnet.com/Picture-Resizer/3000-12511_4-10671352.html)

B Picture Resizer Personal resizes pictures and drawings with minimum image quality loss in either single-image or batch processing mode. It handles TIFF, GIF, JPEG, PNG, and BMP files, and although it can enlarge images it is best suited for reducing images for online use and space saving. Picture Resizer Personal offers a simple, guided step-by-step process and great compression ratios while resizing by percentage or pixel count. This utility provides useful prompts, reports errors, and—importantly—does not overwrite your original images.

Shrink Pic 1.8.0 (free)
On the Go Systems, Inc. (www.onthegosoft.com/shrink_pic.htm)

B Shrink Pic automatically reduces the size of single copies or batches of photos for efficient transmission by email, online transfer, or uploading. It does this quite conveniently, actually monitoring your selection of image files as you assemble them and resizing them invisibly in the background. You control the size criteria used to identify candidate files for reduction.

Shrink Pic works with popular email programs, Internet browsers, and messaging programs. It is particularly useful for sending multiple small image samples when post-processing for clients and colleagues.

Unshake 1.5 release 1b (free)
M.D. Cahill (www.zen147963.zen.co.uk/Unshake/)

A Unshake fixes blurriness in photo images using a sophisticated software technique called "deconvolution." Several of the high-end photo-editing applications include this kind of function, but Unshake does it just as well—if not better—and at no cost. It takes a bit of experimentation before you'll get optimal results, but there's no substitute for this kind of sophisticated post-processing. It significantly improves images that would normally be considered unusable due to photographic errors made at the moment of original exposure.

What's more, Unshake is not limited to fixing digital images: you can also improve images from legacy photo prints, positive transparencies, or photo negatives by simply scanning them to digital format. Unshake is a last-ditch helper for blurred images caused by improper focusing, too-slow shutter speeds, unsteady hands, unexpected movement by the subject, and so forth. It can help you create a decent image from a lousy photograph, which in my experience makes it a uniquely valuable tool. Try it!

Digital Photo Magic Editing Examples

In this chapter, we'll get down to the nuts and bolts of image editing using selected DPM software tools. The focus will be on key post-processing functions and techniques that are available with the different software packages.

Because we will be looking at a variety of programs and utilities, graphic user interfaces (GUI) and command set options will vary markedly. However, my approach is to demonstrate the most intuitive and easy-to-use DPM tools I know of; thus, these variations in how they look and act won't present a big learning challenge. Given some obvious limitations of the print format, I won't attempt to illustrate step-by-step procedures for using each tool. Rather, my approach is to succinctly describe and demonstrate—frequently through the use of photographs and screen captures—the primary functions of the featured software.

Many developers of photo post-processing applications and utilities offer helpful tutorials, demonstration videos, and detailed explanations of product capabilities and operations on their websites. You can also find useful information, examples, and discussions of fine points of usage on special interest (sometimes software-specific) websites, many of which provide objective reviews, evaluations, and user forums. In addition, a wealth of post-processing information is available on YouTube.com and Instructables.com.

Other useful online resources are easy to find using a search engine. For example, Google searches like these will quickly locate evaluative webpages about a product:

photoscape reviews

"retouch pilot" reviews OR comments OR evaluation

Videos and tutorials created by both vendors and users are plentiful on YouTube and similar video archives, while the DPM companion website hosts new and updated content, links to relevant resources, and reader feedback. Be sure to check these locations, and to use your favorite web search engines, to locate additional information on DPM products and post-processing methods.

My usage examples in this chapter are presented in two different forms: First, I cover specific recommended software packages, with examples of using the principal or unique function(s) of each. Next, in the section entitled "Post-Processing Projects Using Multiple Tools," I describe a few "project"-type operations. Here, I illustrate the use of several distinct tools to post-process a single photographic image. I demonstrate major operations only, and describe intermediate or secondary operations more briefly—again, owing to the constraints of print.

Specific Package Editing Examples

The following text presents selected functional examples of nine recommended DPM software products. The coverage is limited to applications and utilities from the mid-level photo editors, automated post-processing software tools, and specialized utility programs described in

Chapters 3 and 5. My focus is on the unique or significant editing capabilities of each product—the kinds of fast, effective, and easy-to-use features that make these packages particularly well-suited for inclusion in your multiproduct post-processing toolkit.

The wide range of photo-editing options and functions (as discussed in the "Post-Processing Functional Operations" section of Chapter 3) makes clear how unwieldy it would be for any one book to attempt comprehensive coverage of dozens of software products in action. Get your bearings here; then, as necessary, consult software internal help and tutorial content, special-interest publications devoted to discrete products, and other print and online resources that provide detailed instruction on the use of specific packages.

Coverage of the selected software packages is presented in alphabetical order by product name. Each descriptive section includes the following:

- Product name (and cost)
- Product summary
- Description of the featured post-processing function
- Figures illustrating the product in action

AltaLux (free demo)

Fast general image quality improvement power in a superb tool. AltaLux significantly enhances the quality of images and videos taken under poor lighting conditions. It analyzes the sections of a photograph by dividing it into a grid and then processing each square in the grid to emphasize the differences between parts of the image in that square. There are only two controls: intensity (strength of the emphasis) and scale (size of the grid squares).

Figure 6.1A A demo screen on the AltaLux website, showing the concept of the processing. (Note that this is simply a demo illustration, not the actual application interface.) Using AltaLux is quite simple. A photo is loaded and quickly processed using one of eight intensity levels and one of four scale levels. You may toggle through full-size previewing mode using Ctrl+0 through Ctrl+9 to set intensity and Alt+0 through Alt+4 to set scale. When you see a preview of your optimal image, simply save that image to disk.

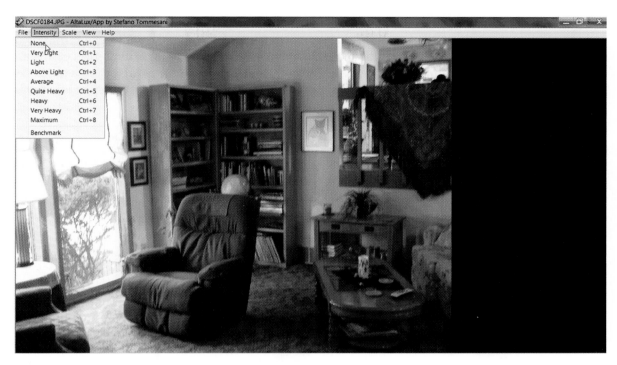

Figure 6.1B The original image, with no enhancement (viewed using Ctrl+0).

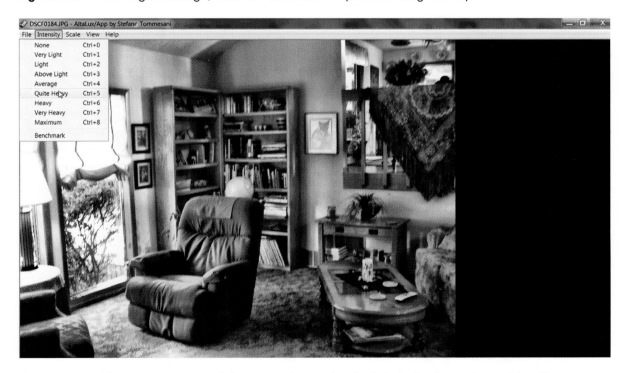

Figure 6.1C AltaLux processing of the image (viewed with Ctrl+5, the "quite heavy" level).

CleanSkinFX (free)

This single-purpose utility offers quick cosmetic retouching of facial images. There are only two controls: one for special attention to pink or reddish skin tones, the other for double-processing an image for stronger improvement. As shown in Figures 6.2A, B, and C, CleanSkinFX does a quick-fix job that may leave behind imperfect area fixes. Even in such a case, it's a good first step before more detailed manual cosmetic retouching.

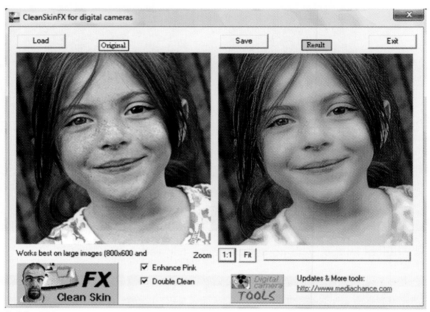

6.2A

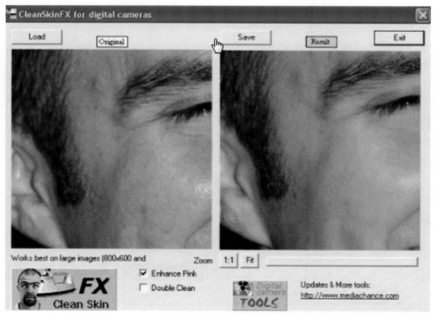

6.2B

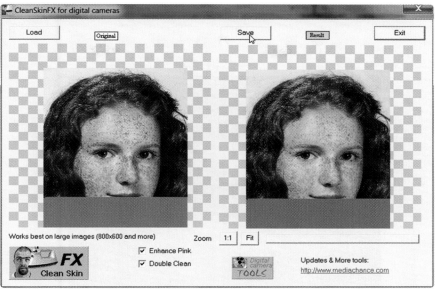

6.2C

Figure 6.2A The working screen of the CleanSkinFX utility, showing a freckled facial image targeted for cosmetic touch-up. After loading and checkmarking both the Enhance Pink and Double Clean choices, the image was quickly processed to apply the cosmetic fixes shown in the right image preview. This improved image can be stored to disk using the save button (above the right image).

Figure 6.2B Another example of a cosmetic fix using CleanSkinFX. In this example, only the Enhance Pink control was selected.

Figure 6.2C A beautiful young woman sporting rather incredible freckling. Even using both processing selections in CleanSkinFX, the utility couldn't do a significant cosmetic fix—and in this case, it wouldn't have resulted in anything close to a realistic portrayal, anyway. Instead, this partial improvement can serve as the basis for further manual retouching.

FotoFlexer (free)

According to TopTenReviews.com, "FotoFlexer offers a fairly comprehensive online image editing program within, arguably, the most simple, low bandwidth-consumptive interface available in higher-end online image editing programs. By combining traditional simple editing features and filters with advanced tools like recolor, RGB or individual color curve adjustment and others, Foto-Flexer lets users craft, create, adjust, improve and, ultimately transform photos and images from virtually anywhere with an Internet connection."

The review goes on to say that "FotoFlexer also offers an array of embellishments, fonts and other scrapbook-like effects for increased personalization and page creation. With full integration with popular photo sharing and social networking sites, FotoFlexer is a capable tool for photo hobbyists and others looking to simplify and enhance their Internet lifestyle." (online-image-editing-review.toptenreviews.com/fotoflexer-review.html)

FotoFlexer is both robust and simple to use. It can be used to conveniently upload your own photos or to select images from one of the affiliated social media or photo sharing networks. Once you're looking at a selected image in the online photo-editor, the GUI plainly and easily guides you through your potential editing choices.

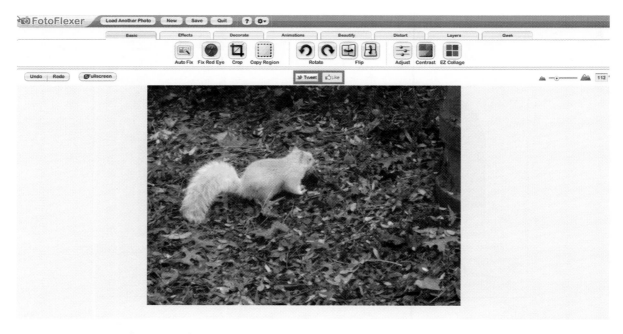

Figure 6.3A FotoFlexer displays the starting image, uploaded from my hard disk. It's a springtime photo of an albino squirrel in my Salem, Oregon back yard.

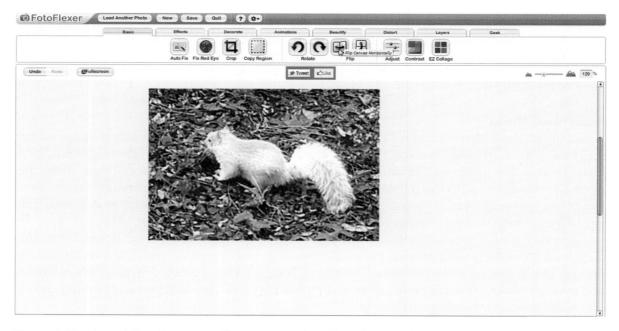

Figure 6.3B I used FotoFlexer's toolbar commands to first sharpen the image, then crop it, then flip it horizontally to produce this final version.

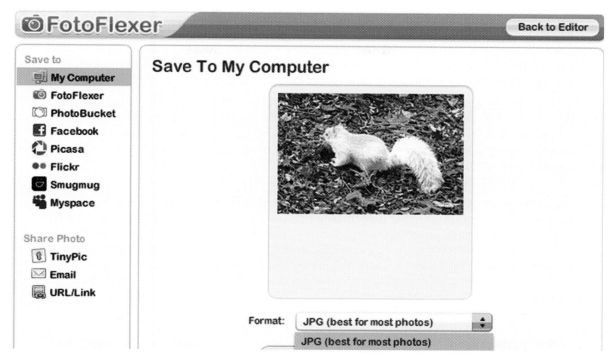

Figure 6.3C At this point in editing, I can use FotoFlexer to save the processed image in either JPG or PNG format to my local hard disk, or to any FotoFlexer-hosted or affiliated Internet location.

Inpaint 5.0 ($19.99)

Inpaint quickly and easily removes objects, people, and more from a photograph, replacing them with a synthetically-constructed background fill-in, based on the pixels adjacent to the area designated for removal. Controls are simple, and offer such added functions as the ability to define boundaries and background textures.

The object removal power of Inpaint (as seen in Figures 6.4A, B, and C) goes a good bit further than you might imagine. Sure, you can remove an unwanted guest from that family banquet scene, erase the dented-up 1962 Ford junker from in front of that magnificent landmark, and so on—but the operation used to deal with "undesirable objects" (Inpaint's automatic background fill-in) can be successfully applied to many other image processing chores. You can use it as an autopilot to handle much of the cosmetic post-processing you used to have to undertake, painstakingly, step-by-step, including the following:

- *Remove* logos, digital camera date and time stamps, photo watermarks, antennas, power lines, architectural features, dead plants, billboards, trashcans, bad paint jobs, and many other undesired artifacts.

- *Define boundaries and texture sources.* Inpaint has tools that allow you to mark boundaries to avoid accidental over-painting or removal of desirable background detail. You can mark areas or objects for removal, but also use simple border definition lines to

exclude background areas or identify texture borders in the background. This means you can remove a person standing in front of a tree without mistakenly removing a chunk of the tree. Similarly, you can mark the "right" area to use for filling in background areas—for instance, by marking the limits of a doorway, fireplace, or wall—in order to avoid replacing distinctive background detail with blank wall.

- Use Inpaint as an *object-removal helper* as part of your software toolkit for photo cropping operations. You can use your photo-editor to crop a photo image and not worry about compromising your graphic image layout concept by having to first completely remove unwanted extra people or objects. You can simply go ahead and crop "as you wish you could," then simply remove the extra "visual debris" using Inpaint. Alternatively, you can remove the distractions first, then crop the image.

- Presto! Inpaint can also be an unexpected *instant retouching tool*. You can substitute it for the scratch eraser, blurring paintbrush, or cloning tool in your primary photo-editing application. Inpaint's powerful background synthesizer can be used to quickly address people's complexion issues, facial wrinkles, double chins, bandages, inappropriate tattoos, intrusive shadows—whatever. You can use it to repair or replace objects in your photo, for instance peeling wall paint, a broken stair rail—even the ugly weeds that have taken over in the far corner of your lawn.

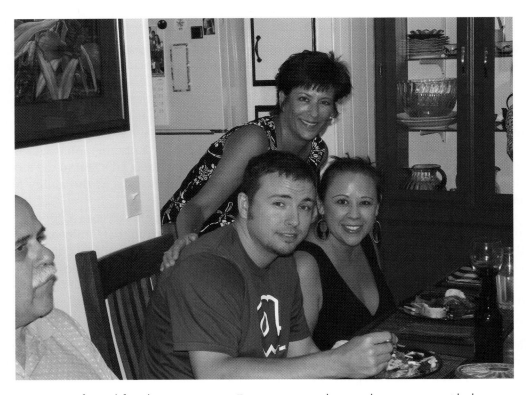

Figure 6.4A An informal family party scene. Everyone is smiling at the camera, with the exception of the gentleman at the left, who is simply not part of the interaction. Here's an opportunity to use Inpaint to get a bit more focus in the group image.

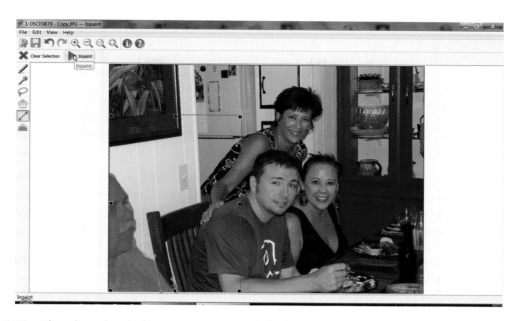

Figure 6.4B The photo loaded into Inpaint. I've clicked on the pencil icon just below the X at the left margin, then used the mouse to "redline" or identify the individual I want to remove and replace by using adjacent background pixels. I also added line indicators to mark the boundaries of the two different textures limiting the edges of the chair's vertical back stile. This allows Inpaint to remove traces of the left arm of the deleted figure, while not blanking out the bottom portion of the vertical wooden upright.

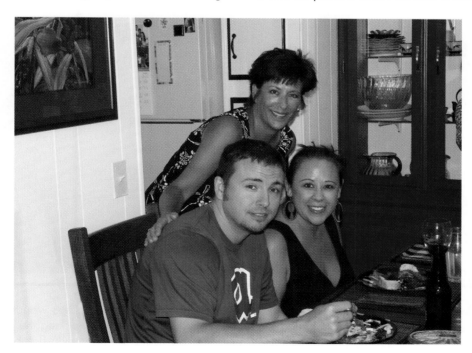

Figure 6.4C The "inpainted" image as finally saved to disk.

- *MultiView* is a relatively new feature of Inpaint that can be used to remove unwanted people and objects in such a way as to "magically" transform your favorite landscapes and scenic vistas. The MultiView function lets you load a "close match" image, then, using your mouse to paint out the unwanted person or object, replaces the area with the matching area from your alternate photo. Thus, if your otherwise ideal shot includes a distracting group of tourists, MultiView can rescue it. From the same location and position where you took the obstructed shot, wait until the unwanted people have moved on then simply take one or more additional photos of the scene. As shown in Figures 6.5A, B, and C, MultiView does the rest.

During the deletion operation shown in Figure 6.4B, I also clicked on the green bar icon, which appears second from the bottom in the left toolbar. I then clicked on the border edges of the last chair rail (just to the right of the blocked-out person) and dragged a straight green line out to the photo boundary, where I unclicked the mouse to end the green bar. The green bar marking instructs Inpaint to continue the wood rail coloring down to the photo boundary edge; if I'd not used it, Inpaint might have automatically applied the white wall background color and texture to the bottom of the chair rail, improperly covering it.

The graphic sequence 6.5 demonstrates how MultiView image processing works once you've loaded one or more "close match" images, with background detail from the alternate image used to replace the unwanted area of your photo.

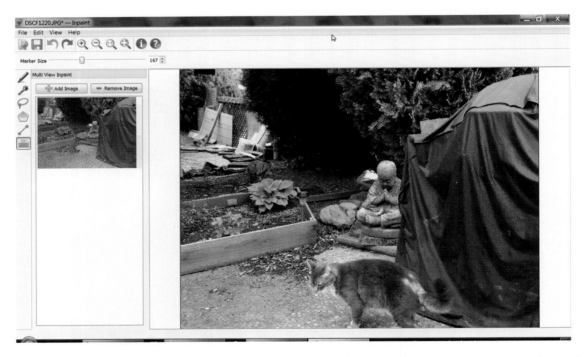

Figure 6.5A Inpaint is already loaded with the larger photo, in which Mason has wandered into the raised garden. The smaller photo at left is a similar view, but without the cat blocking the scene detail. I want to repair the large image, an "irreplaceable" version of the photograph. The blue highlight over the smaller image indicates that Inpaint has already analyzed it and successfully matched, or recognized the matching areas of, the picture.

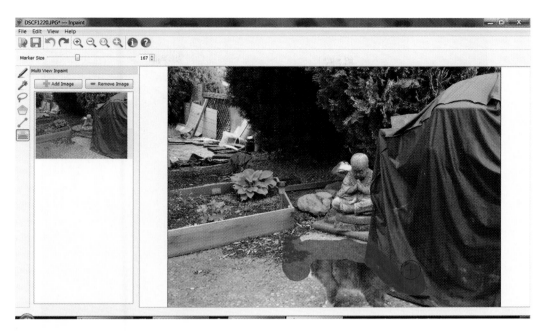

Figure 6.5B I have clicked on the MultiView icon button at the bottom of the Inpaint toolbar, on the left. I have started to block out the offending cat image using my mouse's left button to drag the red-highlighted circular control indicator that contains the plus-sign identifier. If you examine the highlighted area, you will see that Inpaint has already replaced the highlighted area of the cat with matching background detail taken from the other image.

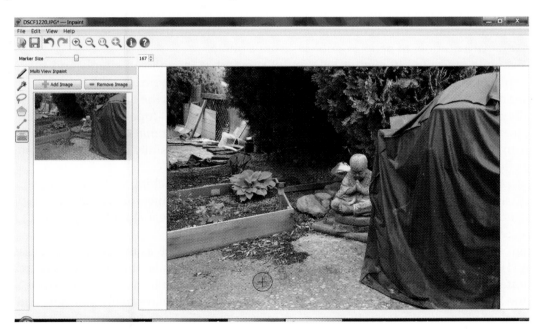

Figure 6.5C I've finished highlighting and have released the mouse button, removing the red highlight indicator to show the successful elimination of my intrusive cat from this "scenic masterpiece."

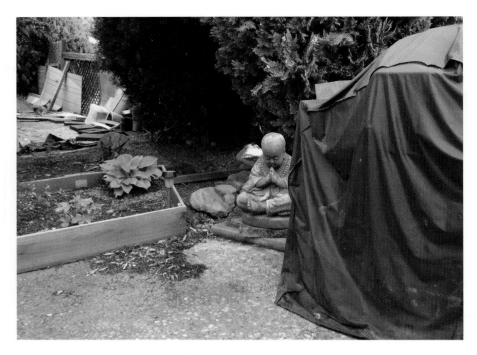

Figure 6.5D The final image as saved to disk.

In the sequence, a small area of my patio stands in for your breathtaking landscape or formal scene, while my cat Mason represents an unwelcome intruder. Although Inpaint can make simple removals using background from the same shot, MultiView is particularly useful in the case of complicated image outlines with lots of adjoining background detail. It also comes in handy when you need to remove a number of people or objects from a photo.

The example presented in Figures 6.6A and B shows that Inpaint can simply and successfully create replacement background detail by analyzing surrounding pixels and patterns. This is a poolside scene in which an unknown man and child are standing in the background. I removed the pool safety rules sign on the wall by simply red-marking the area—Inpaint easily replaced it with the adjacent wooden wall texture. I then needed to use boundary marking lines to continue the white trim at ground level behind the two figures. Inpaint successfully completed this post-processing chore in just a few seconds for each part of the operation.

Finally, as an example of Inpaint's value as an opportunistic retouching tool, I'll demonstrate how it can be used to achieve cosmetic skin improvement. We'll use the image of the pretty young woman with the extravagant crop of freckles first seen in the coverage of CleanSkinFX (Figure 6.2C) for this purpose, as shown in Figures 6.7A and B.

Inpaint support advises that in a densely detailed work area such as this one, the processing be done by (1) selecting small areas for inpainting and (2) using the handles to adjust the squared block to accurately define the "surrounding area" used for analysis of the fill-in color and texture. You can adjust the size of the marked area by clicking on the small dark squares to drag corners and edges. In this way, you can identify fair skin areas to be measured as the basis for correction, ensuring that you don't accidentally include darker or textured areas (such as the eyes, eyebrows, lips, or hair) into the replacement pattern calculation.

Figure 6.6A,B Before and after versions showing the removal of two individuals (and a sign) from the background area of my pool scene.

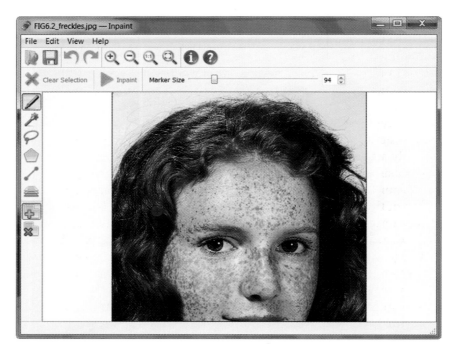

Figure 6.7A The starting image of the freckled subject.

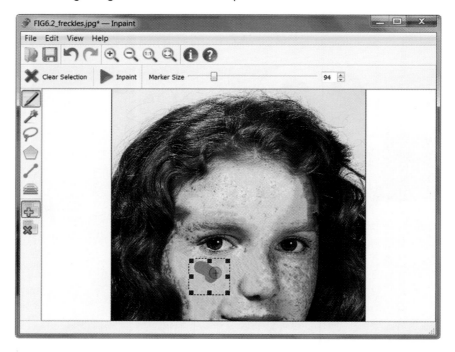

Figure 6.7B The results of a few minutes' work with Inpaint. Additional work followed by final cosmetic touch-up is still needed, but you can see from this example that Inpaint is a plausible alternative approach to specialized retouching applications.

iResizer 2.2 ($19.99)

iResizer is a "content-aware" software tool for rescaling photo images and removing objects from photos while preserving the key features of the picture. You simply use highlight markers to identify the areas or objects in the photo that should remain undisturbed. After you identify those areas, iResizer handles resizing by mostly altering pixels in the "unimportant areas." This differs from normal photo image resizing or rescaling, which generally modifies or changes all pixels uniformly.

You begin by identifying important elements in the image using a green marker. This pinpoints the people or image areas you want to leave undisturbed, leaving other areas as fair game for changes. Alternatively, use a red marker to select features of the image that should be discarded. This "selective emphasis" gives you a great deal of control over the resizing operation.

iResizer avoids distorting important parts of an image while quickly accomplishing the overall resizing or rescaling of the picture. It can also be used to completely remove portions of an image without apparently altering important objects. For example, you can remove selected people from a group picture and close up the spacing to fill in the gap. You can convert a wide landscape shot into a square-format image by automatically closing up space between people or objects in the photo, which works even when the subjects are quite widely separated. iResizer also works in reverse: You can use it to make a photo wider or larger.

As seen in figure sequences 6.8 and 6.9, iResizer easily handles the removal of individuals from a closely gathered group. In most cases, no further retouching is required—but if needed, a bit more touch-up with your photo-editing application of choice is always an option.

Figure 6.8A A starting image of a post-graduation scene. The man just behind and to the right of the couple is a bit intrusive, and the photo might be helped by removing him from the image.

Figure 6.8B The image in iResizer. I've clicked on the red marker in the toolbar and have started marking the person for elimination from the picture. As it turned out, after I completed this red marking operation and clicked on the triangle icon to resize the picture, the girl's head and hair had been distorted a bit by the pixel resizing.

Figure 6.8C Additional marking using the green "important area" marker. I simply identified the width across the girl's body and the graduate's hand so that these would not undergo any horizontal rescaling.

Figure 6.8D The final rescaled image. At first glance it may appear that the image was merely cropped, but a comparison with Figure 6.8A shows that iResizer has in fact removed the unwanted individual and merged the vertical image slices on either side of where he was standing. I would have personally preferred to retain more image area on the right, but accept this as a classic example of not letting the perfect get in the way of the good.

Figure 6.9A A new graduate with three of his cousins. As an afterthought, perhaps the photographer decides he wants a version showing "just the guys" after the ceremony. Here I'm using the red marker highlight to begin identifying the female cousin for removal from the photo.

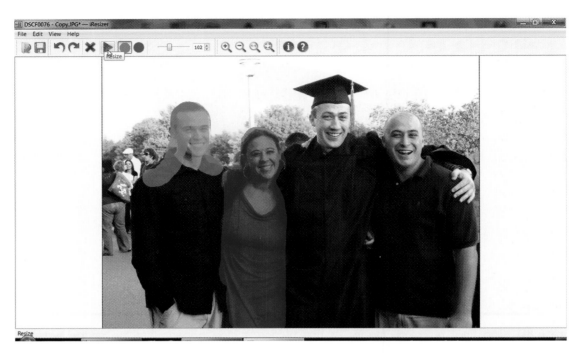

Figure 6.9B The addition of a bit of green "important detail" highlighting across the male cousin's head and shoulders serves to identify the area that should not be reshaped in the horizontal dimension.

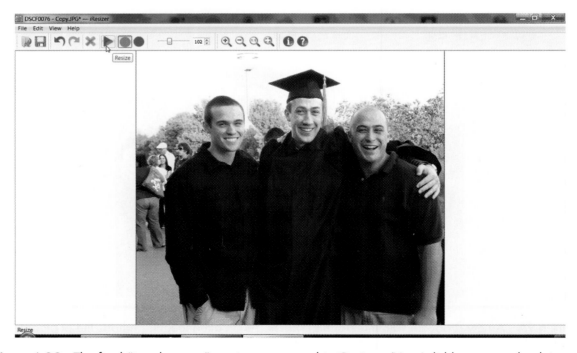

Figure 6.9C The final "just the guys" version as created in iResizer. (Yes, I did have to go back in and remove a few manicured fingers. Did you notice?)

PhotoScape 3.6.3 (free)

PhotoScape is my favorite general photo-editing tool given its intuitive, easy operation and the fact that it's freeware. I use GIMP and Photo Impact Pro when I need a bit more horsepower and control for post-processing, and I also own the best-selling PhotoShop Elements 11 package, which I rarely use; it's simply a matter of personal preference based on what I find easiest and most efficient to use.

In this section, I will briefly demonstrate the basic application and operation of some of PhotoScape's functional tools. Each of the following illustrations occupies no more than a matter of seconds spent first picking a function from the menus, then using the mouse, stylus, or pen to select values or apply an effect using a paintbrush-style control. This is simply a demo, not a planned approach to a photographic post-processing project. I'll illustrate and describe deliberate, planned photo-editing processes later in the chapter.

The process I've just covered shows you how simple it is to complete productive post-processing work using a good and easy-to-use photo-editing tool. It's fast, and pretty much every action or operation is instantly reversible, so you're pretty well protected from disastrous goof-ups. There's an unbelievable difference between today's digital retouching methodology and the bad old days of having to use artist's brushes and dyes and inks for manual photo retouching. (I learned how to do it with that older "technology," but that doesn't mean I ever *liked* doing it.)

In that sense, it's a completely different world we live in now. As I've previously mentioned, I do a bit of touching up with Picasa 3 almost every time I print photographs. And because I use Picasa as my default printing application, the touch-up tools are always right there, ready to use.

Figure 6.10A The full frame of an Oregon coastal scene photograph. This is straight out of the camera, a purely no-brainer automatic exposure from my Fujifilm Finepix S2550HD. It's okay, but if you're anything like me, I'm sure you'll quickly gravitate toward changing things a bit—just to see if it might help.

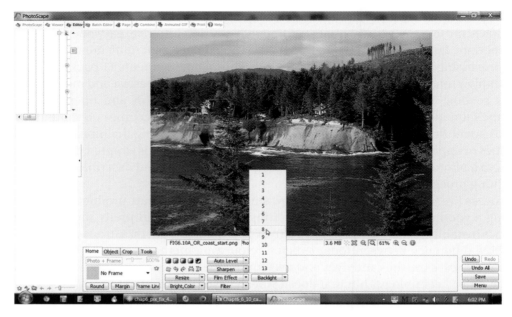

Figure 6.10B I've loaded the coastal image into PhotoScape and applied the sharpen function at value 8 to make the image a bit snappier.

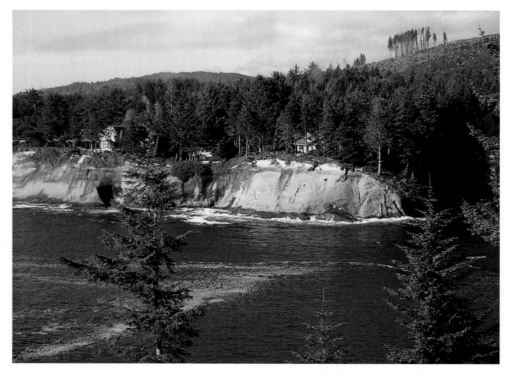

Figure 6.10C Here, I've clicked the auto level button and selected high value. This adds overall brightness to the image.

Figure 6.10D I've chosen the clone function and anchored the area for copying in the white wave area just to the right side of the tree (the tree on the left, this side of the bay). Next, I pressed the left mouse button and began the cloning at the right side of the center of the tree. I dragged the cloning indicator just a bit to the left: You can see that it has begun to copy the white wave pattern right over the middle of the tree.

Figure 6.10E The highlighted bottom toolbar button shows that I'm continuing to use the clone stamp function. I've already removed about half the tree, replacing it with waves and water. You can see the brief help notes appearing in the bottom center text display area. I've selected the largest of the three applicator circles, though you can't see it clearly in the image.

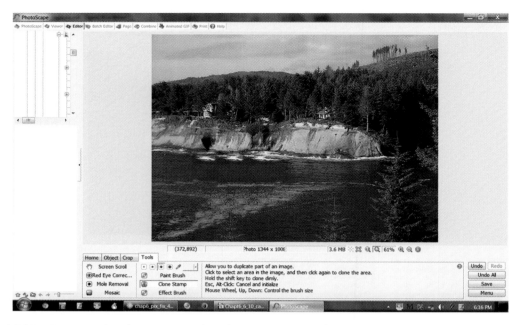

Figure 6.10F I've completed tree removal and am now using cloning to copy the top of the smaller tree, the second tree from the right on this side of the bay. I've copied the treetop a bit lower than the original so that it looks like another, smaller, tree.

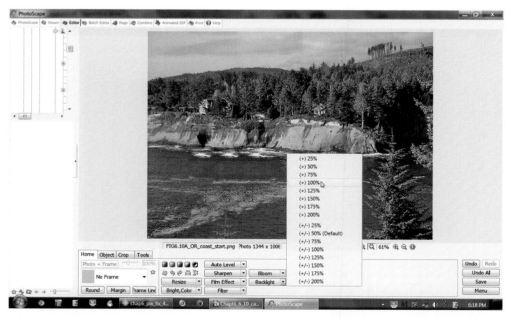

Figure 6.10G I've popped up the backlight menu and selected 100% addition of backlighting. This means that extra light is being added to darker areas of the overall image. You can see the major difference it has made. (You can also add backlight to a smaller selected area by using a mouse- or stylus-controlled "paintbrush" applicator.)

Figure 6.10H I've selected the effect brush for controlled local modification and have chosen the brighten function. I used both the brighten and the darken modes of the effect brush to put more dramatic coloration into the clouds above the coastal area.

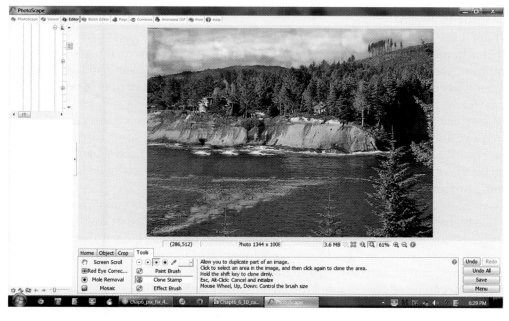

Figure 6.10I I've selected the clone brush and am using it to clone an area of appropriate cliffside dirt and rock. I'm covering up the irregular dark area that was covering part of the cliffside below the large structure on the left. (I don't know exactly what it is, but I want it to go away.)

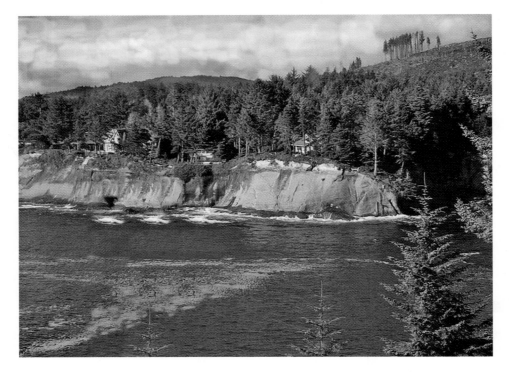

Figure 6.10J The results of my 5–8 minutes post-processing exercise with PhotoScape.

Retouch Pilot ($39.95)

Retouch Pilot is the specialized digital retouching software that really got me hooked into this activity. It's filled with tools that make retouching and cosmetic repair of photo images fast, easy, and fun. It's not freeware, but at $40, you're talking less than a tank of gas or a couple of week's worth of visits to Starbucks. It's easy to download the free trial version to quickly get an idea of how useful this software can be for you.

What does this application do? Simply put, Retouch Pilot "removes imperfections" from a photo. You can remove and repair small technical imperfections, scratches, spots caused by dust particles and hairs, cracks and creases, rips and tears, stains and blotches, and the like. (Such defects may have been on the original print or negative, or they may have been introduced later, possibly during the scanning process.)

But my short description doesn't fully communicate the power this small program delivers. Just for starters, you can totally remove items from a photo; you can move or duplicate areas; you can reverse the direction an object is facing; you can easily and faithfully copy image textures or details; and you can move or "warp" images to change appearance, add or take away bulk, or remove telephone wires, poles, antennas, vehicles, and more.

Moreover, you can do all this so quickly that you won't believe it.

Read on to learn how Retouch Pilot works and—in figure sequence 6.11—a graphic demonstration of how to use it. In that sequence, Retouch Pilot is displaying the image of a young man, at just that age when annoying complexion problems are all too common. The right-side toolbar shows that I've selected the smart patching tool. You can select the size of the paintbrush, using the slider

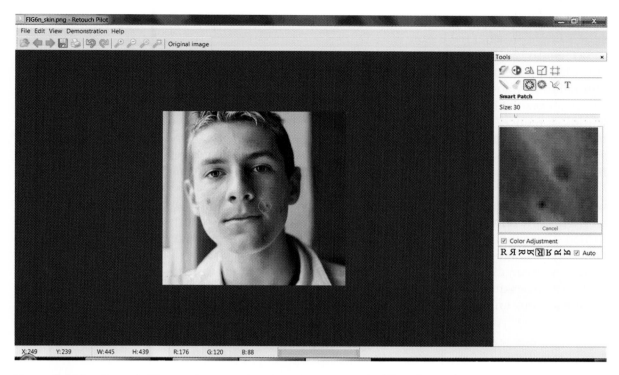

Figure 6.11A Retouch Pilot workscreen showing photo in need of facial complexion improvement.

bar or mouse. The paintbrush tool cursor is displayed over a blemish on the left side of the subject's face. The area enlargement is shown in the square below the right toolbar.

What can Retouch Pilot do to alleviate the problem? You need simply click the left mouse button and move it a bit, away from the blemished area. As you move, the new area under the mouse control is displayed as a replacement or clone area. Once you're satisfied with the way it looks, simply click the left mouse button. That's all there is to it.

Remember, Retouch Pilot gives you the option of using the scratch remover function (toolbar pencil icon). This tool can help with the same sort of image problems. When you position the scratch remover cursor over an image defect or anomaly, this tool examines the surrounding pixels within the cursor circle area, It identifies the "normal"

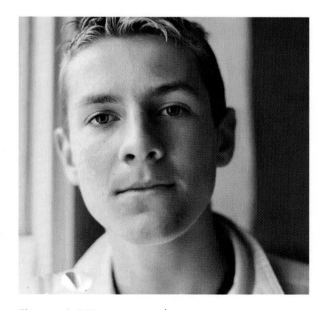

Figure 6.11B Notice the improvement I was able to make to this informal portrait in just 5–10 seconds.

characteristics of that particular area, and overlays that pattern over the unwanted scratch, spot, pimple, or what have you.

In Figure 6.12A, I've done a bit of cloning or scratch removal work on the photo already, then started to use the liquify function. Liquify lets me use the mouse or stylus/pen to drag or move image areas, and deform or stretch/compress the image details. The right side of the Retouch Pilot working screen shows the choices of warp (move or bend or stretch), bloat (enlarge or fatten), or pucker (shrink or reduce), as well as the kind of "strength" or "area concentration" definition to use. With these controls, I can transform or morph shapes. As shown in the figure, I'm attempting to repair some loose neck skin that this gentleman has probably never even noticed. I selected "warp" for this fix, although perhaps "move" or "improve" would be a kinder descriptive term!

The next project (figure sequence 6.13) is designed to give you an idea of the useful (and fun) work you can accomplish with Retouch Pilot in either a professional or hobbyist setting. I started with a historic photograph of the infamous John Wilkes Booth. This portrait of the celebrated actor turned presidential assassin—downloaded from the Library of Congress's online historic image collection—suffers from a multitude of problems including dust spots, scratches, and other signs of age and wear, making it an obvious candidate for restoration. This was honestly a simple quick-and-dirty experimental exercise that took me just 15 minutes; you can achieve better results with additional time and effort.

Figure 6.12A An old fellow who shall remain nameless. (Not a totally ancient gentleman, but you can see he's been around the block a few times.)

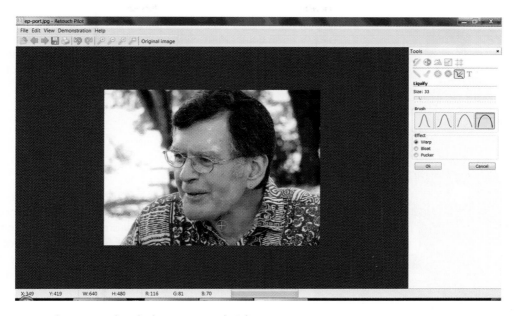

Figure 6.12B The image loaded into Retouch Pilot.

Figure 6.12C The result of a few seconds of "improving" the informal portrait of this elderly—er, I mean, *distinguished looking* individual.

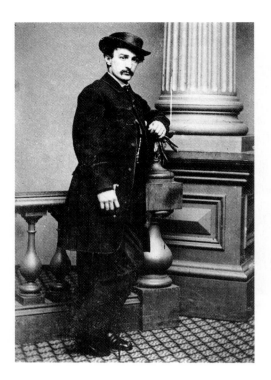

Figure 6.13A At left, the original historic image of actor John Wilkes Booth. It's not a *terrible* photo, considering its age, but it can certainly stand some improvement. We will be using Retouch Pilot for this project.

Figure 6.13B The image loaded into Retouch Pilot, with a closer view of the lower part of the photo from which you can more clearly see the problems with scratching and spotting. I have already selected the scratch eraser pencil icon on the right-side toolbar and cleaned up just a bit in the coat area and now placed the circular area indicator over a small vertical scratch or mark on the right side of the vase shape of the column or standard in the area of Booth's knees. A single click will remove that mark. (I can also click and hold down the left mouse button to use the scratch eraser like a paintbrush, correcting multiple marks to match the surrounding area.)

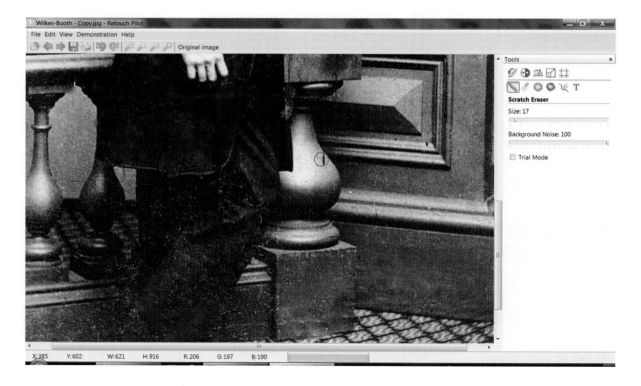

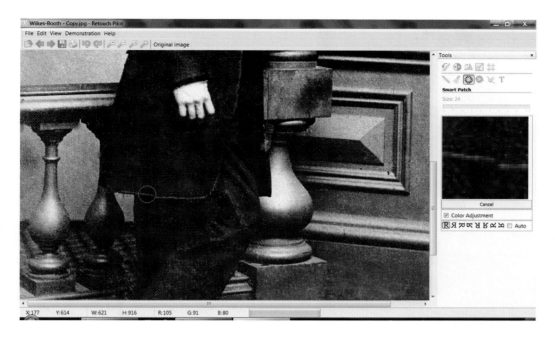

Figure 6.13C The previously identified mark is gone. Now I'm using the smart patching function to repair a missing area on the bottom coat hem. This is a cloning operation whereby I basically select an appropriate replacement image from another area of the coat hem.

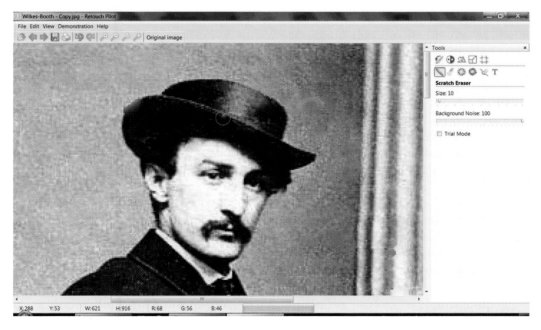

Figure 6.13D Booth's head. I have been using the scratch eraser to clean up the top area of the photo, and here I am removing a small spot from the brim of the hat.

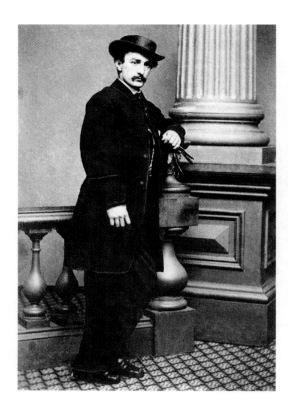

Figure 6.13E My quickly restored version. When you compare it to the original, you can see where I even smart patched a bit of the shiny shoe leather texture onto Booth's right foot to restore some detail lost to the ravages of time.

Recolored 1.1.0 (personal: $19; business: $49)

Recolored is among the memorable programs I've run across in my search for the best DPM software. This application uses technology akin to the powerful motion picture colorization programs developed and used by Ted Turner and George Lucas, among others.

The program is a bit harder to explain than it is to actually use. You simply draw colored lines into image areas of a black-and-white photo that you want to portray in color, picking colors from a palette drawn from such real-life objects as wood, metal, flowers, eyes, skin, hair, and so forth. The program "expands" the colors over the black-and-white area to the boundary or edge of the tone you've highlighted with the color. Recolored offers a natural-looking color gradient rather than the stark and contrasty tempera paint colors you get with a typical computer-based paint program.

Recolored colorizes an area of similar tone or texture until it reaches an "edge." That is, the color coverage is limited by a texture or tone boundary change you've defined with another color or by using a stark white value to indicate a boundary.

This means that when you first start off with just one or two assigned color values and click the colorize button, the colors will bleed through and cover a lot of adjacent space. The fix is simple—you merely draw more colors in the adjacent areas, or you use the "dead white" control to limit the colors.

It's really quite simple—not even as difficult as using crayons in your coloring books when you were a kid. Simply draw colored lines to identify the colors for a given area, click the colorize button,

and continue in that mode until you are satisfied with the results. It's not a time-consuming process. I can typically colorize an image in 10–15 minutes; none has ever taken me more than 30 minutes.

Let's walk through an example using a black-and-white portrait of my parents, Guadalupe and Susie Perez, taken in 1942.

The portrait of my parents shown in figure sequence 6.14 was actually pretty simple to colorize, mainly because the setting and lighting were quite controlled and there was no wide variation in coloring, nor many irregular or detailed edges. Don't get the idea that *all* colorizing jobs are this easy—they're not!

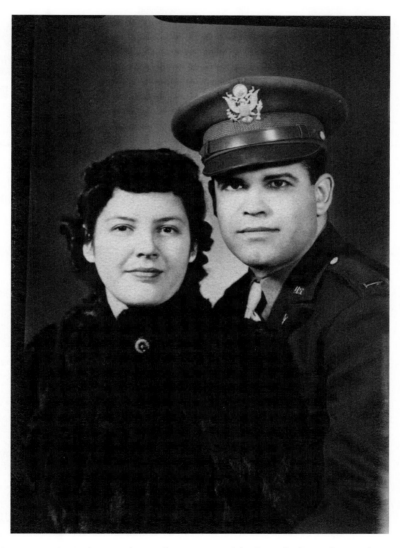

Figure 6.14A A scan at 300 dpi resolution from a 4×6 black-and-white photo of my parents. The digital image needed some minor retouching and spotting, though I won't bother describing that process.

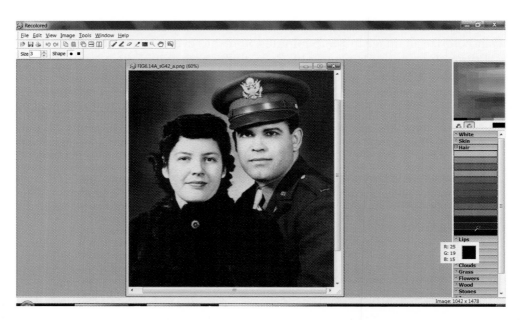

Figure 6.14B The scanned image loaded into Recolored. I've clicked on the right-side color menu to display the standard choice of commonly used hair colors. You can also select any color from the color palette located above the color dropdown menu. Ultimately, I want to use black for both of my parents' hair color.

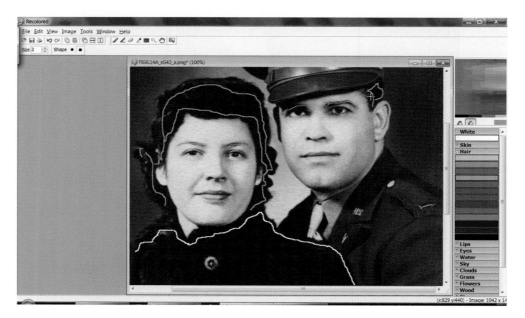

Figure 6.14C Surprise! I've begun by applying orange lines to my parents' hair and eyebrows. While this seems all wrong, there is a practical working reason: If I select black now, I won't be able to see it as I apply it to the black hair areas. So I'll use highly visible orange instead, knowing I'll be able to change all the orange to black with a single click later.

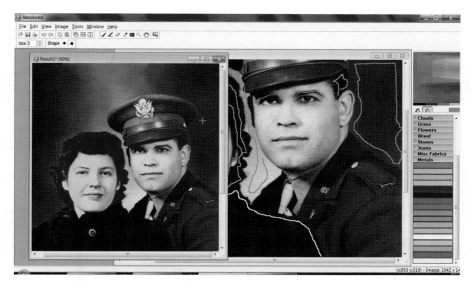

Figure 6.14D I've clicked the colorize icon at the far right of the top toolbar lineup. Recolored applies my color choices and displays the results of what I've done so far. But what is all the weird reddish-orange spilling everywhere? Remember that the color will expand to fill an area until it finds an edge that's been defined with another color or the dead white tone. Note that I've bounded the head areas only with a grayish tone over the background area and also added the dead white line at the top of my mother's coat to stop the color there. I'll change the white to another color later.

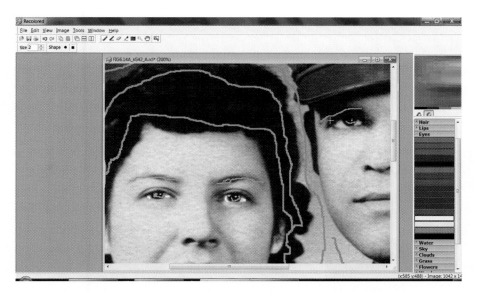

Figure 6.14E A bit more detail work. I've added the orange lines to the eyes to wind up with dark eyes. In my mother's eyes, you can see I've added a regular white for the whites of the eyes and a spot for the highlight in the iris of the eye. I've already added the eye color and highlight spot to my dad's right eye, but I haven't yet added the white for the white of his. Why do I add white to the eyes? Remember, the final black eye color will bleed over into the next area unless I assign another color.

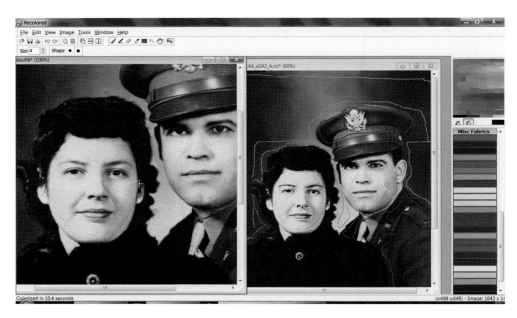

Figure 6.14F I've added some more detail now. I selected black and changed the orange in all areas with a single click in the "replace colors" mode so that now hair, eyebrows, and so-on are black. I've selected and added skin tone color lines for both faces. Why have I circled the eyes, eyebrows, lips and nostrils? Because, again, we want to avoid bleed-over colors when we eventually add color to those areas. Finally, I drew in brown lines to color the hat, coat, and shirt areas.

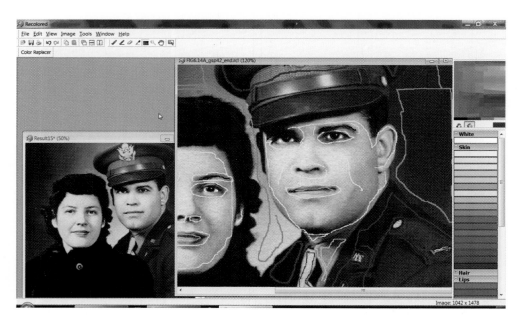

Figure 6.14G I've selected a gold color for my father's hat insignia, collar brass, and lieutenant's bar. This gets easier as you go: Just add a little more every time you refresh the preview and see something else you want to do.

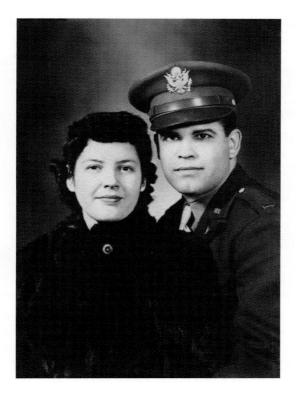

Figure 6.14H I did some refining and made a few trial-and-error fixes, and now here's the final colorized photo—completed in about 12 minutes.

In figure sequence 6.15 we'll look at a more complex example. The photograph is a U.S. Civil War battlefield image by Mathew Brady, downloaded from the Library of Congress collection. I've always been fascinated by such pioneering, stark images depicting the reality of war as this one. Yet, the images are not realistic—they're in black-and-white. Let's see what kind of effect we can achieve by colorizing Brady's original photo.

I think it's safe to say that the colorized version (6.15B) of the photograph emphasizes the immediacy and reality of the tragedy of war. Color makes a vital difference in combat photography, as we learned with the extensive color photo coverage of the Vietnam War and other more recent conflicts. Those Vietnam photographs had a powerful impact on how Americans at home viewed the war in the 1960s and 1970s. As a nation, we essentially experienced the first mass media exposure to the terrible first-person reality of armed combat, by way of vivid, often shocking color photographs that were sent home daily by news photographers and soldiers alike.

I'll close my coverage of Recolored by sharing two additional historic photo applications of colorization, without going into all the functional details this time. (See figure sequences 6.16 and 6.17.)

Recolored isn't your only option, of course; you can do similar and possibly better quality colorizing with PhotoShop or GIMP. The latter applications offer a wide range of editing tools, allowing you to simultaneously work on hue and saturation, gamma, brightness level, and so on. The tradeoff, as noted throughout the book, is a more demanding effort and a steeper learning curve. I think you'll find that Recolored makes this type of work fun and easy, and at an affordable price.

Figure 6.15A The black-and-white Mathew Brady battlefield image loaded into Recolored. The original is on the right, with lines of color added to define the colorization translation. The most recent color preview is partially visible on the left. This is actually pretty quick work: Simply evaluate needed refinements on the preview image, switch back to the black-and-white working image, and add your latest change. You will add many of the "extra" color lines to refine boundaries where colors change; adding more lines also appears to intensify colors. Select colors from the right-column menu of frequently used colors, or pick colors using the color palette menu at the top of that color value column.

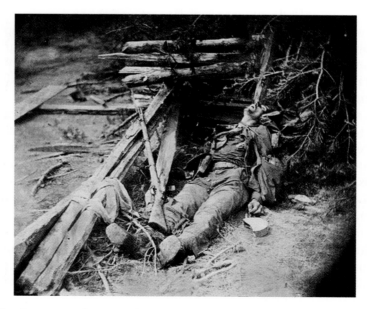

Figure 6.15B The final version of my Brady image colorization project. (Note that the photo looked a little light—as a final refinement, I used PhotoScape to darken the overall image.)

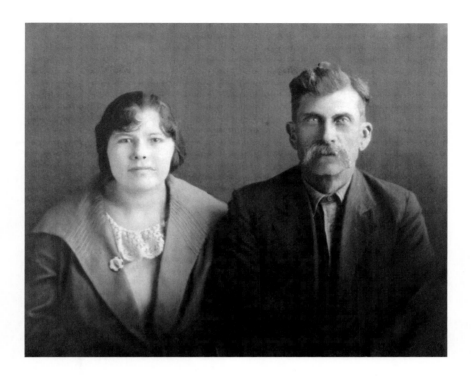

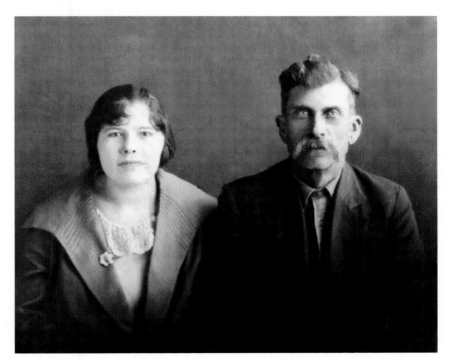

Figure 6.16A,B Original black-and-white and colorized versions of a photo of my paternal great-granduncle Anastasio Perez and his wife, Felipa, in Melvin, Texas, *ca.* 1910.

Figure 6.17A,B Original and colorized versions of a historic photo of a neighbor of mine. The photo shows Gefreiter (Pfc.) Gunther Kerger, paratrooper and machine gunner, a member of Germany's 5th Sturmtrooper Regiment, shortly after the German invasion of France, in 1941.

Image Enlarger 0.9.0 (beta) (also known as SmillaEnlarger) (free)

Image Enlarger is a wonderful free tool for enlarging photos with a minimum loss of quality, as well as a minimal amount of effort. The enlargements are of the whole image frame, so you do have the choice of cropping a photo before or after you enlarge it. As always, it's important to preserve the integrity of your original image, and Image Enlarger makes this easy as it does not overwrite the file. Instead, it saves your new file to the same directory or folder as the original, but with "-e#" appended to the filename, where # is a number added to identify the version number in the case of multiple saved images.

In Figure 6.18A, the top line of the left column controls show that I've set the enlargement ratio to 350%. The second line informs me that the pixel dimensions for the enlargement will be 4480×3360, automatically translated from the percentage number setting. I've set the resolution/quality controls at the top of the right column to what worked out best to my eye. Clicking the preview button provides a quick display of what I can expect. Satisfied, I can then start the enlargement operation by clicking the calculate button: Image Enlarger has already assigned a new filename for my enlarged version in the directory of origin.

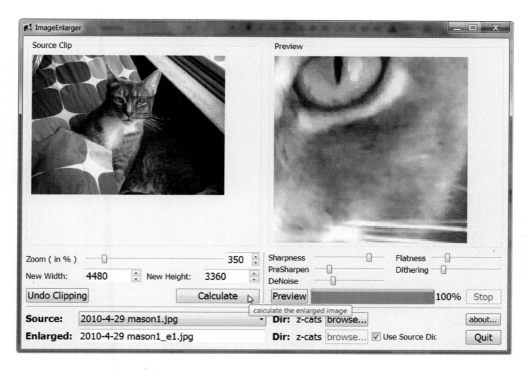

Figure 6.18A A screenshot of the Image Enlarger GUI showing a photo of my cat Mason, loaded as the image to be enlarged.

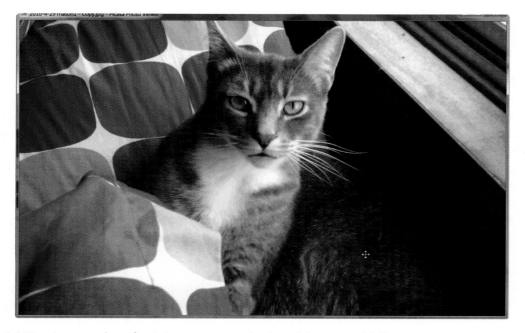

Figure 6.18B A screenshot of a 1:1, or true-size, display of the original full image, measuring 1298×825 pixels.

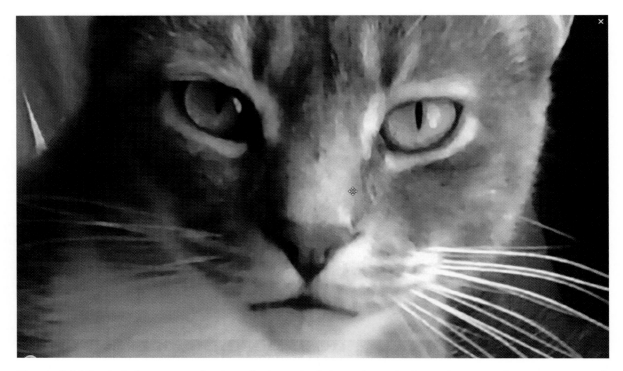

Figure 6.18C A 1:1 true-size display of an area of the enlarged photo. (You're only seeing as much as fits on the full-screen display; the image now measures 4480×3360 pixels.) Considering the extreme enlargement (350%), the level of quality loss is, for me, quite acceptable. (Note that the small blotch on the side of Mason's nose is my mouse cursor, not an artifact introduced during processing.)

Post-Processing Projects Using Multiple Tools

As I've tried to drive home throughout the book, the whole idea of DPM is to use multiple free or inexpensive, easy-to-use photo-editing tools to replace one or more expensive, hard-to-learn, and difficult-to-use software products. DPM alternatives are plentiful in the current software marketplace, and will continue to proliferate in the form of freeware, shareware, and reasonably priced commercial programs.

In the following section I'll provide examples of the multi-tool approach. I'll begin with a short, descriptive title for each project, then list the tools used and describe the actions I accomplished using them. Illustrations will depict many of the major operations. Finally, I'll estimate the time spent on each project.

Restoration of an Old, Poorly Exposed Snapshot

As seen in figure sequence 6.19, our first project is the repair of a photo of my relative, Berta Perez Linton, and a friend, as they visited with Luz Villa, widow of the famous Mexican revolutionary Francisco "Pancho" Villa. The photo was taken in 1966, at the Villa home in Chihuahua, Mexico. Berta was there to do genealogical research and had the good fortune to encounter Señora Villa.

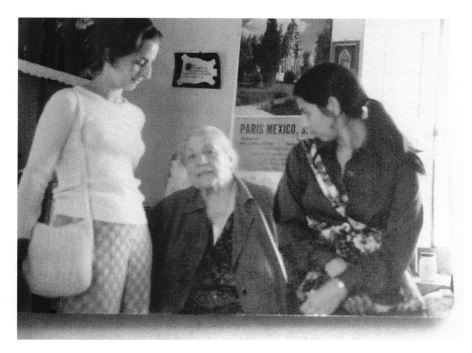

Figure 6.19A The image file scanned from the original color photo showing, from R-L, Berta Perez Linton, Luz Villa, and Berta's friend Martha Hardin. Berta had scanned the photo print to a JPG file and posted it to Facebook. I downloaded a copy of the file and converted it to lossless PNG format. This means there will be a minimum of image deteriorization during the photo-editing process.

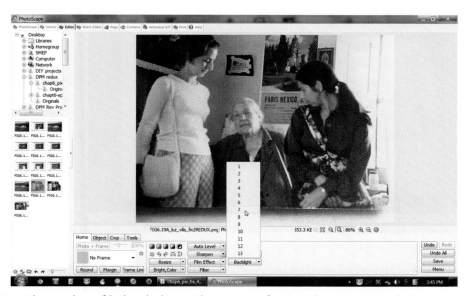

Figure 6.19B The working file loaded into PhotoScape for initial cosmetic work. I've completed some full-image corrections already, using PhotoScape's AutoContrast to improve overall appearance and, as can be seen in the window, the Sharpen function, set to #7. The image is already showing improvement.

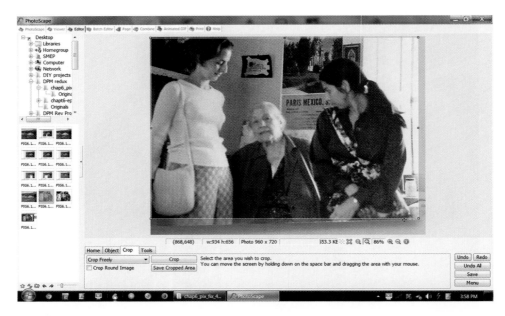

Figure 6.19C Here I've used the Cropping function to straighten the image and crop it to eliminate the snapshot edge from the original image.

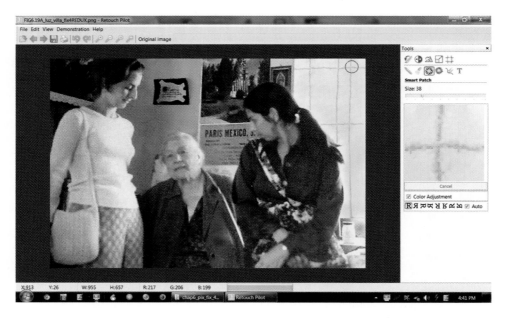

Figure 6.19D Satisfied with the overall image fixes I accomplished in PhotoScape, I've now loaded the image into Retouch Pilot to begin work on image details. In a short session, I have already used the Scratch Remover, Smart Patch, and Concealer functions to eliminate scratches and spots, smooth textures, and improve definition. I've also dimmed the burned-out white of the window area and am using the Smart Patch function to copy window frame details and selectively paste them to other locations. (The cursor at top right shows me pasting a framing element junction that I've copied from another area.)

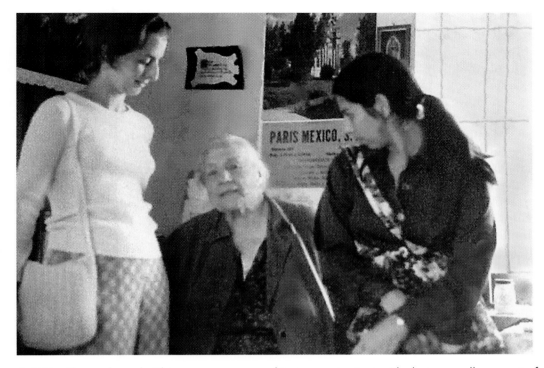

Figure 6.19E The end result. This was a poor quality image to start with, but a small amount of work using DPM tools has resulted in a respectable photo of my cousin's brush with history. The image might benefit from further processing but I've opted to stop here.

The meeting was obviously a remarkable and noteworthy event in Berta's life, but unfortunately the photo fell short of the quality one would want in such an important record. I worked on improving the image for Berta, honored to have the opportunity to restore such a unique photograph.

Total time for this post-processing project: about 15–20 minutes.

Restoration and Colorization of a Historic Photo

The project shown in figure sequence 6.20 involved the restoration and colorization of a historic photo image, downloaded from the Library of Congress's online image archive.

It's easy to recognize President Theodore Roosevelt in a macho equestrian pose from his Spanish–American War days, as Commander of the Rough Riders.

Roosevelt has been a personal hero of mine since my high school days in San Antonio, Texas, and I've always enjoyed reading about him. I've made many visits to his original Rough Rider training site in today's Brackenridge Park, as well as to the old Menger Hotel (1859), right next to the Alamo, where he recruited and interviewed his "cowboy cavalry" in the hotel bar—still in operation today as the Rough Rider Bar.

Teddy later became the youngest elected U.S. president, a distinction he held until the election of John F. Kennedy 60 years later. He was a totally unique historical personage, with a life and career that reads like an American tall tale. What other president could be described as a combination of Davy Crockett, Indiana Jones, and Colin Powell? (Did you know that the Rough Riders had a casualty

rate of 37%, the highest of any American unit in the Spanish–American War? They definitely did not miss any serious action!)

At 115 years old, the faded copy of a commercial photograph featured in the following example was in pitiful condition. It was fun to try restoring it, then to colorize it, in an effort to reveal the "real" Colonel Teddy Roosevelt.

In Recolored, we draw colored lines onto specific tonal areas as a way to direct the automatic colorization processing. The color spreads or expands until it comes up against a different color assigned to a different tonal area, or reaches a border that's been purposely isolated by adding color lines of "dead white" (RGB value 255,255,255).

This means that in this case, where I've only used two colors, they will "bleed" over the whole image—that's what happens when the software doesn't find a color line assignment to mark an adjoining color area.

Total time for this post-processing project: 45–60 minutes.

We could continue working on this colorization project—the photo could probably use a bit more softening, lowered contrast, and the like—but, as in any creative process, at some point you have to say, "That's it—I'm done."

In reaching that point here, I may have been influenced by the subject of the photo. Looking at it now, I think Teddy might have said, "It's a *bully* photograph! Really *bully*!"

Total time for this post-processing project: 45–60 minutes.

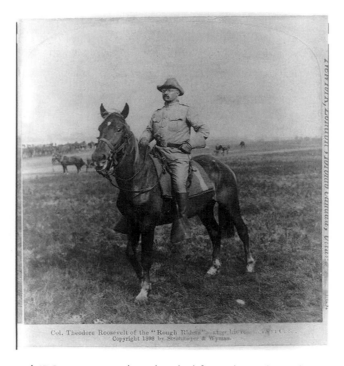

Figure 6.20A The original JPG image as downloaded from the online photo archive of the Library of Congress. I first ran it through the Image Enlarger post-processing utility to enlarge the 571×640 image by about 250%; Image Enlarger's quality settings significantly reduced image grain and contrast. I then converted it to the lossless PNG format for editing work.

Figure 6.20B I'm working with the enlarged PNG file, loaded into PixBuilder Studio. I used the brightness/contrast slider settings and also applied the sharpen function at a 5% value for some quick image improvement.

Figure 6.20C I have loaded the image into PhotoScape, then cropped the photo, using the rotate function to correct the skewed angle introduced in the scanning. Here I am applying 75% added backlight to bring out detail in the darker areas. You may wonder: "How do you choose the percentage of backlighting here?" It's the same as with so many of these post-processing operations: Simply try one modification setting, undo it if it's not quite what you wanted, and keep trying other ones until you're happy with the result.

Figure 6.20D I've loaded the file into Retouch Pilot and, so far, used deepening controls to expand the range of detail and applied the scratch eraser and smart patcher (the cloning function) to remove spots and scratches and to generally smooth the image.

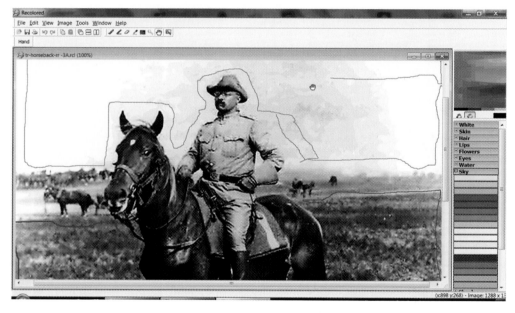

Figure 6.20E The image has been loaded into Recolored and I have started off very simply, adding just a few color lines: Blue in the sky area for the basic sky tones and a green line below the animals in the background to generally define the grassy area. I've just started with the Recolored color definition; when I've finished the colors will bleed across the full image.

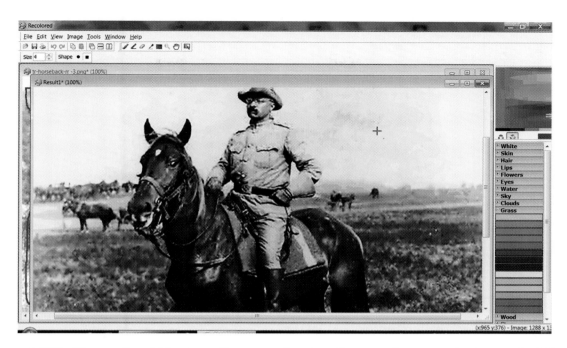

Figure 6.20F The predicted bleeding effect using Recolored's internal preview display mode. We still have work to do.

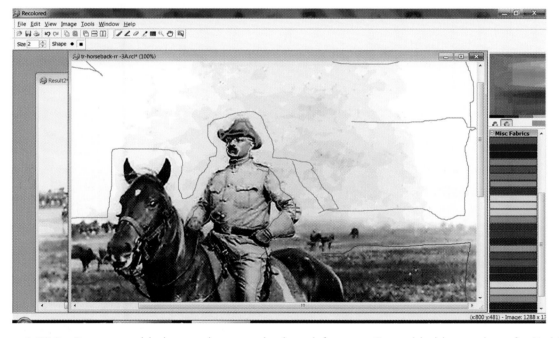

Figure 6.20G I've now added several more color line definitions. I've added brown lines for Teddy's hat, uniform, and gloves, a skin tone for his face and neck area, and small black lines for his hair and mustache. Now we'll begin to see improvements in the image.

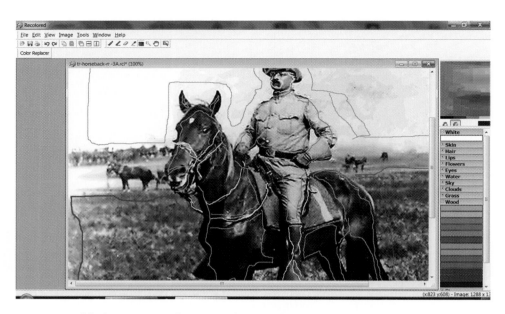

Figure 6.20H I've added even more lines into the Recolored working screen. I've added white for the reins, harness, boots, and so forth, as well as yellowish-brown lines to outline the horse's coat. This is deliberate—not an error. If I used the actual black or brown darker colors to colorize leather objects or the horse's coat, I wouldn't be able to see it clearly while trying to apply the color definition lines, due to the image's dark grayscale tones. Once I've completed this addition of the "wrong colors," I'll use Recolored's global color change function to quickly replace those "visible guide" lines with the real colors.

Figure 6.20I The results after replacing the temporary colors Overall, the image is looking better; now I can begin focusing on the details.

Figure 6.20J In this working screen, I've begun working on the details. I've added additional green guidelines to color in some of the horizon in the background, added dark brown lines to emphasize the horses and wagons in the distant background, and colored in Teddy's belt buckle and shirt buttons—first encircling the buttons with the shirt color, then adding the button color. The circles hem in and stop the button color so that it doesn't bleed over and create unwanted tones by merging with the shirt color. Similarly, the sky and grass lines surround the dark brown selected for livestock coloring. Again, encapsulation or surrounding with adjacent colors is needed so that the brown doesn't bleed over into the adjacent areas.

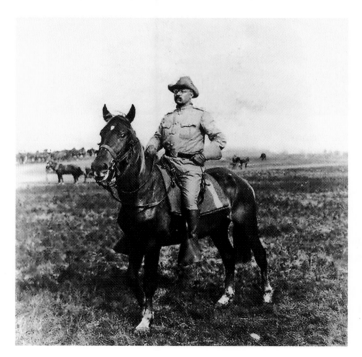

Figure 6.20K Our colorized image of Colonel Roosevelt is beginning to take shape. The uniform color is overly bright—perhaps too far toward the neon end of the spectrum—but it's easy to go back and use Recolored's global color change function to make color alterations. (An alternative approach would be to use one of the general photo-editing tools, such as PhotoScape or PhotoFiltre, to adjust the saturation, or color brightness.)

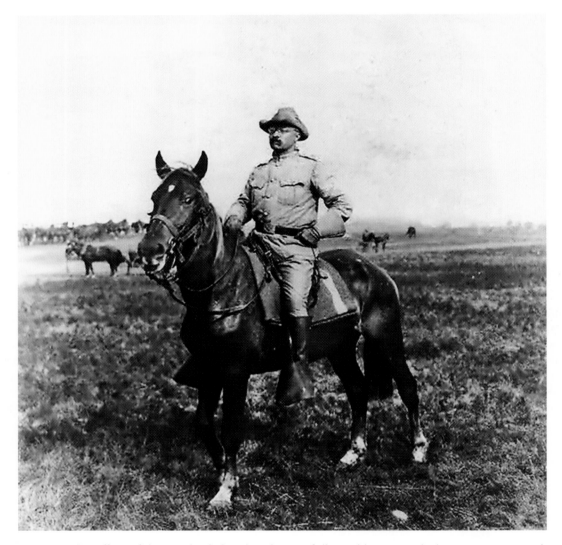

Figure 6.20L　The effect of the single-click color change followed by some darkening using Recolored's level function. At this point, further improvements will be largely subjective, depending on your personal taste and your vision of how the image should appear.

Family Snapshot Colorization

In figure sequence 6.21, I'll share a personal project involving a childhood snapshot of my wife Sandra, on Christmas Day, 1942, in Dallas, Texas. In the midst of a true Christmas gift bonanza, she's all dolled up in her new dress and cowboy boots, enjoying her new picture book. Only a modest retouching effort was needed here, since I began with a good quality, well-maintained black-and-white photo image of the little girl, taken and printed by her dad. I mostly concerned myself with colorizing the image and will briefly walk through the process with you here.

　　Total time for this post-processing project: 35 minutes.

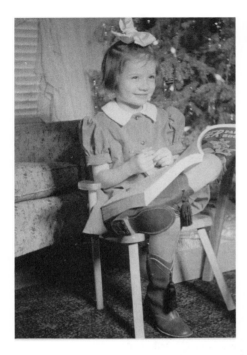

Figure 6.21A At left, the starting image, scanned to JPG format from an old print. This is a delightful portrait that will be fun to see in color.

Figure 6.21B The black-and-white image loaded into Retouch Pilot. I felt it could use just a bit of work to remove spots and improve contrast, along with some easy cloning to repair a few minor problems in the background. It didn't take more than a few minutes to make these fixes.

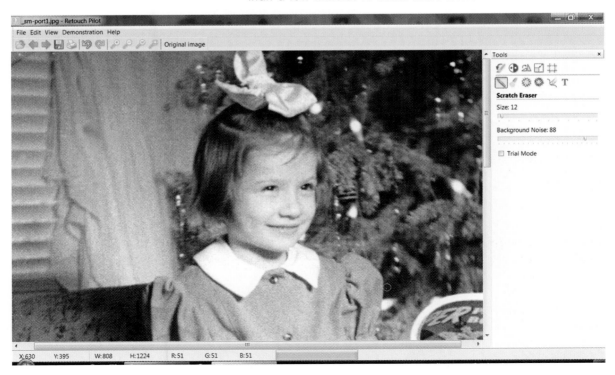

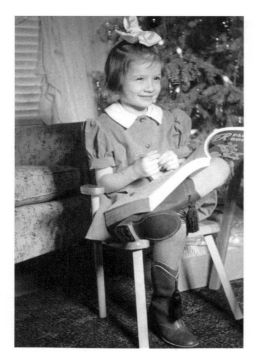

Figure 6.21C At left, the image, nicely cleaned up and now saved as a lossless PNG file.

Figure 6.21D Beginning the colorization work in Recolored. This first quick edit involves only a few added color lines; I've started with the hair, face, forearm, the boot leather uppers, and the darker soles of the boots.

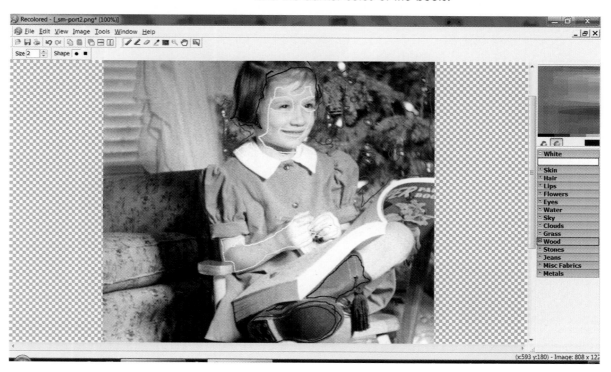

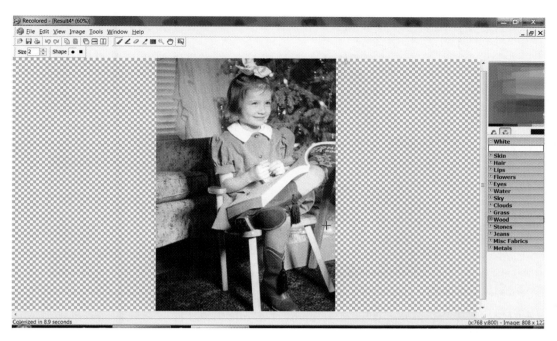

Figure 6.21E The preview resulting from the color line additions in Figure 6.21D. There's a good amount of color bleeding thanks to the small number of color values added so far. My choice for the hair color was a bit off; this girl's hair should be dark brown, and I've made it look almost red.

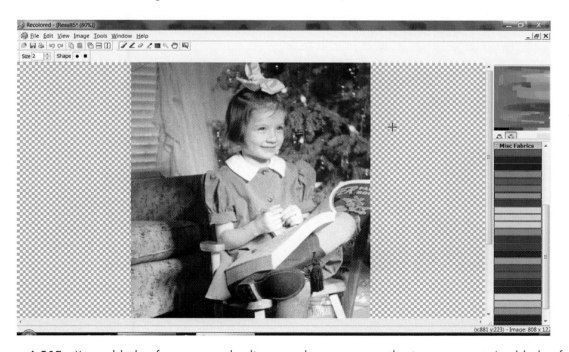

Figure 6.21F I've added a few more color lines, and you can see the improvement. I added a few lines to define colors for the venetian blinds, window curtains, Christmas tree foliage, and sofa. Total time for all the coloring so far: just 3 minutes.

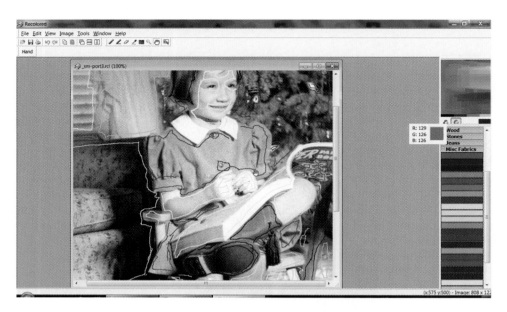

Figure 6.21G Now I'm adding a bit more detail. I've added red lines to color the dress, white lines for the book paper, dabs of color for the tree lights, assorted colors for areas of the book cover, and appropriate color tones for the chair, edges of the sofa, and the wooden railing just below the book cover. I did this additional coloring in just a couple of minutes, even with a few pauses to use the preview mode for tracking my progress.

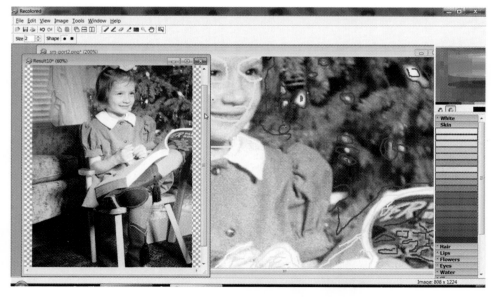

Figure 6.21H A combination view of the working and preview frames. You can see how easy it is to keep track of what you're doing. Please notice in Figures 6.21G and 6.21H how I've used the little green circles surrounding the Christmas tree lights. Remember, this is to "seal off" the added light bulb colors to keep them from bleeding through into the green foliage area. The added red color lines on the book cover are isolated from a bleeding effect without deliberately drawing circular boundaries, since I've simply added sufficient color lines to distinguish the small area details.

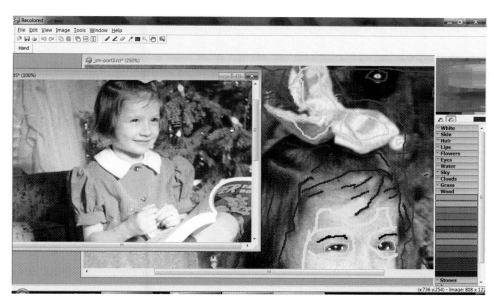

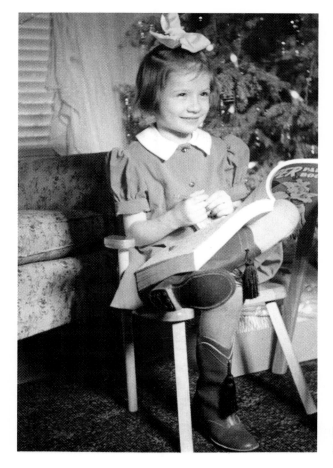

Figure 6.21I At top, again, both the working and preview screens. I've done a global color change on the hair color, changing it from the unwanted reddish to the correct brown tone. You can also see the skin color circles sealing off the colored eyebrows and eye coloring. I've used dead white color dots to create the whites of the eyes and the reflected highlights in the irises of the eyes; if I had not, the entire eye area would have gone toward the designated dark brown eye color.

Figure 6.21J Presto! A "modern" family color snapshot taken way back in 1942!

If you're wondering (1) why I used so many post-processing tools in the examples presented in this chapter, or, (2) how I chose a tool for each part of the process, the answers are simple. First, my goal is to demonstrate the DPM approach of using numerous free and easy-to-use photo-editing tools to get the results you're looking for. Second, I chose tools that best fit the job at hand.

While following my advice should be enough to get you started, you'll only become proficient in DPM image retouching and restoration through experimentation. Through trial and error, you'll soon find yourself settling on a favorite tool for a given application. It won't take you long to realize, for example, that you like Recolored for colorizing but prefer the speedy retouching tools of Retouch Pilot; or that PhotoScape is your favorite tool for cropping, cloning, and sharpening. It's possible you may opt for GIMP's histogram tool when you want to adjust image contrast and exposure.

It really is similar to woodworking, where you may have the option of using a crosscut saw, a rip saw, a back saw, a bench plane, or some other tool. You'll always want to use a tool that makes sense for a given job, but it also needs to be one that works best for *you*.

Digital Image Conversion Issues

The entire process of digital post-processing starts with a digital image that needs improvement. The original image may start off either as a hard-copy print or in a nonstandard photo image digital format. Examples of the latter include such formats as PowerPoint (Microsoft Office), Impress (Open Office), or PDF (Adobe) files or any number of proprietary file formats used by applications with graphic capability.

To effectively use these nonstandard formats, you'll need to convert the images to one of the community standard protocol formats. You can do this by using the save or export functions provided by specific applications, any of the numerous free online format conversion sites, your own locally installed PC image format conversion utility, or even a screen-capture utility on your PC.

Free online conversion utilities are common and easy to locate using a search engine. These include such online services as Fix Picture (www.fixpicture.org), Change Images (www.change-images.com/convert-images.htm), and Online Image Converter (www.online-utility.org/image_converter.jsp). Both free and commercial PC conversion utilities that you can install locally on your PC are also pretty easy to find. For example, the Tucows download website offers user-ranked listings of conversion utilities at www.tucows.com/software.html.

But what if you need to work on something that isn't already in some sort of a digital format? An original image often originates in any of a number of non-digital physical media formats, including

- photographic prints originating from digital, silver, or other analog photo processes;

- printed or published images ranging from low-quality screened images on newsprint to high-quality rotogravures;

- transparencies, including black-and-white or color slides or positive transparency images; and

- originals, reproductions, or published copies of various non-photographic graphic images, such as pen-and-ink drawings, etchings, lithographs, watercolors, or wood block prints.

The first three of these media original forms are probably best converted using digital scanning, although digital camera copying is certainly possible. Scanning is a standardized and automated process that's nearly as simple as photocopying. A good scanner consistently produces high-quality images, automatically, while offering easy adjustment of settings, resolution quality, and choice of digital output format. Scanner hardware avoids the need to physically set up a camera, tripod, and lighting. It dispenses with the need to keep track of focus settings, camera exposure, shadows, reflections, movement, angle distortion, and reflections from glass or other framed transparent covers.

However, the last class of these previously listed media formats may simply require digital camera copying. Originals in these formats are the most likely to be large, immobile or fastened, matted and framed, or covered with reflective glass or plastic—all obstacles to easy scanning.

A handy camera-copying hint: If you do need to copy a framed and glassed image and don't have access to a polarizing filter, it's often faster and easier to copy the image from a slight angle of 20 or 30 degrees, instead of the standard "straight on" camera position. When you take the photo at an angle, you eliminate the reflections from the transparent covering. You then need to do just a bit of post-processing to correct the lens angular-view distortion and put the image back into accurate "square" perspective. This type of perspective correction function is similar to the correction possible using the old-time large format folding bellows camera, à la Matthew Brady. Such perspective correction functions are found in many mid-level photo editors, as well as in the high-end products. This function is generally indicated by terms such as "Correct Lens Distortion," "Fix Barrel Distortion," or "Perspective Correction."

Scanning Equipment

Scanning hardware is no longer the big-bucks budget buster it once was. Conventional wisdom nowadays is that 300–600 dpi of scanning resolution is perfectly adequate for good-quality prints up to 8×10 size.

Ed Hamrick, creator of the excellent VueScan third-party scanning software application, writes, "The other important decision that affects how long a scanning job will take is the resolution that you use for scanning. A good rule of thumb is that most photos don't need more than 200 dpi (dots per inch) resolution, and most slides don't need more than 2000 dpi. For instance, scanning photos at 300 dpi will take twice as long and use twice as much disk space as 200 dpi, but few people will see much difference visually" (Hamrick, 2013a).

Wayne Fulton, another acknowledged wizard of scanning technique, hosts an informative site called Scanning Basics (www.scantips.com). He presents good evidence supporting scanning at 200–300 dpi. He also explains why even expensive commercial and professional printer equipment doesn't actually derive any advantage from large, high-resolution image files: "The [commercial quality] printer machine only has capability in the 250–300 dpi range. If their [digital photo file] dpi number comes out higher than 250 or 300 dpi, it won't hurt, but it cannot improve the quality" (Fulton, 2013).

Accordingly, 8×10 print size is acceptable for most of us, most of the time. In any case, if you need larger exhibition print sizes such as 11×14 or 16×20, you'll need printers with paper width capacity that are much more expensive. Buying one of these may also be a "worst case" trap in that you'll pay a premium for a rarely needed capability.

I'd recommend that if you need larger "fine-quality" prints, simply outsource the printing job to the photo lab in your local Walmart, Target, or Walgreens or to a local commercial photo lab. Before you use such a service, you can always examine examples of the quality of photo prints these shops produce. The commercial photo labs will generally allow you to reject any prints you find to be poorly done—but, again, although they have specialized laser printers that can produce oversized prints, they may not be able to print at a significantly higher resolution than you can with your standard inkjet printer.

Photographer Ken Rockwell warns about depending on these labs. In his webpage "Recommended Photo Scanners," he writes, "All prints today, even from film, are printed with mini-lab equipment that has a digital intermediate stage and only prints at 300 DPI, so there isn't any more detail to be had by scanning above 300 dpi. If you have a fine optical print by Ansel Adams then there's a lot of extra detail to scan, but not from modern lab prints" (Rockwell, 2013).

Processing multiple images, or "batch scanning," methodology is covered in some detail in the text of Ed Hamrick's excellent *Batch Scanning Tips* (Hamrick, 2013a). The "Standardize, Standardize, Standardize" section of Chapter 8 also offers useful coverage, including pointers to a number of online guides to the art and science of scanning.

Photo Scanners "for the Rest of Us"

My main point here is that most moderately priced or inexpensive (and favorably reviewed) scanners for personal or office use will be quite acceptable for routine image-copying tasks. Virtually all of these products provide 300 dpi scanning resolution, as well as the 600–1,200 dpi considered to be high-resolution quality for scanning photo prints.

For example, my budget Epson WorkForce 630 multipurpose ink jet printer/copier/scanner/fax unit has selectable scanning resolution in steps from 50 to 9,600 dpi. (The sale price at my local Fry's Electronics was $49.95 back in 2011!) I used it to produce all the scanned images in this book and for all the post-processing jobs I've done for other people. I also still use my trusty old (2001) Epson Perfection Photo 1200 flatbed scanner, with letter-size/A4 capacity and a slide- and negative-scanning attachment. It's still quite handy for quantity scanning jobs; my VueScan scanning software allows very efficient scanning of multiple photos with one exposure. VueScan automatically crops and saves each image as a separate file, automatically saving them using sequentially numbered file names.

Furthermore, it's easy to scan photo prints or images far larger than the 8.5×11.7 flatbed scanner glass. Simply make multiple overlapping scans to get complete coverage of the larger image area; next, use the panoramic-stitching function provided in many of the photo-editing software products as well as in the various and widely-available inexpensive or freeware image-stitching utilities.

You can quickly see an extreme example of assembling an image using this type of "stitching" function at the Autostitch webpage (cs.bath.ac.uk/brown/autostitch/autostitch.html; the free Windows demo utility you can download there is a lot of fun to play with). Matthew Brown developed the Autostitch technology as a graduate student at the University of British Columbia. It has since been licensed by several commercial software producers, including Autopano Pro (www.kolor.com; Windows, Mac, Linux) and Serif PanoramaPlus (www.serif.com; Windows). Autostitch software technology has even made it to the big leagues: It's been licensed for motion picture use by the movie special effects wizards at Industrial Light and Magic, Inc. (founded in 1975 by George Lucas).

No, my old Epson isn't at the cutting edge any longer, though it was highly regarded by reviewers when introduced more than a decade ago. It continues to produce great-quality photographic scans, making it more than satisfactory for my purposes. My retouching customers, including friends, family, church, and a few freelance customers, have all been quite happy with the output from this unit. As saith the venerable sage: "If it ain't broke, don't fix it."

Scanner Hardware Marketplace

I'd like to present here some information to guide you in selecting and buying scanner hardware. There's a big spread of prices and a wide range of hardware quality and sophistication from which to choose, but DPM-minded users will typically want to look for good value in the low- and moderately priced personal or office levels of equipment. Clearly, credible performance evaluations are more important to take into account than are vendor claims about their products. To this end, I'll

recommend several authoritative and objective sources of hardware reviews and comparative evaluations.

First, I categorize scanner equipment into general groups:

- Cheap Special-Purpose ($35–$150): Small, portable units, "feed-through" rollers for prints; small slide-scanning units (some combining print-scanning ability). Manufacturers include Ion, Pacific Image, VuPoint, and Wolverine.

- Quick-and-Dirty ($50–$250): Economical flatbed and multipurpose scanners, usually including basic scanning software. These include standard consumer/office products made by manufacturers such as Canon, Epson, Hewlett-Packard, and Lexmark.

- A Bit Pricier ($250–$1,000): Higher-quality, better technology with some added features, such as slide-scanning function. General electronics marketplace vendors.

- Top-of-the-Line ($1,000–$25,000): Now you're running with the big dogs, way out of my league. These are the Cadillacs and Bentleys of the genre, with automatic everything: automatic feeding, automatic two-sided scanning, automatic slide feeding and scanning, automatic built-in OCR, automatic database conversion from printed text—among other bells and whistles. These are industrial-strength products from manufacturers such as Hewlett-Packard, Kodak, Pacific Image, and Sony.

Photography and computer magazines such as *Popular Photography* and *PC Magazine* routinely publish credible reviews and comparisons of scanner products. Archives of their evaluations are easily available online. Wide review coverage is also available on the numerous specialized digital photography websites, as well as on a good number of sites specializing in coverage of digital post-processing software and scanning equipment.

Professional photographer Ken Rockwell presents "Photo Scanner Recommendations" at www.kenrockwell.com/tech/scanrex.htm. Here you'll find dependable information from a knowledgeable professional.

B&H Photo Video, Inc. is an established electronics superstore and online retailer offering a full range of photo and video products. Along with its retail service, it also provides a great deal of educational and product comparison information. Its website is a treasure trove of product information, reviews, and shopping guides. Visit the B&H "35mm Film Scanner Roundup" page (www.bhphotovideo.com/indepth/photography/hands-reviews/35mm-film-scanner-roundup) for valuable detail on scanner products.

Also from B&H is the review guide, "Holiday 2012: Digitizing Your Analog Media" (www.bhphoto video.com/indepth/photography/hands-reviews/holiday-2012-digitizing-your-analog-media), which offers a solid introduction to the digital conversion of film negatives, slides, and traditional paper photos, along with links to specifications for products the firm resells.

Amateur photographer Justine Dorton describes her own practical experiences in scanning slides in a post to the MyTrees.com Family History website (Dorton, 2011). She bought a VuPoint Digital Film Scanner for $120 and brashly set off to scan the "thousands and thousands" of 35mm slides taken by her father back in the 1970s. Neither a skilled photographer nor a trained archivist, she simply wanted to preserve her father's photo images from the inevitable color and surface deterioration expected with color film.

Dorton was surprised and pleased by the simplicity and speediness of the operation, even using her low-budget scanner hardware, but was disappointed by the wide presence of dust spots and

color shifts (caused by age) on the images. She found it was too time-consuming to attempt to correct images one at a time during scanning by making careful scanner adjustments, but hit on a solution: She could quickly address most of her image quality problems by using Photo Impression digital photo software to post-process the scanned photos.

Dorton writes, "Within Photo Impression's editing program you can adjust color levels, automatically remove red-eye, crop and adjust image size, straighten or adjust the lay of the photo, and even blur or harden the background and edges of the photo, which is something that can create a more artistic feel to your image. Once my images were in the program, I did notice a small amount of vignette effect on the image. This simply means that the center of the picture was slightly lighter and brighter than the outer edges. This probably occurred as a result of the scanner bulb as it was capturing the image. The effect was minimal, and may only be noticeable to a carefully watchful eye" (Dorton, 2011).

That's a good user experience report, and it bears out the practical advice given by many experts: Spend most of your slide-scanning time simply aiming for the best images you can get with batch scanning, applying the automatic "cosmetic" corrective processing provided by the scanning software: This may address most of your image degradation problems; if you decide additional corrections are needed for certain images, turn to post-processing software.

The reality is that there's no need to perfectly expose and correct every one of, say, 5,000 photo print images you want to convert. (This is especially true if you can realistically expect to use only 150 of them for your high-quality output purposes.) Normal batch-scanning processing captures images that you can post-process *when you really need them*. Again, as suggested by the 80:20 rule, this applies the "just in time" approach, avoiding the greater effort needed for the "just-in-case" option.

You might also consider using VueScan, which offers powerful automatic basic corrective processing during the initial scanning process. VueScan—mentioned earlier and covered in greater detail later in this chapter, in the section on "Third-Party Scanning Software"—can significantly improve the overall quality of your photo images during large-scale scanning operations, even when scanning multiple photo images with a single exposure.

Find Good Advice about Scanning Hardware

There's a broad range of scanner hardware available, at costs predictably correlated with technology and capability levels, and a pragmatic investment decision merits a cost–benefit evaluation of the products. Before starting the research, consider your requirements. The average DPM user will be looking for objective information about quality/durability, ease of use, operating efficiency/productivity, and cost/value. Your hardware requirements will vary depending on image quality and output requirements for the images you will be producing from your digital copies.

Consider the wisdom of the experts I recommend, then remember to be super-realistic about your requirements. It will be useful to examine both individual product reviews and comparative product evaluations of the equipment you're looking at.

The following are among the best articles I have found for this purpose:

- CNET, "Printers" (reviews.cnet.com/multifunction-printers).

- *Consumer Reports.* "Photo scanners review: We tested four devices to find out how well they can digitize pictures" (www.consumerreports.org/cro/2014/07/photo-scanners -review/index.htm). Good review of small personal quickie print scanners.

- Ken Rockwell. "Photo Scanner Recommendations" (www.kenrockwell.com/tech/scanrex .htm). Pro photographer Rockwell offers recommendations for scanning prints and slides.

- Norman Koren. "Making fine prints in your digital darkroom: Scanners" (www .normankoren.com/scanners.html). Professional photographer Koren maintains a terrific information source relating to the selection and use of scanners.

- *PC Magazine*, "Multifunction Printers Review: All In One Printers Review" (www.pcmag .com/reviews/mfp).

- *PC Magazine*, "Top 10 Multifunction Printers" (www.pcmag.com/article2/ 0,2817,2371839,00.asp).

- TestFreaks.com. "Scanners" (www.testfreaks.com). TestFreaks.com presents calculated rankings and links to literally millions of reviews on a wide range of products. Product reviews feature a numeric quality rating based on the spread of reviewer opinions. Reviews are collected from consumer review sites, professional industry magazines, and online retailer websites, as well as from comments made by site visitors. Links are provided to original attributed reviews.

Scanning Software, Methods, and Applications

I've loaded you down with information about scanner hardware—now it's time to find out about the software that makes the hardware useful and practical, and how to use it for specific projects and procedures.

Third-Party Scanning Software

Most scanner hardware manufacturers bundle a perfectly usable scanning software package with their product. Some of these are proprietary, some are licensed from a software provider, and they run the gamut from very basic application to substantial software suite. When what comes with your scanner isn't what you need, a third-party scanning software package is a good option and there are a lot of them out there.

Because virtually all scanner manufacturers and digital photo software publishers have made their products compatible with the TWAIN protocol, all scanning hardware and software is compatible at the practical working level. So it's pretty easy to switch your software if need be. (As an aside, "TWAIN" is not an acronym. The electronic industry's nonprofit TWAIN Working Group never christened the protocol with a formal name. The name supposedly derives from Kipling's *Ballad of East and West*, which contains the line, "and never the twain shall meet." The industry's inside joke has always been that TWAIN is an acronym for "Technology Without An Interesting Name.")

The TWAIN software protocol and API (applications programming interface) defines communication between software applications and imaging devices such as scanners and digital cameras. It is not a hardware driver. You still need a "device driver" for the computer to communicate with printers, scanners, and cameras. However, TWAIN makes life easier for all users and vendors because it is the basis of across-the-board software and hardware compatibility in this particular technical area.

TWAIN thus provides the opportunity for using an array of third-party scanning software applications to control scanner hardware. Many if not most software packages use TWAIN compatibility

to provide their "Acquire Image" external device capability. Even general software, such as word processors and editors, desktop publishing packages, and digital personal assistants, are able to use this standard to easily provide for TWAIN input from hardware such as scanners, digital cameras, video cameras, webcams, and more. (I view this as another victory for standard protocols over proprietary exclusivity!)

If you are accustomed to using TWAIN scanning input from software such as Microsoft Word, ACDSee, or Information Select, feel free to also use these familiar applications for your photo scanning work. As we've already discussed, most knowledgeable users agree that 300 dpi is satisfactory for the majority of photo print scanning projects. Don't use (and pay for) huge amounts of disk space while greatly increasing your processing time in order to achieve 1,200-dpi or higher levels of resolution unless it's really necessary.

In light of the near-universal compatibility provided by TWAIN, I have no reservations in stating that anyone who wants to get more flexibility, workability, and efficiency in scanning hard-copy photos or images to digital formats would be wise to consider good-quality, third-party scanning software. There is an abundance of freeware, open-source, and inexpensive shareware available in this category, and such products are made to order for those taking the economical DPM approach. You simply don't need to pony up the $700 required to use Photoshop as your scanning software; that's going to be overkill in most cases, unless you're trying to impress someone. Instead, consider the third-party solution—VueScan—described in the section that follows.

VueScan 9 Scanning Software

I recommend the moderately priced VueScan package (www.hamrick.com) as the best package for print scanning conversion operations. Ed Hamrick's website offers free trial downloads and quite affordable pricing: the standard edition for $39.95 and the professional edition for $79.95.

Vuescan (at version 9.4.08 in November 2013) is purportedly the world's most widely used scanner software, with over 10 million downloads to date. It's compatible with just about all known scanner hardware, currently supporting over 2,400 different scanners. If you'd like to try it out, it's not a very large installation file; it takes just a few minutes to download and install. Hamrick offers a huge list of compatible scanners at (www.hamrick.com/vuescan/supported-scanners.html).

Many users and reviewers recommend VueScan for use with scanner hardware no longer supported by its manufacturer. In another budget advantage, VueScan 9 makes even your older scanner hardware compatible with newer versions of the full spread of modern operating systems, whether Windows, Mac, or Linux. Back when I bought my Epson Perfection Photo1200 in 2001 (the Stone Age in Internet time), I was probably still using Windows 95 or 98. With VueScan, that old hardware is still chugging along just fine in Windows 7.

Hamrick Software even offers a free VueScan Mobile Free version that works with iPad, iPhone, and Android phone or tablets, using the built-in camera for scanning. Predictably, it offers easy network and hardware connectivity.

Programmer and photographer Ed Hamrick is responsive to his customers, issuing minor version updates nearly weekly. His website contains a wealth of extensive learning and tutorial materials, numerous useful guides and hint sheets, and many helpful external links. He's also produced one of the best and most practical free guides to batch scanning: "Batch Scanning Tips" is downloadable at www.hamrick.com/blog/2013/06/05/Batch-Scanning-Tips.html. I highly recommend referring to this guide before jumping into any large-scale scanning project.

Batch Scanning for Large-Scale Document and Photographic Conversions

Batch scanning processing is of great interest to information professionals focused on preserving and studying graphic records, or even non-graphic records. Graphic record media include two-dimensional images, including photographic prints, slides, negatives, hardcopy documents, periodicals, books, manuscripts, sheet music, vintage or historic written or printed documents, and so forth, but many archival and historical practitioners must also deal with non-graphic formats such as audio, video, and electronic records—and even obsolete electronic formats like kinescope and half-inch videotape.

Ed Hamrick works hard to share valuable information. His site recommends and links to numerous online resources offering content about scanning methods, written by a wide group of specialists. These four resources will be of particular interest to librarians, archivists, and museum professionals:

- "Preserving History: How to Digitally Archive and Share Historical Photographs, Documents, and Audio Recordings" (archivehistory.jeksite.com/index.htm) John E. Kennedy has written and compiled an amazing amount of information about large-scale scanning projects, thoroughly covering technical, management, and procedural detail. He makes his information free on his website and hopes to make it available in a print-on-demand book format as well. It's an encyclopedic effort: complete coverage of scanning technology and methods; hardware and software reviews with extensive coverage of batch processing; automation of batch-scanning operations, with details for popular scanning software and hardware; detailed reporting of numerous large scanning projects; technology and methods for audio and document conversions; slide show software; display of original and scanned material—and on and on and on.

- "A Few Scanning Tips" (www.scantips.com) Hamrick calls this "an excellent web site with scanning tips maintained by Wayne Fulton. It contains scanning tips for flatbed scanners and film scanners, a summary of available film scanners , a review of VueScan and an example of using VueScan's cleaning, intensity, and contrast options" (Hamrick, 2013b).

- *The VueScan Bible* (www.rockynook.com/books/162.html) Sascha Steinhoff, author of the best-selling book *Scanning Negatives and Slides*, has also produced *The VueScan Bible*, an invaluable ebook guide and reference. Steinhoff's informative ebook expertly guides the reader through all stages of using VueScan, from step-by-step software installation through guiding you in the work flow of scanning operations. He also maintains an excellent scanning operations information site (scanmagazin.org); unfortunately, it's written entirely in German.

- "The DPI You Should Be Scanning Your Paper Photographs" (www.scanyourentirelife .com/2010/dpi-should-be-scanning-your-paper-photographs/) Amateur Custis Bisel set out to scan his sizeable family photo backlog and then expanded the project to include other important family records and keepsakes. He recounts the factors, compromises, and practical tradeoffs he used in selecting standard scanning resolutions. Bisel did an amazing amount of background technical research and clearly and fully documents his reasoning. There's also a good amount of valuable information exchange in the attached comments. You can just skip right to the end of his page to see his table of photo sizes and corresponding dpi settings for pretty good results. His recommendations range from using 600 dpi to 1,000 dpi, depending on print size; most of them are for a 600 dpi setting.

For more about VueScan, see the "Standardize, Standardize, Standardize" section in Chapter 8 and Ed Hamrick's aforementioned *Batch Scanning Tips*, at www.hamrick.com/blog/2013/06/05/Batch-Scanning-Tips.html. There is also a direct link to this reference at the DPM website.

More Good Scanning Information

For additional objective, realistic, and authoritative information about high-quality scanning, try these resources:

- B&H Photo Video, Inc., Film Scanner Comparison Chart (www.bhphotovideo.com/FrameWork/charts/comp_filmscanners.html) An example of the kind of comparative technical information available from B&H. They provide a wealth of information for anyone interested in learning about photo and video topics.

- Library of Congress, "Personal Archiving: Preserving Your Digital Memories" (www.digitalpreservation.gov/personalarchiving) An excellent, clearly written guide to planning, procedures, quality control, and maintaining digital collections.

- LeFurgy, Bill, "Preserving Your Personal Digital Memories," American Library Association, Association for Library Collections and Technical Services, April 28, 2011 and April 26, 2012 (www.ala.org/alcts/confevents/upcoming/webinar/pres/042811)
 Excellent video webcast about professional-quality digital preservation work, covering planning, methods, and tools. "Digital photos, electronic documents, and other new media are fragile and require special care to keep them usable. But preserving digital information is a new concept with which most people have little experience. As new technologies appear for creating and saving our personal digital information, older ones become obsolete, making it difficult to access older content. ('You have *what* on 4-track cassette tape?') Learn about the nature of the problem and hear about some simple, practical tips and tools to help you keep your digital memories safe."

- Peterson, Kit A., "What to Look for in a Scanner: Tip Sheet for Digitizing Pictorial Materials in Cultural Institutions," Prints and Photographs Division, Library of Congress, Washington, D.C., June, 2005 (www.loc.gov/rr/print/tp/LookForAScanner.pdf) A guide to logically selecting scanner equipment appropriate to your needs.

- Williams, Don, "Guides to Quality in Visual Resource Imaging: 2. Selecting a Scanner," Research Libraries Group, Council on Library and Information Resources, 2000 (www.oclc.org/research/publications/library/visguides/visguide2.html) Kodak expert Don Williams, an authority on scanner technology, presents information about scanner selection in this paper for the Research Library Group, an academic library professional consortium.

"High-Quality" Scanning Myths

"High-quality" scanning myths spun by resolution perfectionists claim that you absolutely, positively need super-quality scanning equipment, costing at least in the $2,500–$5,000 range, to do good photo image scanning work. That's an understandable view in some ways, for some people, but it's an exaggeration. And, of course, I'm writing this book to help you learn easy, inexpensive, and fast routes to producing retouched and restored images of good quality.

Many respected old hands in the digital photo community disagree about the need for expensive scanners. First, they point to the quite satisfactory practical results of using more economical

equipment and lower-resolution scanning. Second, there is objective evidence showing that most observers cannot reliably visually detect the difference between fine-resolution and average-resolution images, whether in display or print form.

My Plain-English Practical Comments on Image Conversion
My plain-English practical comments on image conversion follow.

- Print scanning: There's no compelling reason for requiring incredibly high-resolution settings for photo print digitization. Most informed opinion holds that a decent scanner capable of scanning at 300–600 dpi will work just fine for most purposes.

- Background research: Be sure to examine both printed sources and specialized websites for reviews and comparative ratings at whatever price level of equipment you're interested in getting. Use online search engines to get reliable current coverage.

- If you really feel the need to go for high-quality scanning perfection, then keep the following in mind:
 - You probably need to go for higher-end scanning equipment, but relax: You'll probably do quite well at the $1,000–$3,000 level. (You can go a lot higher if you want to.)
 - Remember, you'll pay for higher scanning resolution with correspondingly longer scanning times and higher disk storage requirements caused by much larger image files. Print scanning times on good flatbed scanners easily run into multiple minutes per image.
 - Added printer expense: You'll need a high-quality and pricier ink jet printer to make practical use of your high-resolution scan files. If you plan on printing 11×14 or 16×20 exhibition prints, a standard letter-size or legal-size printer won't suffice. You'll need a nonstandard printer with capacity to feed wider paper stock sheets or paper rolls. You'll also need to step up from standard ink to quality pigment-based ink, and you'll need to print on fine-quality archival paper stock. All this means that you need to think ahead before you commit to standard use of high-resolution scanning.

The DPM companion website at www.updates4dpm.com will offer updates to this section as appropriate.

I hope this material about photo image digitization helps you in your own practical planning. And note that Chapter 8 provides additional detail about task and procedural analysis, workflow design, and overall backup needs for your digital archive.

References

Dorton, Justine. 2011. "Digitizing Old Slides," MyTrees.com Family History. www.mytrees.com/Digitizing OldSlides.html.

Fulton, Wayne. 2013. "Pixels, Printers, Video—What's with That?" www.scantips.com/lights/pixels.html.

Hamrick, Ed. 2013a. "Batch Scanning Tips." www.hamrick.com/bat.html.

Hamrick, Ed. 2013b. "Frequently Asked Questions." www.hamrick.com/sup.html.

Rockwell, Ken. 2013. "Recommended Photo Scanners." www.kenrockwell.com/tech/scanrex.htm.

Smarten Up Your Work and Your Work Plan

If you're going to routinely perform post-processing work, it's important to think about your workflow and do some task analysis and planning. The level of detail that goes into this will depend on your work volume: Are you handling a large number of post-processing jobs on a regular basis, a few images each week, or is it more of a rare encounter or occasional one-off job? If you're facing a moderate to major workload you'll want to invest time in developing written procedures and protocols.

Standardize, Standardize, Standardize—and Document It!

Setting up a standardized work plan is important for many reasons. If multiple people will be doing the post-processing work, you'll need all of them to begin on and *stay* on the same page. Standardizing the process will pay off big-time when someone needs to cover for a colleague during an absence, pick up in the middle of a project that someone else started, or take over for a departed coworker or customer who used to handle all the heavy lifting.

You don't have to actually sit down and slave away on a full-fledged, formal task analysis and instruction manual. Rather, I recommend you begin recording your hard-earned bits of wisdom on the fly. Start by keeping and sharing notes on what seems to work best. Informally develop, along with your coworkers, a set of "best practices" you've learned through experience.

Maintain a file or notebook of these written notes and practices, detailing what works and what doesn't, and thus create an evolving record of standardized procedures. If you don't want an "old-fashioned" handwritten record, set it up as a shared document through Google Docs or a similar service. Either way, I guarantee it'll wind up saving you and your organization a lot more time than it took to create it.

While anyone engaged in more than just hobbyist-level work should produce a written work plan or guide, it doesn't have to be a huge creative task; it basically involves documenting your common-sense rules and procedures in writing. Ed Hamrick's useful batch-scanning guide, which leads off the bullet list that follows, is brief and to the point and can serve as a model for the sort of basic documentation you should produce yourself.

You can find dozens of free online guides to trial-and-error print- and slide-scanning wisdom. Some are straightforward and nontechnical; others are compulsively detailed. The approach that works for you is the right one. Some good examples include the following:

- Ed Hamrick's "Batch Scanning Hints" (www.hamrick.com/blog/2013/06/05/Batch-Scanning-Tips.html)
 An easy to follow guide to photo print scanning, written by the developer of VueScan, a leading third-party scanning software product.

- Andrew Hardwick's "Tips for Scanning Photographic Prints with a Flatbed Scanner" (duramecho.com/Photography/ScanningPhotographicPrints/index.html)
 Hardwick is concise, presenting useful procedural suggestions and technical background.

- "Preserving History: Chapter 2. Good and Best Practices for Making Digital Images" (archivehistory.jeksite.com/chapters/chapter2.htm)

 Here is one part of an impressive collection covering professional methods for digital archiving of historical photographs, documents, and audio recordings. Chapter 2 is a gold mine of detail and objective fact on the best technical procedural approaches and the technical settings and specifications for your scanning operations. Without getting too wordy or geeky, this resource offers "everything you ever wanted to know" about photo print scanning.

- "Scan Your Entire Life: Create That Photo Collection You've Always Wanted!" (www.scanyourentirelife.com)

 You'll enjoy this site, and you'll also learn an awful lot about "just plain getting it done!" Curtis Bisel (2013) recounts what happened when he decided to preserve a large collection of family photos. A professional motion picture editor with a passion to preserve his family's record of thousands of prints and slides, Bisel was surprised to learn that archiving photographs "is a different animal." According to Bisel, "It requires an understanding that from the time of capture, these new digital files have now become the true 'master files' and will have to serve every purpose asked of them for years to come" (www.scanyourentirelife.com/about-syel).

 SYEL is a fun, nicely presented, and valuable record of Bisel's extensive learning experience and the evolution of his methods. I wish I'd found the site at the beginning of my own digital photo-editing learning curve; I learned an awful lot on my own, but it wouldn't have taken nearly as long if I'd known about SYEL back in 2011. The site is rich in visitor comments, discussions, and contributions, and you can subscribe to Bisel's free email newsletter and receive updates at no cost.

- Paul Royster's "The Art of Scanning" (www.ala.org/alcts/confevents/upcoming/webinar/irs/082411)

 If you are an "I-gotta-see-it-to-understand-it" type, you'll want to check out this free hour-long webcast. Royster, manager of the Digital Commons at the University of Nebraska–Lincoln, is an acknowledged expert on digital scanning and preservation. This is an introductory presentation, covering what you need to do and how to do it—a solid place to start.

- The U.S. Library of Congress, "Guidelines for Electronic Presentation of Visual Materials" (www.loc.gov/preservation/resources/rt/guide/guid_dig.html)

 One of the hallowed authorities on preserving text and photographic images has summarized its well-tested methodology for the benefit of amateurs everywhere. The information is concise, readable, and top-quality. The index page points to a set of topical pages, including the following:
 - Classifying incoming materials by material content(s)
 - Addressing issues of material form
 - Matching electronic content to each material content area
 - Matching encoding/compression to electronic content and intended use
 - Matching file format to encoding/compression and intended use
 - Factoring in economic issues or technology limitations
 - Choosing a scanning resolution

I doubt you can find a better information source on practical operations for digitizing photos than the Library of Congress.

Yes, You Need to Write It Down

While it's not my intent to dictate the details of your work plan, you may find the following suggestions useful as you begin developing your own procedural guide.

1. Document what you're developing in writing as you go along. Brief, informal notes are fine. Just do it!

2. If others will be involved, review your ideas with these colleagues and stakeholders as you're planning. Incorporate their input in your guide, then distribute and review it again. Go with the flow.

3. Be sure to develop and observe a standardized file-naming protocol, including abbreviations or flags to identify various levels of processing. This will ensure you can find what you need when you need it, and will give others a better shot at finding stuff, too.

4. Create and periodically update a visual chart or guide to your typical job processing flow. A rough, hand-drawn chart on paper will do to get started, while word processing software, outliners, and charting/flowcharting software are all handy tools for quickly and easily turning your notes into a useful at-a-glance guide that you can share with others. If your visual output is concise, say just one to three pages, post it in the work area. Meantime, your digital version of the chart will be easy to update and share with others. Be sure it locates or points to physical or disk file locations for major process steps. Here's a fictional example:

 We routinely use a hard disk working file folder for each individual job, with a standardized name form of (juliandate-job number-customername), for example,

 C:\PhotoJobs\20130225-068-Evelyn

 C:\PhotoJobs\20130215-173-EditPrep

 Our process employs standardized filenames using supplementary file-naming codes, flags, and status markers, along with disk subfolders for different process steps. This allows file folders and filenames to convey useful information. For example, in Disk C the folder \PhotoJobs\20130225-068-Evelyn would include the following:
 - 20130225-068original.jpg (original file for post-processing)
 - 20130225-068scan300.png (original scanned image at 300 dpi)
 - 20130225-068ppA.png (first generation of editing)
 - 20130225-068C2.png (second generation of colorizing)
 - 20130225-068-99.png (final approved version)

To expand on the preceding suggestions, I want to first emphasize the value of work group or collegial input while you are defining and documenting your process. Such input helps in establishing definitions, meeting user/customer needs, identifying the need for special flags or indicators,

and locating in-process items, among other important goals and procedures. It also helps to create excitement and interest in the project, as a cooperative effort.

At the *Chicago Sun-Times,* we took just such a cooperative planning approach when I accepted the job of redesigning the newspaper's photo negative archive system. Virtually every affected stakeholder within the editorial department had the chance to provide input. The photo editor used the paper's editorial computer network to create an original photo assignment and identification code that allowed virtually all electronic identifying and descriptive information to be automatically captured. The assigned name identifier code and online index quickly became everyone's key to easily tracking and finding a photo image—anywhere, any time, and in any format.

To create the finished photo negative database record, the *Sun-Times* editorial library staff double-checked, corrected, and annotated the photo editor's original input. Library staff used automated function keys at the computer workstation to quickly add indexing terms from a controlled classification vocabulary. Thanks in large part to all this cooperation, we ended up with a system that *Sun-Times* photographers put to good use, as did the processing lab, requesting news editors, requesting reporters, library photo archivists, the photo department manager, the external photo copyright sales operation, customer service agents who sold copies of *Sun-Times* photos to the general public, and even the outside commercial photo studio that processed our miscellaneous photo orders. The synergies paid off handsomely for everyone, and in ways that no one had expected.

As regards using standardized file-naming codes and formats, this is a practice that will allow you to link all your varied formats, collections, and filing systems of original digital photo images, hardcopy original prints, and original scans of hard-copy image sources, as well as in-process versions of images. You want a clear trail from original image through the entire post-processing sequence. (This will be a boon when Evelyn decides she actually likes version 3 of the retouched image better than version 5.)

Always, always, *always* keep your documentation up-to-date, recording any changes in your work methods and file-naming protocols. At the very least, make clear handwritten notations on the most recent hard-copy version. Initial all changes so team members know whom to approach with questions about a given modification. In addition to keeping your guide up to date, be sure it's made publicly available.

Figure 8.1 is an example of a standardized workflow for a post-processing operation. The diagram attempts to incorporate the common-sense practices we've been examining. It shows input in both digital and hard copy graphic format, normalization to a digital format, and routing into the digital post-processing process. It ends with completed job delivery to the end-user/customer, with storage in an archival file.

Remember, a file-naming protocol and a status check-off list helps you to easily keep track of where everything is. In addition, look for productive opportunities to perform the same post-processing routine steps on multiple items. Batch processing will often provide improved efficiency to routine operations, such as resizing, resampling, adding copyright or ownership watermarks, sharpening or blurring, and applying contrast or lighting level fixes on multiple related or similar images.

Of course, you'll want to be sure to have an effective backup plan for your digital files. Your IT/tech support colleagues can help, and there may even be an institutional solution; otherwise, do it yourself. I'll get into this important subject in greater detail in the section on "File Backups" near the end of the chapter.

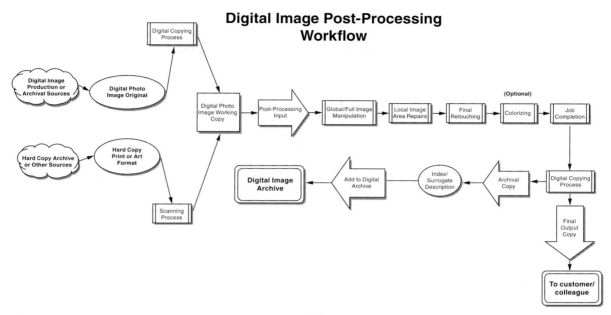

Figure 8.1 Generic post-processing operation workflow.

Once you've put the finishing touches on your work plan and processing flowchart, brief your user community and co-workers thoroughly to ensure that they can

- ○ locate the plan and recognize it when they see it;
- ○ understand the necessity and value of the plan; and
- ○ recognize, decipher, and use the plan's key identifiers for job location and tracking.

If system users can't easily do these three things, you probably have a little more work to do. Your final guide or notebook will help. All the work and discussion that goes into it will pay off quickly when someone is looking for something, requires training to do his or her job, is called on to fill in or provide backup support, or needs to step in and take over the operation.

Practical Planning Suggestions

The first thing to remember is this: Keep your processes simple and use an economical low-resolution format for your images. There's no need to work with enormous digital files at 2400 or 7200 dpi resolution, given that most reproduction and printing processes max out at 300 dpi due to inkjet printer limitations. The "economy" here is not just avoiding large file sizes, but in reducing the time and labor costs of high-resolution scanning and editing large image files. That said, we can hope that advances in scanning and post-processing technology will ultimately eliminate these limitations and considerations.

Scanning Reality Check

Take an effective yet practical approach to image scanning. As I've said elsewhere, it's acceptable as standard practice to perform medium-resolution scanning of 300–1,200 dpi for prints and

2,400–3,000 dpi for slides and photo negatives. Using the higher-resolution for scanning from film is merited, since you're scanning an extremely small physical image which will likely be used to create much larger print or electronic images.

Remember the important three-point relationship of (a) image resolution, (b) scanning time, and (c) disk space. This isn't a quick and simple seesaw relationship. Yes, higher resolution A will drastically increase both scanning-time B and disk-space requirement C. But higher resolution scans don't typically produce higher-quality printed or display images due to (1) the dpi limitations of even commercial-grade photo printer hardware, and (2) the effective 72- or 96-dpi limit of computer and video displays.

Some Scanning To-Do's

- Keep up to date on changes in methods and equipment. Use your normal sources for research, reviews, evaluations, and reliable word-of-mouth information.

- Take the time to conduct hands-on testing of new ideas for improving your workflow and methods.

- If one or more of your scanned images doesn't appear to be of optimal quality, don't bother with detailed analysis. Most scanning software includes simple contrast and brightness control settings, just like a photocopier: lighter, darker, and more/less contrast. Just go ahead and make additional scans using slightly different settings—or what's referred to as "bracketing."

 Bracketing doesn't add extra film, paper, or processing costs. It's just a minor increase in your scanning time and effort. The modest labor cost increment is cheap insurance; it provides a quality guarantee for your effort. Even if you figure $50 per-hour for your time, extra bracket scanning time of 1–2 minutes merely means an effective cost increase of perhaps $0.75–$2.00 per job.

 This is a low overhead cost that gets you guaranteed quality for your output product. It's only a paper overhead cost, not really an out-of-pocket cash cost. It seems to me that the extra minute or two will just disappear or evaporate into the general overhead of doing a good job—and you won't have to redo it.

Printer Reality Check

When it comes to printing your images, my first piece of advice is this: If you only occasionally need larger than 8×10 prints and aren't already set up to produce them, outsource them. It doesn't pay to buy the hardware to produce large, high-quality prints yourself unless you need them frequently. You'll pay a premium price, perhaps $500–$2,500, for wide paper capacity, and for many of us this will not be a cost-effective purchase. You can easily find a local firm to handle the production, including not just commercial photo services and office supply stores but also chain department and drug stores such as Walmart, Target, and Walgreens. A print is likely to run $3–$20, depending on size and paper.

In terms of production quality, remember my earlier caution that even commercial printers are often limited to 300-dpi output. Be sure to verify the resolution your outside printing service is able and willing to provide before spending extra money on so-called "high quality" prints.

If after considering my advice you are determined to invest in a premium printing system, do your purchasing homework:

- Perform due diligence in product research. Seek out and read competent, unbiased comparative reviews of competing products. There are many reputable manufacturers offering excellent products. Know your options.

- Talk to other users. Once you've identified a make and model of interest, ask your vendor to put you in touch with a satisfied customer or two. If that isn't possible, use online forums or social networks to find out what users are saying. Ask questions; the answers you get may well affect your purchase decision.

- Try before you buy. Test the equipment yourself, putting it through its paces to be sure it performs as promised, producing quality output with acceptable speed. Confirm for yourself that the unit is easy to set up and connect, intuitive to operate, and not too hot or noisy when running.

- When setting up for premium printing operations, devote your high-tech equipment to critical graphic production rather than using it for routine print jobs, like text. Using another, lower-end printer for everyday use, where print resolution is not a factor, will help you conserve premium inks and extend the life of your high-end equipment.

Adding Artistic Skill

Let's face it, adding artistic skill through technology isn't realistic; the extent to which your output appears artistically inspired will come down to your eye, talent, training, and willingness to "practice, practice, practice." That said, there is an easy way to improve your manual dexterity for image-editing: Use a hand stylus, as shown in Figure 8.2.

The input dexterity provided by these inexpensive tools is far beyond what can be achieved using a mouse. A stylus enables you to effortlessly input manual handwriting or drawing strokes into a digital device. They can work with your desktop computer, notebook, touchpad, or smartphone. You'll need just a bit of practice to familiarize yourself with the feel of the "virtual pen" or brush. Once you're comfortable with it, you can significantly improve your level of finesse or delicate control over photo-editing work.

Wacom, Inc. is the world's leading manufacturer of "pen" or stylus digital input devices. Its current stylus hardware is cordless, with excellent interface software that allows you to transform your hand motions into virtual and accurate drawing, sketching, and handwriting input to your computing device. Priced in the $30–$75 range, Wacom styluses (www.wacom.com/products/stylus) are compatible with notebook and desktop computers, tablets, and smartphones and are readily available at computer and electronics retailers.

Standardize Your Post-Processing Work

You can use or adapt the following common-sense work plan to organize your post-processing work.
 Work from big to small:

- iResize and remove image area

- Major whole image corrections: dust, color shift, white balance, sharpen, and blur

- Level, contrast, and histogram b/w points

- Local paintbrush corrections and filters

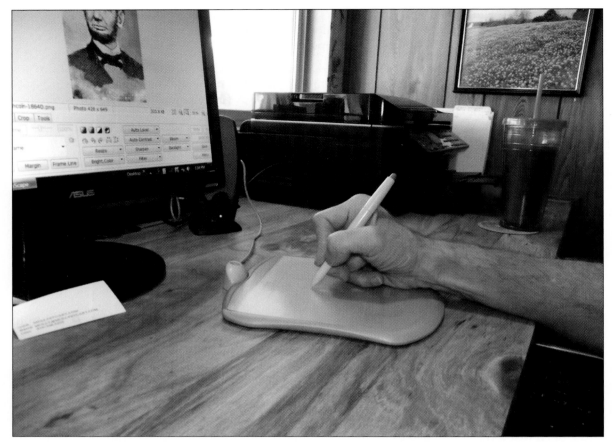

Figure 8.2 I'm using my trusty old Wacom digital pen stylus on the sensitized tablet surface. (Yes, the virtual eraser on the end of the stylus really works when you need to scrub out errors—that is, assuming the software you're using understands the stylus erasing command.) Compared to my own "antique" stylus equipment, modern current pen/stylus technology is amazingly streamlined and usable.

- Restoration/correction post-processing to include the following:
 - Larger scratches, stains, abrasions, tears, creases, burns, background, and textures
 - Extensive use of smooth, clone, blur, and scratch functions
- Detail retouching
 - Spotting, cosmetic, facial, and similar small fixes

In addition to observing the "big to small" rule, you'll want to develop a standard operating procedure. Where a team is involved, a documented, by-consensus work plan will help to avoid confusion (and mistakes), ensure compatibility (and harmony), and improve productivity. Even if yours is a single-person effort, written guidelines will help keep you on track and working as effectively as possible. Here are some "best practices" for your process document:

- Standardize on PNG format for most of your digital post-processing operations, for several reasons:

- PNG is a lossless format. You avoid the possibility of image degradation after a series of version saves and re-openings for subsequent editing.
- PNG produces smaller files than TIFF, BMP, and even high-resolution JPEG.
- PNG is increasingly compatible with photo-editing software.
- PNG is easy to convert to any desired final output file format.

- Always start with the highest-resolution, highest-quality image you can get.

- Begin with a minimum 300-dpi scan, setting size to *at least* original scale. "Magnify" or enlarge the image size setting if the image is small, perhaps using a 600- or 1,200-dpi scan. Do this especially if your output is intended for a larger print or reproduction size.

- If your original digital file is not in lossless format, it's probably best to convert to PNG format for post-processing. It's easy to do this in batch processing using a resizing conversion utility. Then you can edit and save intermediate versions without introducing image degradation. You can convert the final output to a user-required format as needed.

- Make bigger fixes first. Here I'm talking about operations where you are manipulating large areas or even an entire image. These kinds of editing processes include large area repairs, light level corrections, contrast improvement, and full image changes (for instance, color, hue, sharpening, and blurring). Only after you finish with large areas should you proceed to small area or fine detail work. If you ignore this rule, you'll invest time and effort in detail work (such as removing spots and scratches, and making cosmetic improvements) that you may unintentionally lose or degrade later when making large-scale modifications. This can be a major time waster, so don't forget the sequence.

In addition to following my advice in this chapter, be sure to check out the recommended sample guides and resources mentioned in the text. I've compiled additional resources at the DPM companion website.

File Backups

When it comes to file backups, there's no way around it: You simply have to do them. And remember: Backing up is in your own self-interest. It's cheap insurance that protects your investment in time and effort and safeguards your reputation for timeliness and efficiency.

The good news is that backing up doesn't need to be drudge work; it's easy to automate. Today we even have the option of cloud backup. There are good arguments in favor of using either the local or cloud backup approach, but I personally prefer the relatively cheap local method. While cloud backup is often promoted as cheap and easy, it's probably even cheaper and easier to use your own hard disk. External hard drives from 500GB to 1TB are very inexpensive and prices continue to drop. (I recently bought a 2TB Toshiba hard drive for less than $75.) And with a local drive, you'll enjoy the benefit of full backups of all your system data, not just your photo files.

Following are some of my own experiences using the local backup approach:

- Back in 2009, I purchased a Hitachi 500GB external hard disk for $65 at my local Fry's Electronics. (A ridiculously low cost of 13¢/GB, even back then.) I downloaded a freeware copy of the highly-regarded Cobian Backup software, Gravity Edition, which I continue to use. It's easy to set up for monthly full backup and offers daily differential backup. (A differential backup copies any file that has been created or modified since the last full backup.) My routine is to keep the current month's differential files, plus three generations

of full backup (last month, two months earlier, three months earlier). Cobian Gravity completely automates backup sessions, the archiving of previous backups, and the deletion of no-longer-needed archives.

- My current photo backup file goes back to the year 2000 and contains nearly 14,000 color images. I have easy access to my active *primary* hard disk file of all photo images, plus the external drive backup file. The automatic external backup contains daily-updated copies of the current month's added or edited photo files, plus three-month backfiles of the complete archive. All told, this only uses about 50GB of disk space. I also annually copy the past year's images onto DVD and put it in my bank safe deposit box. The "real" cost for all this is about $7 spent on disk space and DVD media and 20–30 minutes of initial and later configuration time for the freeware backup program. That's a pretty economical means of soothing my wildest OCD fears of losing my photo images.

- Backing up my entire current active data file collection to the external drive, keeping the current month differential file and three months full backups of *all* data and image files on my personal PC, requires about 100GB of storage. This is not a costly undertaking, though it is an essential one.

My point is, considering the low cost of storage today you'd be crazy not to protect your photo archives by making multiple and redundant automatic backups. The backup technology is inexpensive, if not free. It's simple, easy-to-use protection for your time and effort—not to mention your irreplaceable digital photo archive!

Of course, depending on your situation, you may decide to use both local *and* cloud backup. The added expense will be modest, and it might one day prove well worth the investment.

References

Bisel, Custis. 2013. "Scan Your Entire Life." www.scanyourentirelife.com.

What Can *You* Do with DPM?

Okay, so I've hopefully convinced you that DPM is cheaper, faster, easier, and produces work almost equivalent to what you'd get by using top-of-the-line photo-retouching tools with all the production skills generally known only to PhotoShop Zen masters. Yet, grasshopper, I know you may have reservations about your readiness for the tasks at hand: Do you still have questions or comments such as the following?

- It can't be all that good. (There ain't no such thing as a free lunch, right?)

- If I'm going to get good at this digital photo post-processing stuff, I just know it's going to eat up all my time and resources. (It's bound to take me away from what I really *want* to be doing, or at least am *supposed* to be doing.)

- As busy as I am already, why should I trap myself into yet another time-consuming activity? (Isn't that like being in the military and volunteering for an extra duty detail?)

Those Nagging, Niggling Doubts

Yes, doubts are understandable. And the questions above are good ones. Let's look at them closely.

First of all, DPM is really, truly affordable. Remember, we're talking here about freeware or moderately priced software—mostly shareware—that typically costs, if anything, less than $100. It's the same kind of approach as with your PC hardware: There's no budget-busting, no scrimping and saving, no competition for scarce resources. Your cost-recovery or payback period is maybe a day or two.

Second, DPM is fast. Learning is fast, and the recommended applications and utilities are easier to learn and use than you might imagine. These programs make short work of your post-processing tasks, with no long, dragged-out procedures and no fatiguing detail work. Since I began using DPM about 5 years ago I've only twice spent more than an hour on a photo retouching project.

The labor commitment is minimal. Hard work is an exception that will apply in the case of problem images, not a regular, everyday thing. DPM work goes quickly. You'll complete most of your jobs in 5–15 minutes. Yes, you may occasionally take on a particularly challenging restoration project, but even then we're talking no more than 45 minutes to an hour per image.

Third, DPM is easy. This isn't brain surgery; it's nothing like trying to master Photoshop. Most of the products I've recommended in the book will take an hour or two to learn. Some will take even less. A very few may take a couple of days, mostly just getting a bit of experience, getting comfortable using the tool, and gaining confidence. The images you practice on will be improved, so you might want to start with real or likely tasks. Your new skills will produce results beginning on Day One, and what you produce is going to be a whole lot better than just "pretty good." If you're anything like me, you will soon find yourself gaining a reputation as a wizard who can do unbelievable things with digital images.

What Can You Really, *Really* Do with DPM?

For librarians, archivists, educators, and many other professionals, the benefits of using DPM are obvious. You'll take advantage of previously unusable photo image resources. You'll improve the variety and quality of the various photo-related activities in your workplace or organization. Your work will contribute to all the work-related activities for which photos are useful, including the creation of publications, exhibits, certificates, awards, webpages, and all types of promotional materials.

And remember that there are also many spin-off applications for your DPM talents. It's not a skill that's limited to the workplace, but an in-demand personal skill, as well. For under-funded non-profit activities, in particular, skilled photo image retouching and restoration has traditionally carried an unacceptably high price tag. That's no longer the case.

Your mastery of DPM can contribute to teaching, training, learning, group-building, and social activities, as well as to any number of personal hobbies. With your newfound DPM skills you'll be able to

- colorize black-and-white photographs;

- restore valuable family or historic photos;

- repair torn, scratched, faded, or physically damaged photos;

- scan and restore photo collections from family albums then compile them on CDs, DVDs, USB drives, websites, and social networks (a historical photo collection of the extended family on CD makes a wonderful holiday or family occasion gift for about 35–50 cents per person);

- undertake specialized photo genealogy and family history projects for genealogy hobbyists or groups;

- routinely improve your own everyday digital color photos, moving from taking decent snapshots to producing truly impressive photographs;

- use photographic images as part of teaching and interest-building activities for teachers, parents, scout leaders, groups, and clubs;

- show your kids how to find and restore old photographs and assemble photo collections in support of class papers, term papers, and school projects (DPM can truly make learning fun for many children);

- use DPM processing for projects benefitting civic, professional and social organizations, churches, Chamber of Commerce or business groups, historical societies, genealogy groups, and more;

- create "looking back in time" photo exhibits for anyone or any group—including companies, organizations, schools, churches, clubs, and fraternal orders;

- turn organized photo collections into video presentations—easily done, for example, using Picasa—then move them to websites, social networks, CDs, or DVDs;

- start a home-based business restoring photographic images (as easy as DPM is to use, most people are yet to discover it—in our digital age, the commercial potential is vast).

Personal Rewards

The personal rewards of using DPM effectively are many. If nothing else, you stand to gain satisfaction from producing work that is appreciated and valued by your family, friends, colleagues, and the world at large. You may also enjoy the pure and simple pleasure (and fun!) of using your new skills and talents to produce beautiful, striking, thought-provoking, inspiring, warm, culture-affirming, informative, family-valued, and humorous photographic images.

Following, just for fun, are some assorted images I enjoyed retouching with DPM. I look forward to seeing *your* handiwork, so please visit me at update4dpm.com and don't forget to share!

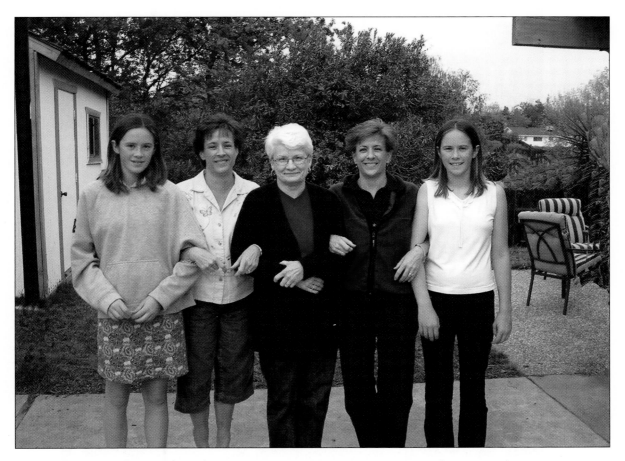

Figure 9.1A Family snapshot after cropping, perspective correction, and exposure/contrast correction.

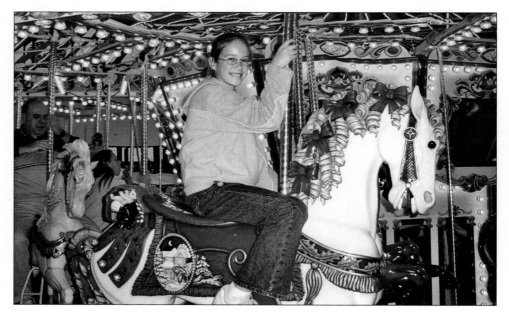

Figure 9.1B Historic photo of Geronimo (R) and warriors, retouched and sharpened, with my caption added.

Figure 9.1C Carousel Fun in sparkling color! About 3 minutes in PhotoScape improving brightness, color saturation, depth, gamma, and backlight.

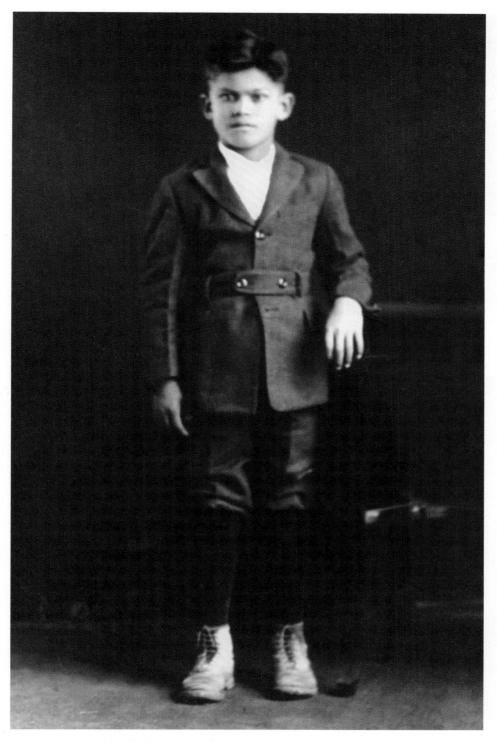

Figure 9.1D Colorized version of a black-and-white vintage photo of my father, ca. 1920.

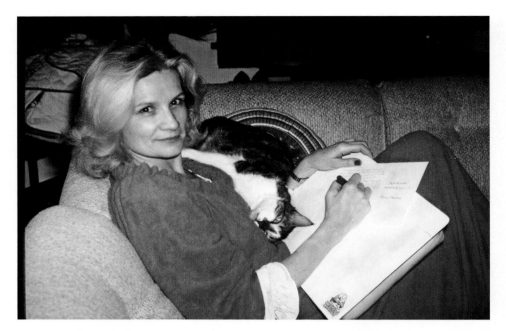

Figure 9.1E Retouching work on a blurry, dark, and poorly lit snapshot of my wife Sandra and her cat.

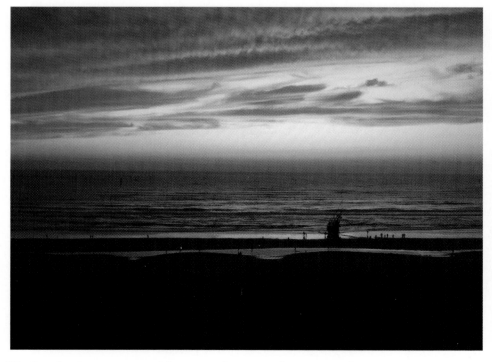

Figure 9.1F Pacific Ocean sunset, Newport, Oregon, after some color, exposure, contrast, and image leveling adjustments.

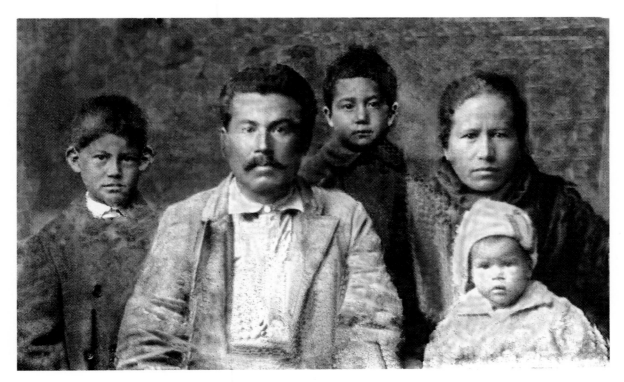

Figure 9.1G Colorized image of my great-granduncle and his family from a yellowed and faded black-and-white photo, ca. 1910.

Figure 9.1H Colorized portrait of another great-granduncle, from a torn and scuffed black-and-white snapshot, ca. 1910.

About the Author

Ernest Perez, Ph.D., was most recently Group Leader for Reference Services, Technical Services, and Automated Systems at the Oregon State Library, Salem. Oregon.

A native of San Antonio, Texas, Ernest has a BA in Journalism from the University of Texas at El Paso, an MS in Library Science from the University of Texas at Austin, and a Ph.D. from Texas Woman's University, Denton, Texas.

Ernest's academic library experience includes working at the University of Texas–Austin Libraries, the Southwest Texas State University Library, and the Texas Woman's University Library. In special libraries, he was Library Director at both the *Houston Chronicle* and *Chicago Sun-Times*. At the *Sun-Times* he also worked as Circulation Department Administrator and managed the department's Automation Task Force.

A leader in the development of full-text databases at both the *Chronicle* and *Sun-Times*, Ernest was a recipient of the Henebry Award from the Newspaper Division of the Special Libraries Association (SLA) for his contributions in the automation area. He led numerous seminars and presentations on the topic for the American Press Institute, the Southern Newspaper Publishers Association, and the Inland Daily Press Association.

Ernest's recent interests and projects have included the design and production of networked and online information services for Oregon State employees, web database migration of the statewide cooperative Oregon Index, conversion and web database migration of the Oregon Union List of Serials, development of the Find-OR GILS system for the State of Oregon, startup of the Libs-OR electronic mailing list for the Oregon library community, coordinating the testing of a prototype statewide shared catalog and ILL system in Oregon, and managing the hosting of over 300 mailing lists for Oregon State agencies and regional and national library interest groups.

True to his undergraduate journalism major roots, Ernest is a frequent contributor to the library professional literature. He has published more than 150 articles and book chapters, served as a contributing or associate editor for numerous journals, and was editor of the Sage Publications journal, *Library Computing*.

A serious longtime amateur photographer with a deep interest in digital image-processing tools and techniques, Ernest resides in Roseville, California. *Digital Photo Magic* is his first book.

Index

Note: Page numbers in *italic* indicate figure captions; those in **boldface** refer to tables.

PC Magazine, 158
perfection, vs. good enough, 9, *10*
personal skills, 13, 21–25
perspective correction, 154, *175*
Peterson, Kit A., 161
photo editing. *See* Digital Photo Magic
PhotoFiltre Studio X, 86
Photographic Society of America Nature Division
 (PSA ND), 30
PhotoImpact Pro 13, *65,* 85
PhotoScape
 cloning in, *117–119*
 color correction in, *51, 176*
 cropping in, *45, 138, 141*
 described, 85–86, 115
 lighting modifications in, *116, 118–119, 141, 176*
 sharpening in, *116, 137*
 user interface, 19, *20*
 vignetting in, 64, *64*
Photoshop
 alternatives to, 19–21
 described, 83–84
 power and complexity of, 18–19
Photoshop Elements 13, 84
photoshopped (term), 18
PhotoStitcher, *67. See also* panoramic stitching
PhotoUpz, 90
PhotoWipe, 90
Picasa
 blurring in, 59, *59*
 described, 86–87
 sharpening in, *53*
PicMonkey, 93
Picture Resizer Personal, *46,* 95
PixBuilder Studio
 described, 87
 lighting modifications in, *49, 50, 141*
 sharpening in, *141*
pixelizing, 52
pixels, in resizing, 45
planning tips, 167–169
plugins, 7
PNG format
 compared to other types, **73, 74**
 described, 71, 72
 as standard, 75–78, 170–171
 in workflow, *77*
poor exposure correction, 136, *137–139, 178*
portrait format, 46, *47*
portraits
 removing objects from, 2, *3*
 skin corrections in, 56, *56,* 100, *100–101*
posterization, 64, *65*
post-processing, defined, 1. *See also* Digital Photo Magic
precision, in DPM, 14, 25–26
printers, 154, 168–169
PSA ND (Photographic Society of America
 Nature Division), 30
public domain materials, 14, 15–17

R

raster images, 72–73
RAW format, 72, **73**

Reaves, Sheila, 29
Recolored (software)
 colorization examples, *127–134,* 140, *142–146,* 146, *147–151*
 described, 90–91, 126–127
 vs. high-end software, 131
removing objects
 automated software for, 88
 in Inpaint, 2, *3, 61, 104–109*
 in iResizer, 111, *111–114*
 smart removal, 60
resampling images, 45
resizing images
 methods of, 45, *46*
 smart resizing, 61–62, *62, 63*
 software utilities for, 94–95
resolution changes, 45
restoring or retouching images. *See* Digital Photo Magic (DPM);
 specific operations
Retouch Pilot
 described, 120
 multiple functions in, *138, 147*
 scratch removal in, *57–58,* 122, *124–126, 142*
 skin correction in, *3,* 120–122, *121–123*
 user interface, 19
reversing images, defined, 29
Rockwell, Ken, 154, 158
Roosevelt, Theodore, 139–140, *140–146*
rotating images, 46, *47*
royalty-free images, 14, 15–17
Royster, Paul, 164

S

saving files, 44
scanners, 4, 36–39, *37–39,* 154–158
scanning methods
 guidelines, 75, 162, 167–168
 high-quality myth, 161–162
 information resources, 160–161, 163–164
 large-scale scanning, 160
 software, 158–159
scratch or spot removal
 described, 57–58, *57–58*
 project examples, 122, *124–126, 138, 142*
Seelig, Michelle, 28–29
selected area modifications. *See also specific*
 operations
 blurring or sharpening, 59, *59*
 brightening or darkening, 60, *60*
 color corrections, 60
 defined, 56
 scratch or spot removal, 57–58, *57–58*
 skin corrections, 56, *56*
sequencing work, 66–69. *See also* work plans
sharpening
 full-image, 52, *53, 116*
 project examples, *137, 141, 176*
 selective, 59
Shrink Pic, 95
silver-based negatives, 35
simple blur, 52, *54*
skin correction tools
 Beautune, *3,* 7
 CleanSkinFX, 7, 56, *56,* 94, 100, *100–101*